A Zone System
for all Formats

A Zone System
for all Formats

Joseph Saltzer

AMPHOTO
American Photographic Book Publishing Co., Inc.
Garden City, New York 11530

Copyright ©1979 by the American Photographic
Book Publishing Company, Inc. Published in Garden
City, New York, by American Photographic Book
Publishing Co., Inc. All rights reserved. No part of
this book may be reproduced in any manner or form
without the written permission of the publisher.

**Library of Congress Cataloging in Publication
Data**

Saltzer, Joseph
 A zone system for all formats.

 Includes index.
 1. Zone system (Photography) I. Title.
TR147.S24 770'.28 78-12888

ISBN 0-8174-2419-9

Manufactured in the United States of America

To my parents Daniel and Kathryn
To my children Rebecca Weston and Amanda Adams
(and to their namesakes)

ACKNOWLEDGMENTS

In an undertaking such as this, there are many people who add to the whole. A very special thank you to the staff of the International Center of Photography, who gave me a chance to teach and to explore the magic of photography: Cornell Capa, Via Wynroth, Lester Lefkowitz, Regina Fiorito. To Jean Witterschein, whose help was above and beyond the call. To the various manufacturers who supplied me with materials and equipment:

Minolta Corporation
Polaroid Corporation
Ilford Incorporated
HP Marketing
Eastman Kodak Corporation
Edwal Chemical Corporation
Hasselblad Co., A.G.

Thanks to Lester Kaplan, whose enthusiasm and editing through adversity helped to give the book definition. And most importantly, thanks to Michael Edelson for his keen, critical eye and understanding, but most significantly his friendship, which has brought me through.

CONTENTS

Introduction

The Zone System can accurately be defined as the pragmatic application of the fundamental scientific principles of photographic theory. This synthesis between the scientific basis of and the practical application of photography was first developed and promulgated by Ansel Adams in his *Basic Photo Series.* There is little question that these books were a watershed in photographic education; however, the Adams' texts were primarily concerned with the large-format camera, while this volume addresses itself to both the 35 mm and roll-film user as well. Too, materials and processes have undergone sufficient change to necessitate an overall revision of the technique involved in the translation of theory to practice.

Throughout this text, three summary concepts that I feel embody the entire procedure are emphasized:

1. The dysfunction of the eye, as evidenced by the bias of perception in relation to that which is recorded by the camera.
2. The translation of what was perceived to that which is to be recorded.
3. The process/technique that allows the perceived image to be recorded as desired.

These concepts are stressed and, once fully understood, will lay the foundation for the scientific principles involved in the procedure.

The scientific theories pertaining to the process have been presented as succinctly as possible. The practical application of the principles are of much greater importance to photographers than the pure science involved. To this end, the presentation is as accurate and complete as possible, although there are many who will wince at the possible simplifications involved. Included in the bibliography are texts that will expand on what is presented, and you are urged to further your studies if you feel that the concepts relating thereto are not explained to your satisfaction.

The photographic print is a personal statement, and as such is not subject to absolute standards. It is highly unlikely that any two photographers will agree on precisely what qualities a print should embody. However, this is not to deny that certain criteria are applicable and should be maintained. The standards referred to in this text are personal, yet they are closely allied to those that are nearly universally accepted.*

The calibrations that are outlined and detailed herein are of primary importance to the understanding of the procedures/technique involved. These calibrations must not be considered as appendages to the text or as mere exercises. They are purposefully placed in those sections that offer enough explanation so that they can be accomplished with understanding. Their successful achievement will allow you to ascertain with a high degree of certainty how the materials of the procedures operate in concert with the photographic theory involved.

Through the years, as the methodology of the Zone System developed, a vocabulary was devised to accommodate and give definition to the procedures/concepts as explained. With some exceptions, the terminology that was employed throughout the Adams' texts is used in this text. Whenever and wherever there is a deviation from these terms, it has been carefully explained, and the differences defined.

The genesis of this book grew out of many years of teaching. The basic outline is the same as that which was employed in class,

*These are personal preferences at this writing. It is not unusual for a photographer's conception of print quality (and all that this phrase entails) to undergo major modification.

and as such, is of proven quality. However, as materials change and subsequent processes undergo modification, the technique and application of the theory should always be considered as an ongoing, fluid process, although the fundamental photographic concepts remain unalterable. It remains the responsibility of you, the reader, to be aware of the changes in materials and their pertinence to the procedures involved.

In conclusion, this book should be considered as an introduction to the application of photographic theory to the subsequent photographic uses to which the theory leads. While the text presents sufficient information for you to translate your perceptions of a subject/scene either literally or creatively, it remains your responsibility to use the technique wisely and to expand the conceptual matter to that which will allow for creation to occur with a sure knowledge of materials and their application.

New York, New York 1979

1

Visual Perception/Tone Reproduction

One of the interesting things about photography is the fact that its records of our selves and our works so often do not correspond to our mental images: The photographs make our waistlines look thick, and our postures slovenly, and our houses graceless and ill-proportioned. Generally we assume that the difference between our expectation and the camera's evidence is the result of some kind of photographic aberration. We call it distortion and preserve our faith in the validity of our mental image.

John Szarkowski
Looking at Photographs
Museum of Modern Art, New York

CHAPTER CONTENTS

THE EYE AND THE CAMERA

In most classical photographic texts, there is a lengthy discussion of the differences and similarities between the eye and the camera. As George Wald points out in an anthology of articles from *Scientific American* magazine, "Perception: Mechanisms and Models"*: the "usual fate of such comparisons is that on closer examination they are exposed as trivial." These surveys usually

*George Wald, "Eye and Camera," Readings from *Scientific American—Perception: Mechanisms and Models.* San Francisco: W. H. Freeman and Company, 1950, Chapter 10.

14

include an analogy between the iris of the eye and the aperture blades of the lens diaphragm; the inverted image projected by both the eye and the lens; the focusing of the camera by changing the distance between the lens and the film plane as compared to the thickening of the lens of the eye. However, in recent years, Wald continues, "the more we have come to know about the mechanism of vision, the more pointed and fruitful has become its comparison with photography." Knowledge of the similarity between the two has extended far beyond the study of the optical properties of each and today includes the correlation between film and the latent image and the eye's mechanism of retinal rods, and the grain of fast and slow film emulsions compared with the "grain" produced by the eye's receptors (rods and cones). These analogous examples are discussed throughout this book, but perhaps of most interest to the photographer is the difference between how the eye perceives (a subjective inference) and how the camera records (an objective connotation).

PROBLEMS OF PERCEPTION

The eye, as a photographic receptor, is incapable of accurately differentiating contrast, shape, or tone. Rather, it is predisposed to a personal perception of what is seen. It will substitute a subjective reference for the object viewed rather than give the observer accurate information as to the true qualities of the object seen. Our concern is primarily with the dysfunction of the perception of tonalities, although optical illusion and contrast play an integral part in the understanding of photographic vision. It is this knowledge, which I termed *translation,** that is the hallmark of the successful artist. The artist "translates" what he or she sees and feels into a medium (a painting, a sculpture, or the photographic print) that will ultimately contain the essence of his or her perception.

*The term "previsualization" has often been used and, in this context, is very nearly equivalent. However, over the years, it has assumed certain implications (mostly pietistic), which I feel subvert its essential meaning.

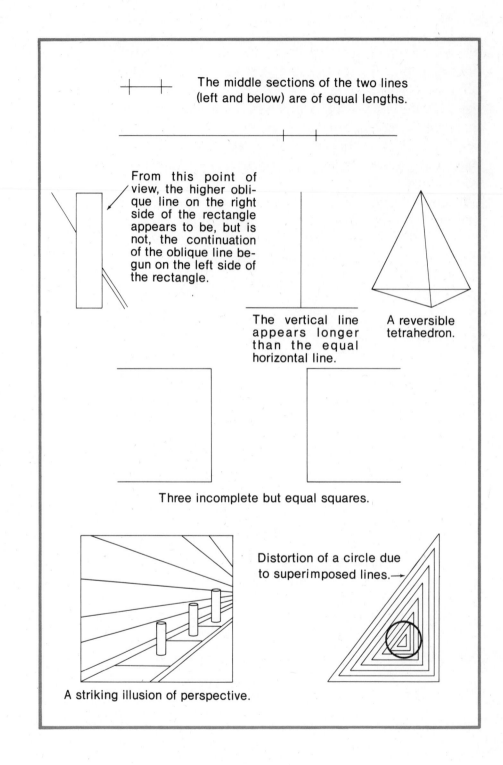

The middle sections of the two lines (left and below) are of equal lengths.

From this point of view, the higher oblique line on the right side of the rectangle appears to be, but is not, the continuation of the oblique line begun on the left side of the rectangle.

A reversible tetrahedron.

The vertical line appears longer than the equal horizontal line.

Three incomplete but equal squares.

A striking illusion of perspective.

Distortion of a circle due to superimposed lines. →

VISUAL ILLUSIONS

The phenomenon known as visual illusion has been ascribed to various mechanical (eye movement), physiological, neurological, and behavorial theories. Any one of these hypotheses can solve the riddle of a particular illusion, but none can provide a universally acceptable answer. These hypotheses do not, however, give us much useful photographic information (the illusion of perspective being an exception), but they illustrate graphically the general problems of perception.

The illusions dealing with geometric perspective (translating from three dimensions to two) are interesting in the photographic sense. The camera does indeed record true perspective, which looks/feels/appears incorrect in the photographic print because the eye has transmitted biased and subjective information to the brain. We are aware of the classic photograph and its resultant "distortion" produced by tilting a camera upward while photographing a building. The building seems to fall backward, with its sides converging to its top. The photograph is a true rendering of the building; we, however, cannot accept the visual information of a building falling over.

When artists accepted the phenomenon of perspective and introduced it into their work, they were in fact not drawing what they saw; rather, they were representing their retinal image. R. L. Gregory, in *Eye and Brain,** states:

> It is fortunate that perspective was invented before the camera, or we might have had great difficulty in accepting photographs as other than weird distortions. ... We do not see the world as it is projected on the retina, or a camera. ...

*R. L. Gregory, *Eye and Brain: The Psychology of Seeing.* New York: World University Library, McGraw-Hill Book Company, 1972.

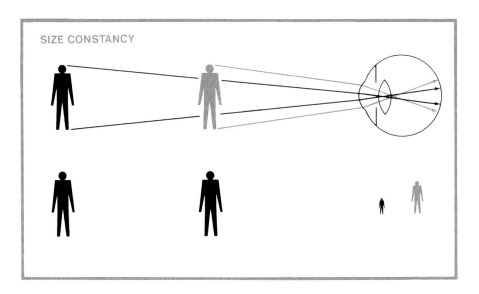

SIZE CONSTANCY

When the same sized object is viewed from twice the distance, the actual brain-retentive image is reduced by one-half. However, since its actual size is known, the object is perceived as being equal in both circumstances.

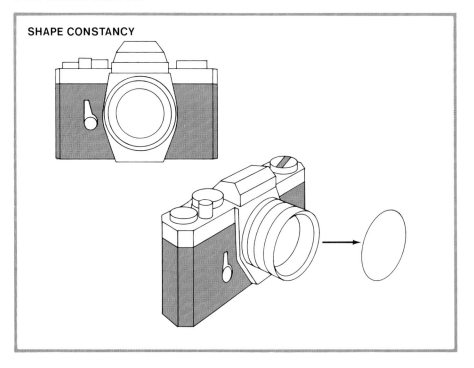

SHAPE CONSTANCY

SIZE/SHAPE CONSTANCY

The perceptual process of size constancy is related to the problems of visual illusion and, in the photographic context, to perception distortion. It is a fundamental optical principle that when a viewed image of an object doubles in size, its apparent distance from the viewer is cut in half. Conversely, when an object is viewed from twice the distance, the image size is reduced by half. However, it does not appear smaller; quite the contrary, it is perceived as nearly the same size. Two objects of like dimension when viewed at differing distances will be perceived as equal. An interesting experiment can be conducted by tracing an outline of your face, at arm's length, on a mirror. The reflected image from the mirror will look/appear/be perceived as life size; yet once the tracing is analyzed, its measure will be no larger than that of a grapefruit.

Descartes, in 1637, was the first to write about size constancy:

> ... size [of an object] is judged according to our knowledge or opinion as to their distance, in conjunction with the size of the images as they impress on the back of the eye. It is not the absolute size of the image that counts. Clearly they are a hundred times bigger when the objects are very close to us than when they are ten times farther away, but they do not make us see the objects a hundred times bigger (the area, not the linear size); on the contrary, they seem almost the same size, at any rate so long as we are not deceived by (too great) a distance. ...

> [As to shape constancy] our judgments of shape clearly come from our knowledge, or opinion, as to the position of the various parts of the objects, and not in accordance with the pictures in the eye; for these pictures normally contain ovals and diamonds when they cause us to see circles and squares.

The awareness of the actual shape of an object (a circle) transcends the reality of its shape, when it is viewed at an angle (left).

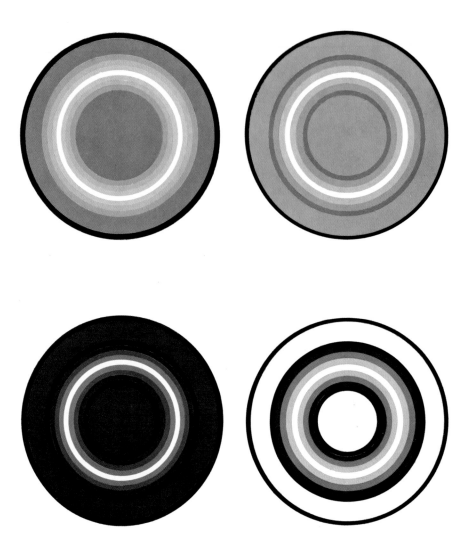

In each of the constructions, the absolute value of the black-and-white circles remains the same. Note, however, how the addition or subtraction of the surrounding circles (tones) changes the perception of these values. The greater amount of contrast provided by the adjacent tones, makes the black-and-white values appear both darker and lighter, respectively.

TONE CONSTANCY

Of all the visual phenomena that concern the photographic process, the most important is tone constancy. Simply stated, our perception of tone operates in the context of our experience and our acquired knowledge. A white handkerchief in bright sunlight will of course appear as white; when taken into a dimly lit room, it will still be perceived as white, although photometrically it would almost certainly record as gray. A white barn will appear white no matter what the illumination. Our knowledge has influenced our vision. The perception of tone has come between the viewer and the reality of the object observed.

The receptors in the eye react under differing light conditions. Cone nerve endings operate under intense illumination, while rod nerve endings react under low-light levels. When you walk into a darkened room from the outside, you experience a sensation of temporary blindness because the cone nerve endings are not sensitive enough to react under dim illumination, while the rod nerve endings take time to adapt to the new lighting conditions.

Under normal illumination, with both the cone and rod nerve page 32 endings operating, a gray scale will be seen in all its gradations. If, however, the illumination is reduced, the low and midtones will blend together, while the white or high values will still be perceived as white.

The amount of illumination also influences our perception of space and distance. Space is increased under high levels of illumination and compressed under low-light levels. As Faber Birren writes in *Color Perception in Art:**

> Daylight is bright, night is dark, but great distance is gray.... page 75
> Brightness and darkness are associated with light and illumination. Whiteness and blackness are associated with surfaces. Total darkness does not look black but a deep and pitlike gray. A black area will look blacker under greater illumination (even though in fact it may reflect more light).

The page references in the margins of this book are cross references for further information. Using the cross references will add to your understanding of the concepts discussed.

*Faber Birren, *Color Perception in Art.* New York: Van Nostrand-Reinhold, 1976.

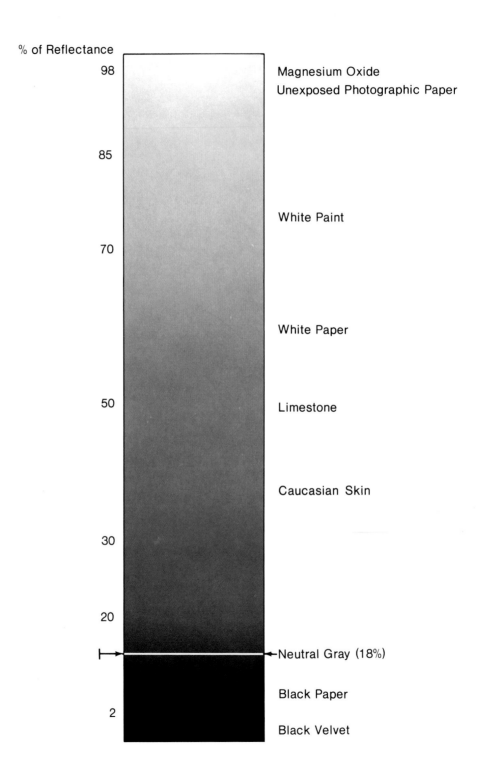

% of Reflectance

98 — Magnesium Oxide
Unexposed Photographic Paper

85

White Paint

70

White Paper

50 — Limestone

Caucasian Skin

30

20

Neutral Gray (18%)

Black Paper

2

Black Velvet

TONE REPRODUCTION

The study of tone reproduction was begun with a review of how the eye perceives and the camera records. While the discussion has centered mainly on the differences between perception and reality, the one quality that is central to both has not been addressed, namely, light, and the mechanism of reflection and absorption that makes our vision operable and the photographic process function.

REFLECTANCE/ABSORPTION

Everything seen, or photographically recorded, reflects and absorbs illumination (incident light), the general illumination falling upon the scene. If the object observed reflects more light than it absorbs, it is understood to be a high (light) tone; if it absorbs a greater proportion of the incident light than it reflects, it is called a page 33 low (dark) tone; if it reflects and absorbs equal amounts of light, it is called a midtone.

Reflectance/absorption, as a characteristic, is expressed as a percentage of the incident light reflected. The ratio is not dependent upon the intensity (quantity) of the illumination. If the incident light is low, the object will be perceived/recorded as dark; nevertheless, it would reflect the same percentage of light as if the illumination were great.

For the purpose of this text, the transmission characteristics of certain objects (for example, glass) can be eliminated, and it can be assumed that reflectance + absorption equal 100 percent.

NEUTRAL GRAY

Neutral gray, or middle gray, or 18 percent gray, is at the perceived center of the gray scale. It is important to note that this is a *perceived* midtone which, although it has a basis in a mathematical formula, uses a subjective coordinate as one of the constants in its computation.* By definition, 18 percent reflectance gray is

*The mathematical formula is presented in C. B. Neblette, *Photography: Its Materials and Processes,* 6th ed. New York: Van Nostrand-Reinhold, 1962, p. 128.

universally recognized as the tone that is visually midway between black and white. It is a photographic standard.

THE PERCEPTION OF TONE

The eye's response to tone does not function proportionately to the amount of light reflected. If it did, for each doubling of reflected light, the object would be perceived as being twice as light. In fact, however, the perception of the progression of low values to high, even though photometrically proportional, is not seen/perceived as such. Rather, the low values and the very high tones/reflectances are perceived without much differentiation.

Our hearing mechanism operates in much the same manner. Low and high frequencies compared to a mid-frequency of equal volume will not be perceived as being as loud—the reason for "loudness controls" on most high-fidelity systems.*

The dysfunction of perception cannot be overcome; it can, however, be dealt with. Through acquired knowledge and the correct use of a photometer, you can eliminate the dysfunction and be able to match your perception with the reality recorded.

THE INFLUENCE OF COLOR IN THE PERCEPTION OF TONE

The photographer must translate the visual world about him/her, which is composed of infinite color, into terms of black, gray, and white. Perceived objects that are delineated by color will be rendered as monotone and, in the process, will lose the character that gave them definition. It is the distinguishing mark of the master photographer that he/she can envision this conversion.

page 262

The concept of color, in terms of black, gray, and white, is included in Chapter 9. The section deals with the use of contrast filters to manipulate the translation of color to monochrome. In order to give you an idea of the scope of the problem, purchase a Wratten Series #90 (gelatin) Filter. This is a monochromatic viewing filter, which can be used to render all colors in their monochromatic equivalents. This filter is also used in the calibration process.

*The Fletcher-Munson effect.

HUE CONTRAST

When viewed through a monochromatic viewing filter three hues of equal saturation/brightness, but of differing hues, will appear as approximately the same on the black-and-white photographic print.

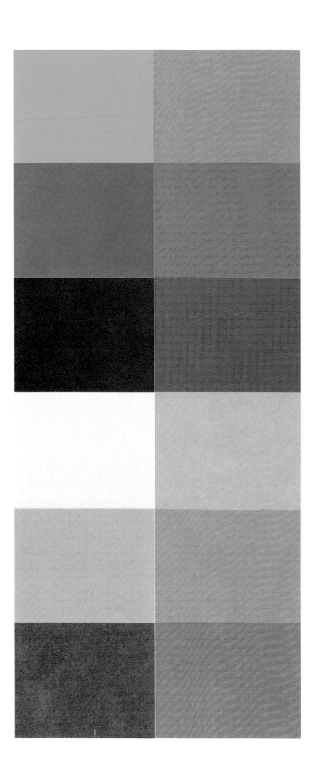

BRIGHTNESS CONTRAST

A scale of saturated colors from yellow to violet. All the shades near yellow, when viewed through a Wratten No. 90 filter will tend to be light, while those toward the violet will reproduce as deep tones.

HOT-COLD CONTRAST

A hot color tends to be colder next to an even hotter color; conversely a cold color tends to be hotter next to an even colder color.

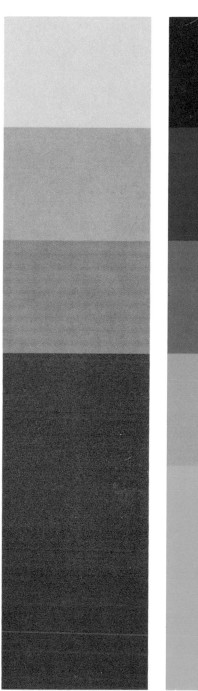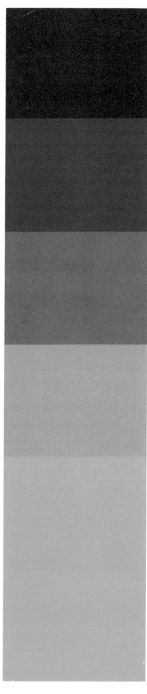

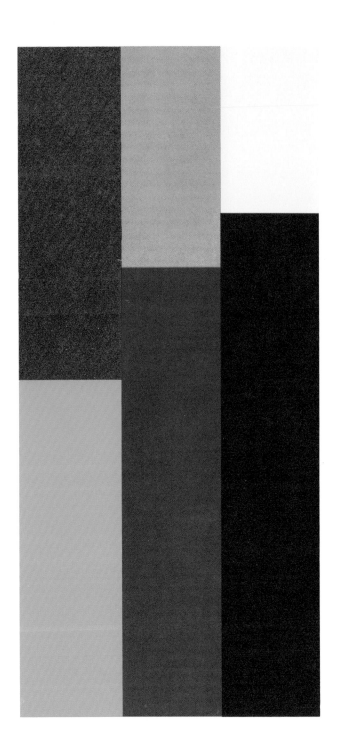

QUANTITY CONTRAST

The quantity of a color is greatly influenced by the reflection/absorption characteristics of that color. Yellow will reflect three times the amount of light as violet, and will achieve an undue importance in the photograph once the tones are rendered into black, gray, and white.

CONTRAST FILTERS

The contrast of a photographed object can be either increased or decreased by the use of contrast filters. A filter will transmit light of its own color and absorb dissimiliar colored light. Thus:

Additive Primaries

	Transmits	Absorbs
red filter	*red*	*green and blue*
green filter	*green*	*red and blue*
blue filter	*blue*	*red and green*

Secondary Primaries

magenta filter	*magenta (red and blue)*	*green*
yellow filter	*yellow (red and green)*	*blue*
cyan filter	*cyan (blue and green)*	*yellow*

On the next pages a color chart has been photographed using different filters. The reader can observe the changes in contrast (the increase or decrease in tone of the black and white rendition of the filtered color).

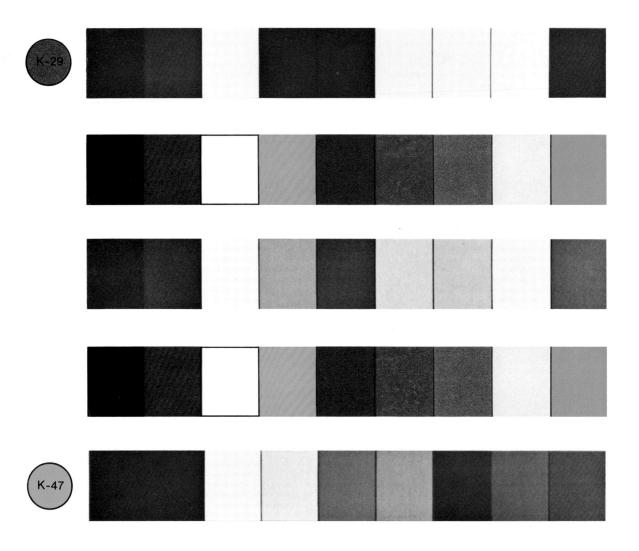

THE TONE SCALE

From the previous discussion, all tones relative to and based upon their reflectance characteristic can now be defined. It can also be demonstrated graphically where the reflectances are in relationship to each other.

It is customary to divide the gray scale into segments based upon the exposure sequence, each step being proportional to one stop more or one stop less exposure than the preceding or succeeding tone.

It is important to remember that perception of tones is not based on this progression; rather, the very low tones or the very high tones are not differentiated with the same ease as the midtones. The perceived midpoint of the scale in actuality reflects just 18 percent of the reflected light; however, for purposes of graphic demonstration, this tonality is placed in the center of the scale. The range of the low tones is therefore expanded, while that of the high tones is compressed.

The tone scale is divided into nine steps, each step having an analogous definition with its opposing tone. page 26

Once the scale is divided (segment B), the geometrical average of the parameters of the segregated tone is used to describe the entire segment. This portion of the scale is called a "Tone," and it is numbered 1 through 9. Ansel Adams, in the first edition of his *Basic Photo Series,* called these portions of the scale Zones and used the term to apply to the negative (exposure page 177 scale of the film) as well as the print. In the current editions of his work, he uses the term to apply only to the exposure scale of the film. As currently defined, the term relates to the entire area encompassed by the boundaries imposed by the divisions. However, in practice, one rarely speaks of the general area, nor does one produce exposure based on an area within the boundaries of the Zone; rather, one is more specific, and the reference and exposure are usually based on the mean imposed by the borders produced by the segmentation of the scale. Therefore, the term Tone is substituted here, which in the context of this text limits the reference to the midpoint of each segment.

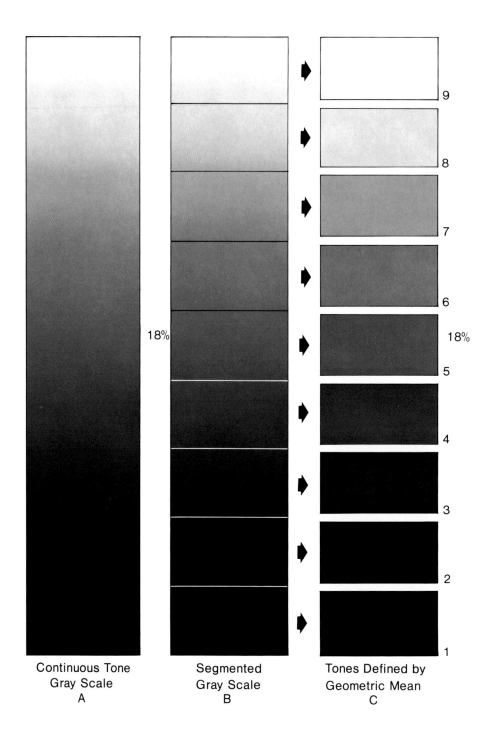

Continuous Tone
Gray Scale
A

Segmented
Gray Scale
B

Tones Defined by
Geometric Mean
C

Adams segments the tonal scale into 10 groups of tone. The extra area comes into being by dividing Tone 1 into two portions (Zone 0 and Zone 1). With modern negative materials, this separation is impractical* (certainly it is with 35 mm and roll films). In addition, with the calibration process, which is based on visually determining low tonal differences, the nine-step scale is easier to reproduce consistently.

In the nine-step scale Tone 5 (18-percent reflectance gray) is page 23 in the middle of the progression. Therefore, it becomes easier for the photographer to grasp the concept of tone, because each tone has a reciprocal definition. However, it should be understood that the resultant print quality is not degraded by substituting a nine-step scale for one of 10. The tonal range remains the same.

*Impractical but not impossible.

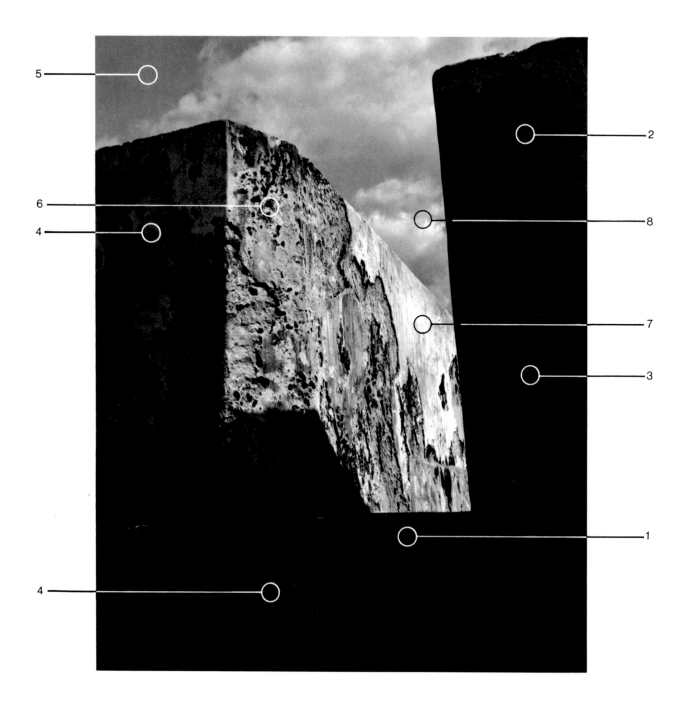

DEFINITION OF TONES*

Tone 1	As black as the maximum deposit of silver of which the photographic paper is capable.
Tone 9	The reciprocal of Tone 1 —paper base white.

Tone 2	Reflects twice the amount of incident light as Tone 1. It is the first low tone that is not black.
Tone 8	Reflects one half the amount of incident light as Tone 9. It is the last area to exhibit any tone.

Tone 3	Reflects twice the amount of incident light as Tone 2. It is the first low tone in which shadow detail and texture appear.
Tone 7	Reflects one half the amount of incident light as Tone 8. It is the high tone where highlight texture and detail are recorded.

Tone 4 **Tone 6**	The midtones where the greatest amount of information is recorded.

Tone 5	A midtone by definition (18 percent reflectance gray).

*Each tone reflects one half or twice the amount of incident light as its adjacent tone; for example, Tone 6 reflects twice the light of Tone 5 and one half the light of Tone 7.

Tones can be further categorized by dividing them into groups of three:

The low tones —Tones 1–3
The midtones —Tones 5–6
The high tones—Tones 7–9

NOTATIONS

The study of tone reproduction must be preceded by an analysis of the mental procedure wherein what was seen, felt, perceived (all subjective inferences), are translated into the recording process (an objective connotation). The analysis includes the dysfunction of the perceptual visual mechanism—specifically, how it relates to size, shape, and the tone of the objects viewed. By its two-dimensional monochromatic nature, the photograph can never duplicate the three-dimensional multicolored world, nor is it necessary for it to do so. What is of the utmost importance, however, is that the photograph contain the essence of the photographer's perception of what was seen and, therefore, translated. Once this concept is fully realized and explored, the photographer will be able to exploit the inherent differences between the subjective and literal—of what is seen compared to what is translated.

From the preliminary discussion of tonality it is obvious that perception is intrinsically intertwined with a knowledge of the reality of tone. It is the full understanding of the subjective bias of tone perception that allows people to photograph creatively. It is the translation process—from what is perceived to what is recorded—that is the basis of creative photography.

Examine the photographs in this book and others,* with a goal of categorizing and defining the tones in the image, and analyzing these tones as they operate in support of each other. You should also be keenly aware of how a white area makes a black area appear darker, how the midtones convey information, and the like. This exercise should extend to your everyday experiences as well. You should be constantly aware of tone and should identify tone as it exists in its natural surroundings. This is the beginning of learning how to see photographically.

"I'm always mentally photographing everything as practice."

Minor White

*In the bibliography there is listed a selection of books which underscore the possibilities of tone quality and its affect on the print. However, beautifully printed as they are, they cannot substitute for the actual print. The reader is advised to search out those museums that exhibit photographs and to spend time in their study.

2

Tone Reproduction/Exposure

Ansel met me at the train yesterday. This morning
in his class at the old California School of Fine Arts
the whole muddled business of exposure and
development fell into place. This afternoon I
started to teach his Zone System. Ansel did not
know it, but his gift of photographic craftsmanship
was the celebration of a birthday.

San Francisco, 9 July 1946

Minor White
Mirrors, Messages, Manifestations
Aperture Monograph, Copyright 1969

CHAPTER CONTENTS

ILLUMINATION/PERCEPTION

The study of the perception of tonality is interwoven with an analysis of light. Under normal illumination (and with experience), the photographer can easily identify tone.* The operative phrase, however, is "normal illumination," which when fully understood gives rise to a whole host of meanings. When, if ever, is "normal illumination" normal? Is it out of doors or in a well-lighted room? The visual mechanism is constantly striving to make every scene appear normal, regardless of the amount of illumination. Areas are

page 21

*Easily—just as long as there exists a standard reference point. In a photographic print, this would be either a pure black or a paper base white. It is extremely difficult to identify tone without these points of reference.

termed bright or dark (subjective terms) in reference to precon-
ceived ideas of what the illumination should be. One example will
suffice. On a cloudy day, the illumination level out of doors would
be at least 50 times greater than that in a well-lighted room, yet the
latter would be categorized as bright, the former as dark. The eye
cannot translate illumination levels into photographic exposure, nor
can it be trained to do so.

INCIDENT LIGHT/MEASUREMENT

Incident light is the light illuminating a scene. It is a measure of the
quantity of light. A photographic incident-light meter operates
much like the vision mechanism. The iris regulates the amount of
light (exposure) that causes the rods and cones of the retina to
react. Similarly, the incident-light meter will read out/indicate (in
terms of aperture and shutter speed) an exposure that will (when
related to the film's sensitivity) produce a negative/print that will
adequately record the scene in noninterpretive, perfunctory terms.

REFLECTED LIGHT/MEASUREMENT

Reflected light is the light reflected from an object to the visual
mechanism or to the camera. As has been discussed, all objects page 23
reflect and absorb light, which yields tonality. If the differing tones/
reflectances can be analyzed as to the intensity of light reflecting
from an object's surface, an exposure can easily be determined
that would now include the actual measurement of light (as
computed from the intensity of the light reflecting from the subject)
as well as the inherent tone/reflectance of the subject. When
several tones are measured within a scene, a ratio can be
established between their reflectances (low, middle, and high
tones) and plotted to allow for the purposeful manipulation of the
negative/print that will satisfy the creative intent of the photogra-
pher. The Zone System was derived from the systematic and
creative use of the reflected-light meter.

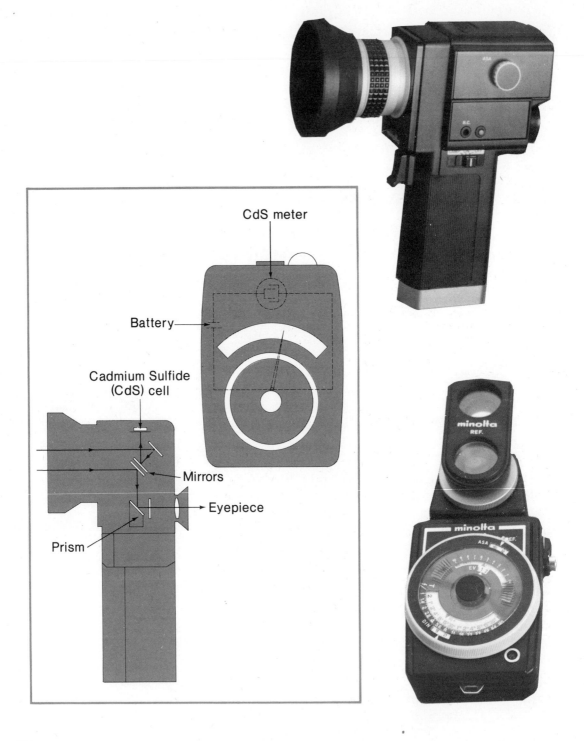

CdS meter

Battery

Cadmium Sulfide
(CdS) cell

Mirrors

Eyepiece

Prism

34

PHOTOELECTRIC PHOTOMETER/MECHANICS AND DESIGN

The first modern photoelectric meters* were introduced in the 1930s. They used a selenium cell as their primary light detector. This photovoltaic cell was capable of producing voltage (electricity) from light in the same manner as the eye perceives illumination. However, these instruments were unreliable at extreme light levels (high and low) and were eventually replaced by meters employing a cadmium sulfide photoconductive cell, which changes its conductivity relative to the amount of light that causes it to react. A battery supplies the energy needed to power an indicator needle. These meters are not without inherent limitations, as the cells used do not respond to quickly changing light levels, for example, from high to low. The cells are "blinded" by intense illumination and are slow to react to a lowered light intensity. Furthermore, their response to energy radiated at differing wavelengths (color) is limited. Current technology has now produced a new conductor, the silicon photoconductive cell, which has overcome these difficulties.

The Minolta meters illustrated in the following pages use the silicon photoconductive cell as their light receptor.

The most important quality of a photometer is its consistency—whether it will give proper exposure determinates under all illumination conditions. Meters, like camera shutters, should be inspected and recalibrated at set intervals.

*The more common nomenclature has been carefully avoided, and the photometer will not be referred to as an exposure meter. Implicit in the latter term is that exposure is determined by the device rather than by the photographer. It is in fact this difference in terminology that points out the fundamental error that exposure is "automatic" and fixed—without artistic control.

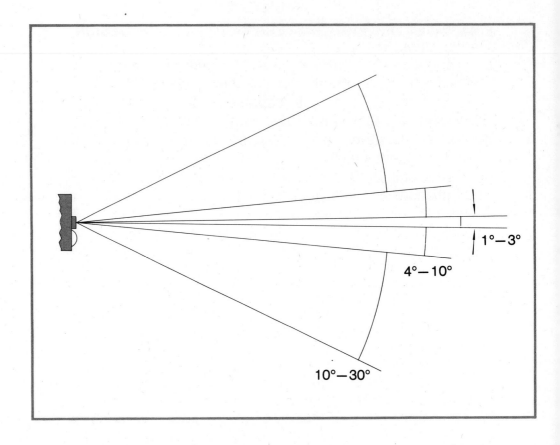

1°–3°

4°–10°

10°–30°

THE REFLECTED-LIGHT METER

Generally, reflected-light meters are divided into three categories, each distinguished by the field of view it encompasses:

> Wide field — 10°–30°
> Narrow field — 4°–10°
> Spot meter — 1°– 3°

These are arbitrary divisions and are not in accord with manufacturers' specifications. However, any meter that subtends an arc of 10° or more usually cannot be used to measure tones/reflectances from the camera position.

The angle of acceptance of through-the-lens meters, which is found on nearly all modern miniature cameras, is dependent on the focal length of the lens used. A 100 mm lens used on a 35 mm camera, for example, subtends an arc of 19° measured diagonally, which would hardly make it selective enough to assess tonality from the normal camera-to-subject distance.

The difficulty of measuring tones with a wide- or narrow-field meter can usually be overcome by moving the camera/meter closer to the object, thereby restricting its field of view to one key tone. Other methods of determining tone, using meters other than those which measure a very small area, are discussed in future chapters.

page 232

THE SPOT METER

The Minolta Spot Meter combines a high degree of accuracy and quality. Focusing on the subject tone, the viewer encompasses a 9° field, with a central circle having an angle of acceptance of 1°. The outermost scale contains aperture indications, while the inner scale indicates shutter speeds. When the meter is activated, the time scale moves in relation to the intensity of the illumination and the tone/reflectance being measured. The scale stops moving when the proper determinates have been reached. For diagrammatic purposes, the illustrations in this book will abstract the scales and viewfinder indices of the Minolta Spot Meter.

Variable-Angle Meters. These instruments are essentially wide-angle meters, but with an accessory baffle placed on the light receptor, the meter's field of view becomes selective. The Minolta Auto Meter II is of this type. The viewfinder/baffle limits the field of view to 10°. For most photographic applications, this angle of acceptance is entirely adequate; however, for precise measurement of tonality, the meter has to be moved close to the subject.

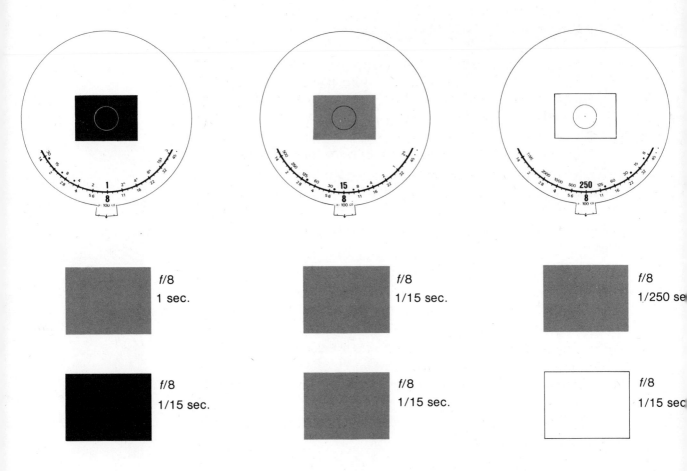

	f/8 1 sec.		f/8 1/15 sec.		f/8 1/250 se
	f/8 1/15 sec.		f/8 1/15 sec.		f/8 1/15 sec

By restricting the photometer's field of view to one tone, the exposure indication will allow the photographer to purposefully manipulate exposure for that which he desires.

OPERATION OF THE METER

Photometers, regardless of type (spot or wide-angle) and mechanical differences, operate in a similar manner. They average all tonalities in their field of view and indicate/read out an exposure that would be the geometric mean between the high and low tones being measured. Specifically, if the meter's angle of acceptance were restricted to one tone, it would indicate an exposure that would produce a negative/print having a pure midtone, regardless of the tonality measured. This midtone is variously referred to as neutral gray, 18 percent reflectance gray, or middle gray. Again, it is the geometric midpoint between black and white—an average of each.

page 23

The photometer's field of view is restricted to each of three separate tones.

In the first example, a long exposure (low reflectance) is indicated. This exposure would produce a negative/print whose density would be middle gray. The meter has averaged all tones in its field (in this case only one tone) and has read out/indicated an exposure that would yield 18 percent reflectance gray.

In the third example, a short exposure (high reflectance) is indicated. Again, because the meter translates everything in its field of view to 18 percent reflectance gray, the resultant negative would produce a print having the same tone as the first example.

The middle segment shows a midtone. Here the exposure determinates would produce the correct exposure, resulting in a negative/print with the tone reproduced as measured.

PHOTOMETER/TONE REPRODUCTION

We have seen that a photometer will indicate, in terms of aperture and shutter speed, the average of all tonalities in its field of view. By restricting this angle of acceptance (limiting it to one important and representative tone/reflectance), and with the knowledge that the resultant exposure will produce a middle gray, we can manipulate the key tone/reflectance to what is either seen or felt by the photographer.

Once the key tone is selected, its measurement in terms of exposure coordinates will produce middle gray. By increasing the shutter speed or decreasing the aperture,* thereby reducing the light striking the film, the photographer can match the measured tone with what is understood to be the correct tone, either literally or creatively.

For example, if a measurement were taken of a dark tone/reflectance and the photographer felt this tone should reproduce as a Tone 3 value in the print, the amount of exposure would be decreased by either stopping the lens down or by increasing the shutter speed. The amount of this decrease in exposure is dependent on the photographer's understanding of the tone scale. Because each tone represents one unit of exposure, the reduction would be two units. This would be accomplished by either stopping the lens down two stops, or increasing the shutter speed by a factor of 2 (4 ×), or a combination thereof.

If a Tone 4 print value were desired, the exposure would be reduced from the indicated readout by one unit of exposure, either by decreasing the aperture one full stop or by doubling the shutter speed.

If a Tone 2 print value were desired, the exposure would be reduced from the indicated readout by three units of exposure, or by an increase in shutter speed by a factor of 3 (8 ×), or by a combination of the two.

page 59 *Low tones are not greatly influenced by development and are mostly dependent on exposure. Practice dictates that the shadow (low tones) areas of a scene are measured, with the resultant exposure based on this reading.

40

1/15 sec.

1/2 sec.

1/30 sec.

1/8 sec.

1/125 sec.

1/60 sec.

1/4 sec.

1 sec.

1/8 sec.

41

The photograph on this page is an example of using the exposure indication provided by the meter—average, while the photograph on page 43 is an example of using an exposure reading taken from the key low tone at a given development to match the perceived high tone.

EXPOSURE TABLE

Tone	1	2	3	4	5	6	7	8	9	Aperture	Speed	Factor*	Exposure	Development
a			1/15		1/60									
	Meter indicates 1/15 sec. Texture desired. Tone 3 Placement.													
b¹	1/4			1/30										
	Meter indicates 1/4 sec. at f/5.6 — Tone 2 Placement.													
b²	f/5.6				f/16									
	As in b¹													
1														
2														
3														
4														
5														
6														
7														
8														
9														
10														

*Factor = Bellows
Reciprocity
Filter

Ansel Adams calls this manipulation of low-tone values "placement," a term that correctly defines the concept. One "places" the key tone to match a preconceived/perceived tone in relation to the tone scale. The term is used throughout this text.

You should study the mechanical aspect of tone placement so that you have a facility with the actual manipulaton of the meter.

Reproduced here is an example of how exposure information may be readily compiled. Answer questions 1 through 10 after studying Examples A through C.

A study of the table will reveal the following:

1. Exposure takes place at Tone 5.
2. It is easier to think of doubling speed rather than decreasing aperture, as in example b2.
3. Tones are not "placed" on Tone 1.*

QUESTIONS

Subject	Expose for	Indicated Shutter Speed (in sec.)
1. Deep foliage in shade	Texture	1/2
2. Bark of a tree	Information	1/15
3. Rocks in shade	Texture	1/30
4. Deep shadow area	No texture	1/2
5. White house in deep shade	Information	1/60
6. Red bricks in shade		1/15
7. Caucasian skin in shade		1/30
8. Dark leaves in diffuse sunlight		1/30
9. Black roof shingles in shade		1/15
10. Weathered wood in shade		1/60

*Exposure is based on important shadow detail—that detail that is to be preserved in the print. Lower tone/reflectances will naturally record deeper tones (black).

EXPOSURE TABLE

Tone	1	2	3	4	5	6	7	8	9	Aperture	Speed	Factor*	Exposure	Development
1			1/2		1/8									
2				1/15	1/30									
3			1/30		1/125									
4		1/2			1/15									
5				1/60	1/125									
6			1/15		1/60									
7				1/30	1/60									
8			1/30		1/125									
9			1/15		1/60									
10			1/60		1/125									

*Factor = Bellows
Reciprocity
Filter

ANSWERS

Tones	Indicated Shutter Speed (in sec.)
1. Texture is defined as Tone 3	1/8
2. Information is greatest in midtones	1/30
3. Texture is defined as Tone 3	1/125
4. Absence of texture and detail is defined as Tone 2	1/15
5. Information is desired	1/125
6. Has the appearance of a deep tone	1/60
7. Usually rendered on Tone 4	1/60
8. Information and/or texture, Tone 3 or Tone 4	1/125–1/60
9. Detail texture—information, Tone 3 or Tone 4	1/60–1/30
10. Information, Tone 4	1/125

By matching your answers to those supplied, you will begin to understand the implication of the creative aspect of exposure. If you feel that your answers more nearly coincide with your perception of tone, then follow your own dictates, so long as the concepts of the process are fully understood.

On page 30, it was suggested that you look at photographic prints to observe how tonalities complement each other. Continue this practice, substituting arbitrary meter indications and "placing" the exposure determinates called for by these meter indications.

INTRODUCTION TO THE CALIBRATION PROCESS

By utilizing the visual calibration process, you will unite such seemingly disparate elements as camera, lens, meter, film, enlarger, and chemistry into a unified whole. The sequence has the effect of a chain, each link being interdependent with the next.

The objective of tone reproduction is the ability to produce, with accuracy, any given tone, whether seen or felt. In order to mechanically translate the tone you see/perceive, you must have an understanding of your materials and you must eliminate any variables that would breach the photographic chain.

By calibrating your equipment, you will in effect be photographing, albeit not in the usual sense. By photographing according to established standards, under controlled circumstances, you will be manipulating meter, lens, and processing technique.

This testing/calibration is *vital* as an introduction to the mechanical process and, more importantly, to the full understanding and potential of tone reproduction. A companion text, *The Calibration Manual,* is being published concurrently with this volume. Special care was taken to reproduce tonalities with great accuracy in order that you may compare the results of your tests with those standards exhibited in the *Manual.* It is an invaluable adjunct to this book, and is heartily recommended.

SUPPLIES

Purchase the following supplies and use them for all calibrations:

1. Negative Materials
 a. Film. 35 mm: 1 carton (20 cartridges) of 20-exposure reels; 120 roll film: 20 rolls; sheet film: 1 box of 100 sheets.
 b. Developer. Any developer that can be used primarily without replenishment (a one-shot developer) such as Kodak HC-110 or Edwal FG-7.
 c. Stop Bath. Kodak Indicator Stop Bath or equivalent.
 d. Fixer. Kodak Rapid-Fix or equivalent.
 e. Clearing Agent. Edwal 4 & 1 or equivalent.
 f. Wetting Agent. Kodak Photo-Flo or equivalent.

2. Paper Materials
 a. Paper. 1 box of 100 sheets of 8″ × 10″ Kodak Polycontrast F-Surface, double-weight. (Do not use either Polycontrast Rapid or the resin-coated [RC] version of this paper.)
 b. Developer. Any neutral or cold-toned prepared developer, such as Ethol LPD, Kodak Ektaflo, or Edwal Super-111.
 c. Stop Bath. Kodak Indicator Stop Bath or equivalent.
 d. Fixer. Heico NH-5 or equivalent.
 e. Clearing Bath. Edwal 4 & 1, Heico Perma-Wash, or equivalent.
 f. Toner. Kodak Selenium Toner.

3. Testing Materials
 a. One package of Kodak 18-Percent Reflectance Gray Cards.
 b. Two 500-watt tungsten floodlights in reflectors or equivalent (blue, 4800 K).
 c. Rheostat (optional).
 d. Kodak Polycontrast #3 Filter.
 e. Kodak Wratten Series #90 (monochromatic viewing) Filter.
 f. A 75- and/or a 150-watt enlarging bulb (preferably both).

page 193

Kodak Polycontrast Paper. The use of Kodak Polycontrast Paper is recommended for the following reasons:

1. The concept of Calibration 4a is dependent on the use of a variable-contrast paper.
2. The tones reproduced in *The Calibration Manual,* which you can use to compare your tests, use Kodak Polycontrast Paper as their standard.
3. Kodak paper is readily available and nearly always consistent.

Throughout the chapters dealing with processing materials and techniques, certain equipment is discussed and illustrated. This equipment, in nearly all cases, is durable and functional. You should be aware of the continuing "improvements" in design and manufacture of equipment (both good and bad), analyze your needs, and purchase those items best suited for your purposes.

As with any equipment, purchase the best you can afford. Products of quality manufacture last indefinitely, and while their initial cost is high, the savings realized over the years will surely outweigh their initial cost differences.

PROCEDURES FOR ALL TESTS/ALL FORMATS

1. Keep a log of your accomplishments. Note exactly what was done and the results, even if the tests performed were not acceptable.
2. Keep all solutions at a constant temperature of 20 C or 21 C (68 F or 70 F).

page 53

3. Before beginning any calibration, test for safelight fog.
4. Thoroughly clean camera, camera lens, enlarger, and enlarging lens.
5. Have camera speeds checked and adjusted if necessary.
6. Establish a system for viewing test samples. A 100-watt bulb without a reflector at a distance of four feet from the print is adequate. All tests/prints are viewed by this illumination.

page 149
page 208

7. Before beginning these calibrations, familarize yourself with basic darkroom procedures.

SAFELIGHT ILLUMINATION TEST 1

Place a full sheet of 8″ × 10″ photographic paper on your enlarging easel. Place a piece of cardboard, approximately three-inches square, over the paper and turn on your safelight for two minutes. Process the print in complete darkness. Repeat the above; this time, however, process the print with the safelight on.

If in either test the paper shows the outline of the cardboard, evidenced by a lighter tone where the cardboard was in contact with the paper, your safelight is causing fog.

Remedies. Safelight fog can be caused by any one or a combination of factors, including the following:

1. Use of a safelight filter not specified for that particular paper. A Kodak OC Safelight Filter (light amber) is specified for Polycontrast Paper.
2. The filter is old, faded, or cracked.
3. The light bulb behind the filter is of a higher wattage than recommended.
4. The safelight is too close to the paper surface.

A safelight test adapted from the standards set forth in the American National Standards Institute, (ANSI) publication *PH2.22-1971* is included in this text.

page 167

CALIBRATION 1: STANDARD PRINTING TIME

The following chapters describe how to produce negatives of varying densities through exposure and/or development. In order to correctly analyze your results, you must project the negatives and evaluate the resultant tones/prints. In order for your results to be valid, you must establish a nonvariable standard printing time.

The first calibration begins with the establishment of a fixed light source, the output of which will remain unchanged for the duration of the tests. Therefore, any variation in tone that might be produced could only be caused by exposure and/or development.

The enlarger is the obvious as well as the ideal source for this standardization. It is perhaps better suited for these calibrations than a densitometer—a device used for analyzing negative densities—because the characteristics peculiar to your enlarger will influence the tests. These characteristics will of course be carried over to all succeeding photographic uses.

page 105
page 183

PROCEDURE

1. Raise the enlarger head to a height that will produce, without cropping, an enlargement having an approximate diagonal measurement of eight inches (regardless of negative size). Mark this height on the enlarger support. All tests will be made at this elevation.

page 189

2. Set the lens diaphragm two stops down from its maximum aperture.

3. Place a processed but unexposed film in the negative carrier. This negative will have no density except for its film base + fog level. It is essential that the film be thoroughly processed according to the following directions:

page 97

 a. Develop in HC-110 (dilution 1:9) or FG-7 for three quarters of the manufacturer's recommended time.

page 147
page 146

 b. Stop bath for 30 seconds.

page 146

 c. Hypo for four minutes.

pages 147,
151

 d. Wash thoroughly (at least a half hour).

 e. Dry film.

page 151

4. Expose a series of 4″ × 5″ sheets of Kodak Polycontrast F-Surface Double-Weight Paper without a filter* in the following manner:
 a. Cover half of the paper with a piece of cardboard. Expose the uncovered half for five seconds. Uncover the unexposed half and expose the entire sheet of paper for eight seconds.
 b. Using sheets of 4″ × 5″ unexposed paper, repeat Step 3 above, giving progressively greater exposure in two-second intervals, that is, 10 plus 5, 12 plus 5, 14 plus 5, and 16 plus 5 seconds.
 c. Process all five test samples in your developer for 90 seconds. (Do not vary this time: stop bath for 30 seconds; fixing bath for four minutes. Wash and dry according to manufacturer's directions.)

You cannot evaluate the results of your tests until your prints are thoroughly dry.

Evaluation. The correct sample is the one that shows no separation between the heavily exposed paper and the timed half. The correct time should be approximatley 12 seconds, which represents the minimum printing time needed to produce pure black with the enlarging light passing through unexposed film. This is your standard, which will be used for all the ensuing calibrations.

Remedies. If your enlarging time is greater or less than the parameters set forth (8 to 16 seconds), there are three remedies available to you.

1. Increase or decrease the lens aperture, but do not set the diaphragm between lens stops. Use whole apertures.
2. Change the enlarging bulb. Enlarging bulbs come in two wattages, 75 and 150—a difference of one full lens stop.
3. Use a rheostat, which decreases the light output while maintaining the lens aperture.

page 193

*Polycontrast Paper exposed without a filter is equivalent to a grade #2 paper.

page 175

Notes. In other texts dealing with this calibration, two additional procedures are discussed, neither of which is recommended.

In the first one, you are instructed to set the timer at two seconds, then to cover the enlarging paper with cardboard, and to move the board a half inch every two seconds for the entire width of the paper. This method produces a tonal scale with the area that first produces black, called the standard printing time. However, this presupposes that the timer used is accurate,* which usually is not the case. A \pm 10-percent variation, which is not unusual, will be multiplied by the number of times the paper was moved. So by the time 14 seconds of exposure is given, the variance could be as much as or greater than \pm 2 seconds.

In the second procedure, whole sheets of paper are exposed for the marked time and compared to a standard sample of maximum black. The test sample and the standard are then placed in contact with each other and compared. However, the edge of the white paper base of the sample interrupts the flow of tones, thereby making the comparison unduly difficult.

Summary. The enlarger is now being used as a testing and evaluation medium. By placing differing negative densities in its light path, you can produce prints whose tones/reflectances are exactly proportional to the exposure and development they have been given.

Several tests have been conducted comparing the results of the calibration method with that of a densitometer. In no case did the results differ by more than five percent. This difference would hardly be noticed in direct test comparisons and would, for all practical purposes, have no effect in reproducing predetermined (visualized) tones.

page 191 *This caution applies to mechanical timers, even though they are electrically driven. The caution does not apply to the new electronic timers now being manufactured.

3

Tone Reproduction/Development

... the expression of what one feels should be set forth in terms of simple devotion to the medium—a statement of the utmost clarity and perfection possible under the conditions of creation and production. That will explain why I have no patience with unnecessary complications of technique or presentation.... I use the legitimate controls of the medium only to augment the *photographic* effect. Purism, in the sense of rigid abstention from any control, is ridiculous; the logical controls of exposure, development and printing are essential in the revelation of photographic qualities.

Ansel Adams
"A Personal Credo"
American Annual of Photography
Vol. 58, 1944, pages 7–16

CHAPTER CONTENTS

THE TONE SCALE

In Chapter 2, the concern was with the creative placement of low values based upon the use of a reflected-light meter, together with an attendant understanding of the relationship of tones to each other as graphically represented by the gray scale. Exposure was determined by the placement of low values, and through manipulation of the photometer the meter's indication (neutral gray) was translated into what was either seen or felt. The analysis now turns to the high values of the gray scale and a study of the purposeful manipulation of the high tones/reflectances.

The low tones/reflectances are a function of exposure. The highlight areas are a function of exposure and development. This is equivalent to the adage: "Expose for the shadows and develop for the highlights." The development process controls the contrast of the negative independent of the amount of exposure the negative has received. Increasing development (and thereby increasing contrast) makes negative densities greater; decreasing develop-ment (and thereby decreasing contrast) makes negative densities less—without any appreciable change in density in the low tones.

By the intelligent use of the reflected-light photometer, you can determine where the high tones/reflectances would be in relationship to the placement of the low tones/reflectances, and you can either accept the result, based upon your interpretation of the scene, or modify the result by a change in development. The goal is to produce a negative with the various tones/reflectances of the scene photographed in their proper relationship. If the photographer wants to alter an original perception, different contrast papers and/or developers can be utilized. However, first impressions, if they are well conceived, planned, and properly executed, are invariably incisive; resorting to other techniques to overcome flawed translation of tones/reflectances is rarely suc-cessful.

This is not meant to imply that the utilization of darkroom technique to alter the original concept is unacceptable. However, it is unlikely that a fine print can be produced from a poorly or improperly executed negative. With few exceptions, the prints that

pages 69–71

High Tones	High Tones	High Tones
	Middle Tones	Middle Tones
Middle Tones	Low Tones	Low Tones
Low Tones		

Development Contraction

Normal Development

Development Expansions

have the most meaning for me and possess the most brilliant tonal quality were printed on normal (grade #2) or equivalent paper without manipulation occurring after development of negative.* Those negatives/prints that were of inferior quality resulted from a lack of vision rather than a lack of technique. When an artist has both his vision and technique under control, the results are often greater than the sum of their parts.

To attempt to change the vision that prompted the creation and execution of the photograph rarely results in an image of quality—both from a creative and a technical viewpoint. Print quality confirms the thesis that good vision and good technique are indivisible.

> I start with no preconceived idea—discovery excites me to focus then rediscovery through the lens—final form of presentation seen on ground glass, the finished print pre-visioned complete in every detail of texture, movement, proportion, *before exposure*—the shutter's release automatically and finally fixes my conception, allowing no after manipulation—the ultimate end of the print is but a duplication of all that I saw and felt through my camera.

> Edward Weston

*Manipulation does occur, however, in the exposure and development of the negative. Also, the use of darkroom techniques can be anticipated during exposure and development of the negative. The photographer can expose and develop film with a special paper or developer in mind.

EXPOSURE TABLE

Tone	1	2	3	4	5	6	7	8	9	Aperture	Speed	Factor*	Exposure	Development
1														
2		1/15	1/15		1/60		1/250							Normal
3					1/125	1/250→								Normal +1 (Tone)
4				1/15	1/30		←1/250							Normal −1 (Tone)
5														
6														
7														
8														
9														
10														

*Factor = Bellows
Reciprocity
Filter

MANIPULATION OF CONTRAST THROUGH DEVELOPMENT

Two meter readings are taken:

Low tone = 1/15 sec.
High tone = 1/250 sec.

By placing 1/15 sec. on Tone 3, the high tone (1/250 sec.) will automatically "fall" on Tone 7. The term "fall" is used by Ansel Adams to signify what the high value would be in relationship to the "placed" low value, assuming normal (N) development (normal as measured by a standard development time—Calibration 3).

page 65
page 153

In this example, it is assumed that Tone 7 is the desired high tone, therefore, development would be normal.

A Tone 2 placement is desired. Therefore, the high value would fall on Tone 6. A Tone 7 is, however, desired. In order to achieve this, an increase in development is necessary—specifically, an increase that would render Tone 6 as Tone 7, an increase/expansion of one tone. The symbol would be normal +1 (N +1). If Tone 8 were desired, an increase of two tones, or normal +2, is necessary.

A Tone 4 placement is desired. The high value would now fall on Tone 8. Since a Tone 7 is desired, a decrease/contraction in development is indicated—a decrease of one tone. The symbol would be normal −1, or N −1. If a Tone 6 were desired, a decrease of two tones, or N −2, is necessary.

You can see that the creative placement of low values by exposure is complemented by the creative manipulation of the high values by development.

Some photographers take reality as the sculptors take wood and stone and upon it impose the dominations of their own thought and spirit. Others come before reality more tenderly and a photograph to them is an instrument of love and revelation.

Ansel Adams

The table begun on page 46 can now be completed.

EXPOSURE TABLE

Tone	1	2	3	4	5	6	7	8	9	Aperture	Speed	Factor*	Exposure	Development
1														
2														
3														
4														
5														
6														
7														
8														
9														
10														

NORMAL DEVELOPMENT

Normal development is the development (usually measured as a function of time) needed to render all the tones in the scene photographed so as to appear in the negative/print with their tones/reflectances in the same relationship as they originally occurred, or as they were perceived/translated. Negative density is a function of exposure and development. For the measurement of both the low and high tones/reflectances, determined by the use of the reflected-light meter, to be valid, it is necessary to determine the correct amount of development time needed to produce these densities/reflectances. This is the subject and purpose of Calibration 3.

page 153

EXAMPLES

	Deep Tones		High Tones				
	Indicated exposure (in sec.)	Desired tone placement	Indicated exposure (in sec.)	Will fall on tone	Tone desired	Exposure (in sec.)	Development symbol
1.	1/2	3	1/30	7	7	1/8	N
2.	1/15	4	1/125	7	8	1/30	N +1
3.	1/30	3	1/1000	8	7	1/125	N −1
4.	1/2	2	1/125	8	6	1/15	N −2
5.	1/60	4	1/250	6	8	1/125	N +2
6.	1/15	3	1/125		8		
7.	1/30	4	1/125		6		
8.	1/30	4	1/250		7		
9.	1/15	3	1/60		7		
10.	1/60	4	1/125		7		

EXPOSURE TABLE

Tone	1	2	3	4	5	6	7	8	9	Aperture	Speed	Factor*	Exposure	Development
1			1/2		1/8	1/30				f/8	1/8			Normal
2				1/15	1/30		1/125→			f/8	1/30	2	f/8 at 1/15	Normal +1
3			1/30		1/125		←1/1000			f/8	1/125			Normal −1
4		1/2			1/15		←1/125			f/8	1/15			Normal −2
5				1/60	1/125	1/250→		↓		f/8	1/125			Normal +2
6				1/15	1/60					f/8	1/60			
7				1/30	1/60					f/8	1/60			
8				1/30	1/60					f/8	1/60			
9				1/15	1/60					f/8	1/60	2	f/8 at 1/30	
10				1/60	1/125						1/125			

*Factor = Bellows
Reciprocity
Filter

EXPOSURE TABLE

Tone	1	2	3	4	5	6	7	8	9	Aperture	Speed	Factor*	Exposure	Development
1														
2														
3														
4														
5														
6														
7														
8														
9														
10														

*Factor = Bellows
 Reciprocity
 Filter

In time, you will be able to mentally calculate the computations diagrammed in the table at left. However, it is recommended that you keep a record of exposure and development so that any errors in the preparation of the print can be traced to their source.

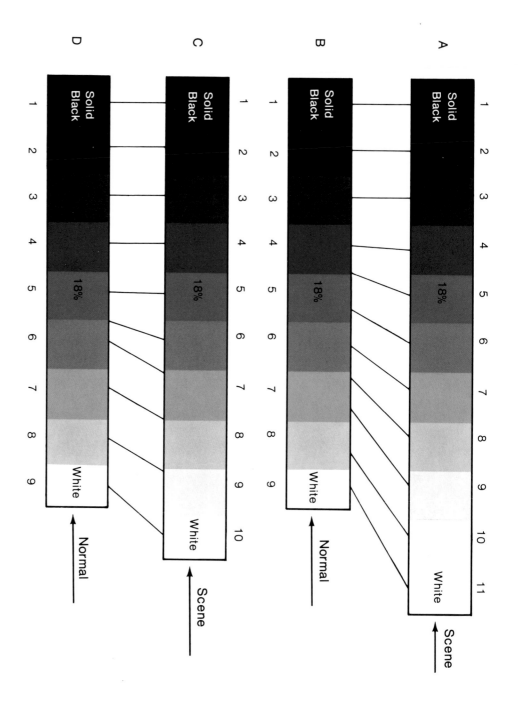

68

DEVELOPMENT CONTRACTIONS/COMPRESSIONS

A decrease in development is required when the high tones/reflectances (Tones 7 through 9) are to be rendered in the print as lower than they originally appeared or were perceived. The methods available to accomplish this effect are either physical (decreasing development time) or chemical (modifying the development formula or substituting a new developer).

Decreasing Development Time. The simplest method is to decrease the amount of time that the film is in the developer, thereby limiting the action/rate of the developer on the high densities. However, a development time of less than four minutes (with an infusion bath) is not recommended, as the developer will not have sufficient time to permeate the emulsion and operate evenly over the entire tonal scale.

page 226

Increasing Dilution of Developer Solution. The developer constituent of any developing formula reduces a fixed amount of silver; once this limit has been reached, the process slows. Decreasing the amount of developer available (by increasing the dilution of the formula) makes the developer solution too weak to develop the high tones to their full potential density.

page 225

Changing Developer Formulas. Soft-working or semi-compensating developer formulas, by their very nature, prohibit the high tones from reaching their potential densities.

page 225

Employing Lower Contrast Paper Grades. By employing a printing paper of lower contrast, an effect nearly similar to that of a decreased development/compression may be obtained.

page 175

Using Contrast Filters.

page 268

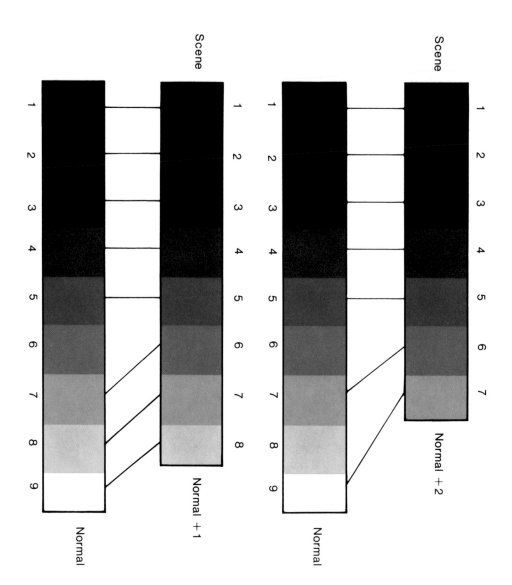

DEVELOPMENT EXPANSIONS

The various procedures employed in the compression of negative densities/reflectances have their counterparts in the expansion of tones.

Increasing Development Time. Increasing development time will increase negative densities (Tones 6 through 8) without an appreciable increase in the density of the low tones/reflectances. However, granularity increases and sharpness decreases.

page 223

Changing the Formula. Using an energetic, or rapid-acting, developer will produce disproportionately high negative densities.

page 194

Employing Higher Paper Grades.* By changing the grade of paper (using grade #3, for example) the effect is somewhat similar to increasing the time of development or changing the formula. However, the separation between the low-density print reflectance will be sacrificed.

page 221

Using Contrast Filters.

page 268

*This does not apply to Kodak Polycontrast Paper.

page 221

ROLL FILM/VARIABLE DEVELOPMENT

It is erroneously assumed by most photographers that the practice of variable development is not applicable to the roll-film/miniature-film user. However, if all the frames of roll film are exposed quickly and under same general light conditions, then one set of meter readings (low and high) is entirely adequate and accurate for entire roll. If, however, the illumination changes, it is a simple procedure to change rolls of film and develop each for the indicated time* (20-exposure rolls of 35 mm film were specified for the calibration process for this reason). Also, with the price of paper increasing, the waste of film more than makes up for the added cost of the paper that would be used to try to achieve an acceptable print from a poorly exposed and developed negative.

If it is impractical to change rolls of film, there are other procedures which, while not assuring negatives of the highest possible quality, will produce, within limits, negatives that are easily printable. These techniques are discussed in the text accompanying Calibration 4a.

pages
231-232

*The 2¼″ × 2¼″ film user can, with cameras of this type, change backs, that is, one back each for normal, normal −, and normal +.

EXPOSURE/SOURCES OF ILLUMINATION

As discussed in Chapter 2, exposure is based on the quantity of
the illumination and the reflectance characteristics of the object
photographed. Outdoor illumination (natural light) can be
categorized by the type of light source illuminating the subject.

page 33

1. Direct sunlight.
2. Diffused sunlight.
 a. Skylight, the light reflected from the sun to the sky, and
 reflected from the sky to the object.
 b. Shade.
3. A combination of direct and diffused sunlight.

A scene that is illuminated by one light source (either direct or
diffused) usually indicates a normal or a normal + development. A
scene that contains both light sources usually indicates a normal or
a normal — development.

TWO LIGHT SOURCES/NORMAL DEVELOPMENT

The direction and intensity of an early-morning sun produced a scene with sharply delineated shadow and highlight values. The deep tone of the house in the background further emphasized the brilliant white reflectance of the fountain in the foreground.

page 21

 An exposure reading was taken of both the underside of the fountain as well as a significant detail of the background (the area above the balcony). The tone/reflectance from underneath the fountain was "placed" on Tone 3. The area above the railing was found to be one full exposure unit more (Tone 4); the highlight "fell" on Tone 8. Therefore, normal development was applied.

page 65

 It is interesting to note that the door frame under the balcony, which has a print value of Tone 5, was perceived at the time of photographing the scene as white, a perfect example of tone constancy. (The perception/knowledge of a white door transcended the actual reflectance.) If the frame had in fact recorded as white, it would have visually disturbed and interfered with the brilliant high tone of the fountain. The door frame was measured and, in relation to the Tone 3, placement fell on Tone 5. The reality of the scene made for a better photograph than the perception of the scene.

page 21

TWO LIGHT SOURCES/DEVELOPMENT CONTRACTION

The building facade is halved by shadow, which has the effect of producing two photographs, each having its own tonal structure. The shadow falling on the left side is a light source in itself, while the side that is unhindered by shadow is illuminated by direct sunlight—the other source of illumination.

If the camera's field were restricted to either side, the exposure and, more importantly, the development, would be quite different than if both halves were (as in this case) contained within the same photograph. If each side were photographed independently, development would have been either normal or normal $+1$. In this photograph, however, development was normal -2. The tonal range produced by two light sources is much greater than if only one source illuminates the object seen.

Usually, the greater the field of view encompassed by the camera, the more the likelihood of the presence of important shadow areas. Inevitably, this would indicate two sources of illumination, which would denote development compression.

ONE LIGHT SOURCE/NORMAL DEVELOPMENT

Where the camera is in close proximity to the subject being photographed, the development indication is usually normal or normal +.

Invariably, there is one light source illuminating the limited field. Further, the various tones/reflectances encompassed by such a photograph do not have the tonal range (from very low to very high) found if the scene were only a part of a much larger vista.

In this example, an "average" reading was taken and exposed for accordingly. The meter was held at camera position and pointed at the leaves. The angle of view of the meter was equivalent to that of the camera and lens. The photometer "averaged" all tonality and indicated an exposure that was the geometric mean between the high and the low. The major tone (that of the leaves) was therefore recorded as Tone 5.

From a sensitometric point of view, however, the leaves were somewhat deeper in tone (Tone 4). One less exposure unit,* and their real tonality would have been duplicated, while at the same time giving more development to the negative would have insured that the white flowers maintained their tone.

*A Tone 4 placement.

TWO LIGHT SOURCES/DEVELOPMENT COMPRESSION

A backlighted subject is essentially composed of two sources of illumination: the powerful light at the rear of the subject being photographed, and the diffuse light illuminating the main body of the object.

The side of the face in "shadow" (diffuse illumination) was read and placed on Tone 4; the side of the face in direct sunlight fell beyond Tone 9. A theoretical normal −3 development was given, with the result that the side illuminated by direct light was reduced to Tone 7, while the shadow side was recorded between page 229 Tones 3 and 4.

The eye perceived the shadow side of the face as Tone 5; however, by placing the reflectance photographically on Tone 4, the feeling of tremendous contrast and brightness (a subjective measure) was maintained.

If the perceived subject had been adhered to, the contrast and sense of brilliant sunlight would have been lost.

ONE LIGHT SOURCE/DEVELOPMENT EXPANSION

This photograph is indicative of how the perception of a scene differs from that of photographic/sensitometric reality.

An examination of the photograph will reveal that there is no significant shadow or low tone/reflectance from which to formulate exposure. Therefore, a gray card (18-percent reflectance)* was placed against the wall opposite the iron gate, establishing a ratio between a known tone/reflectance (the gray card) and the white wall. A difference of two exposure units between them determined that the tone of the wall was equivalent to Tone 7 (Tone 8 was the desired/perceived tone). Further analysis of the scene revealed that light was flowing through a portal that illuminated the far arch (a second light source, but of only secondary importance). Ordinarily, the far arch should have had tone and texture; however, I felt in this instance the strong sense of illumination should be preserved. Consequently, exposure was based on the gray card reading, and development was normal + 1. If a normal or normal − 1 development had been attempted, texture would have been more apparent, but the sensation of illumination would have been sacrificed.

The walls were perceived as white; photographically/sensitometrically, they were light gray. Perception was matched by a manipulation of reality.

*This is not equivalent to an average exposure.

TWO LIGHT SOURCES/DEVELOPMENT COMPRESSION

This is an example of the creative translation from what was seen to what was perceived. The photograph is of an interior space as seen through two openings in the wall. The image was arranged so that the tonal value of the floor corresponded to the tonal value of the walls. They merge, creating/emphasizing the two-dimensional effect, and severely restricting the feeling of perspective.

The key low-tone value (the floor) was placed on Tone 3. The high value fell on Tone 11 (two full exposure units above Tone 9). Development was reduced so that the outer edge of the wall opening fell on Tone 8 without an attendant increase in exposure. page 229 Thus the original Tone 3 placement was reduced to Tone 2. Had a corresponding increase in exposure been given (in order to maintain the Tone 3 placement), the graphic quality of the image would have been minimized.

The compositional aspect of the photograph is enhanced by its tonal quality—each underlies and reinforces the other. The translation process is a mirror of the perception of the scene. The reality of the subject serves the creative intent.

ONE LIGHT SOURCE/REDUCED DEVELOPMENT

This was an intentional departure from reality. Use of enhanced grain (as an element of the photograph) eliminated skin texture, page 111 while an attendant reduction in development reduced contrast. The materials and process emphasized the graphic quality of the image.

Kodak Tri-X Panchromatic Film (miniature camera) was developed in D-23. This combination of film and developer will not page 136 produce a fine-grained image; rather, the two in concert emphasize the grain. To try to suppress the grain inherent in the page 141 faster films is a procedure that is at odds with itself. If you desire a fine-grained image (with detail and texture), then use a fine-grained film and developer combination. Had a fine-grained image been produced in this example, the textural quality of the model's skin would have been in and of itself an element of the image. By enhancing the grain, however, the texture was minimized; by reducing the contrast, the diverging elements of the photograph form a unified whole.

ONE LIGHT SOURCE/INCREASED DEVELOPMENT

The photographer, by choosing (by inclusion) and rejecting (by exclusion) the compositional elements of the subject, can either define the subject (by emphasis) or create an entirely new idea by taking those subject values out of context.

The difficult aspect in photographing a scene such as this is the compositional placement of the strong vertical line. Through the years I have made changes in this photograph, moving the line either slightly to the left or to the right. Needless to say, the movement has a profound effect on the image.

The contrast of the image was increased by development, bringing out the strong but subtle textural quality of the concrete wall. The tactile feeling of the wall combined with the strong geometry of the compositional elements defines, in a sense, the entire photographic process. The photographer selects, while his materials provide delineation that can only be achieved by the process.

NOTATIONS

At the end of Chapter 1, it was suggested that you analyze tonalities as "they operate in support of each other." At this point in the study of tone reproduction, it is advisable that you also look at those same photographs and not only identify the tones but imagine the exposure and attendant development as well. This exercise, when properly applied, will give you a heightened awareness of the process/procedure. It will also point out to the viewer a photographic truth: There is no mystery in the control of the process; rather, it is the sympathetic understanding and knowledge of the craft that allows the photographer to approach the subject not as a victim of circumstance, but as a master of the process.

4

Sensitometry—
The Language of Photography

... but Hurter and Driffield had proved that by no chemical or printing sleight of hand could you change the relation of one tone to another; a dark tone remained inevitably darker than a light one. Emerson had thought you could change the relation at will; it was one of the cornerstones of his argument that photography could be an art. ...

It is strange to us today to comprehend why Emerson, himself scientific in training, did not realize that H&D offered photographers a superb creative control through which they could achieve effects otherwise only accidentally possible. But the fact remains that only one or two photographers realized its importance until Ansel Adams, in 1941, brilliantly translated it into his famous Zone System. ... Adams himself insisted that the Zone System was nothing but applied sensitometry, an aesthetic use of H&D.

Nancy Newhall
P. H. Emerson
Aperture Monograph, Copyright 1975

CHAPTER CONTENTS

SENSITOMETRY

Sensitometry is the branch of physics concerned with how energy (light) affects a receptor (film). It is the scientific discipline in the evaluation of the characteristics of photographic film and paper. Broadly speaking, the scientific aspects of sensitometry have only passing concern to the practicing photographer; however, sensitometry is an invaluable tool as a vehicle for the graphic demonstration of the photographic process.

It is beyond the scope of this text to discuss anything more than how sensitometry can be applied to the fuller understanding of tone reproduction in general and the Zone System in particular. If you desire a greater understanding of the discipline, refer to the bibliography for books that will expand the concepts that have been demonstrated and discussed in this chapter.

LOGARITHMS

It is often confusing to the photographer that the language of sensitometry is expressed in terms of logarithms. Therefore, this mathematical concept is briefly reviewed here—specifically in its relation to the photographic process.

A logarithm is an arithmetic series representing a geometric progression of numbers (2, 4, 8, 16, 32, 64, 128, 256 units of light). The silver deposit on the negative, called density, is always expressed in terms of logarithms. The greater the density, the higher the logarithm—representing a greater ratio between film base and density.

page 97

In terms of graphic demonstration, logarithms take ratios of numbers and condense them, for example, the photographic progression of doubling or halving the amount of light reaching the film. If a graph were to be constructed, making each unit of light represent an area of one inch, then:

Tone 1 = 1"
Tone 2 = 2"
Tone 3 = 4"
Tone 4 = 8"
Tone 5 = 16"
Tone 6 = 32"
Tone 7 = 64"
Tone 8 = 128"
Tone 9 = 256"

Therefore, if a diagram were drawn with each unit represented by 1", the graph containing all nine tones would be 256", or

21' (feet) long. By translating this geometric progression into logarithms, graphs containing the data can be drawn.

DENSITY/TRANSMISSION

The formula for computing density is:

$$D = \log \frac{1}{T}$$

where D = density—the amount of the silver deposit that stops light passing through the film,

and T = transmission—the ratio (percentage) of the amount of light passing through an object (the negative) to the total amount of light that falls upon it.

If transmission = 100% (no silver deposit film base + fog), then

$$D = \log \frac{1}{1.00} \text{ or } D = \log 1.$$

By referring to a logarithm table, you will see that the log of 1 = 0. Therefore, if there is no density,

$$D \log = 0.$$

If transmission = 50%,

$$D = \log \frac{1}{.50} \text{ or } D = \log 2,$$

the log of 2 = 0.3,

$$D \log = 0.3.$$

If transmission = 25%,

$$D = \log \frac{1}{.25} \text{ or } D \log = \log 4,$$

the log of 4 = 0.6,

$$D \log = 0.6.$$

By halving or doubling the transmission, the density is either increased or decreased by 0.3 (an arithmetic progression). A table can be constructed which shows the following:

DENSITY VALUES/TONES

Tone	Transmission	Density
1	100	0.0
2	50	0.3
3	25	0.6
4	12.5	0.9
5	6.25	1.2
6	3.125	1.5
7	1.562	1.8
8	.781	2.1
9	.390	2.4

The table of density values/tones is only a model of a theoretical input (tone/exposure) versus output (density)*—one unit of exposure producing an equal density deposit. As you will see, the actual output is on the order of 60 percent of the input, or for each unit of exposure given, only 60 percent of it will produce density.

page 178

*A straight-line "curve."

page 97

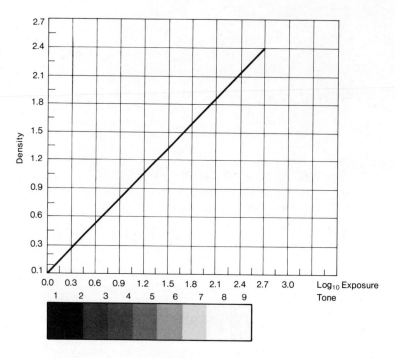

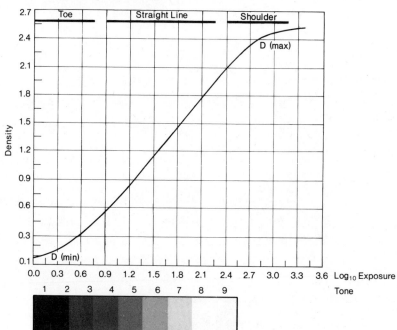

STRAIGHT-LINE "CURVE"

If each increased unit of exposure produced an equivalent increase in density, a graph could be constructed whose representation would be a straight line. A straight line results when density and exposure have a 1:1 (linear) relationship.

S-SHAPED, OR CHARACTERISTIC, CURVE*

A curve is drawn by the actual measurement of negative densities. The curve may be expressed in terms of its components.

The Toe. Beginning at the film base + fog level of the film and increasing in a nonlinear manner (exposure and density do not have a 1:1 relationship)— *the low tones.*

Straight-Line Portion. This is a nearly linear portion where exposure and density increase proportionally— *the midtones.*

The Shoulder. This is an area of nonlinearity. As exposure increases, so does density but not at the same progression— *the high tones.*

D (min). This is the minimum density of a film when optimum exposure and development are given, where a decrease in exposure produces no decrease in density. It is also termed gross fog level (film base + fog).

page 93

D (max). The maximum density generated with increased exposure produces no increase in density.

*Also called the H&D Curve after Hurter and Driffield, who first investigated the relationship of exposure and density. The curve is also (and most properly) called a *D*-log *E* Curve.

97

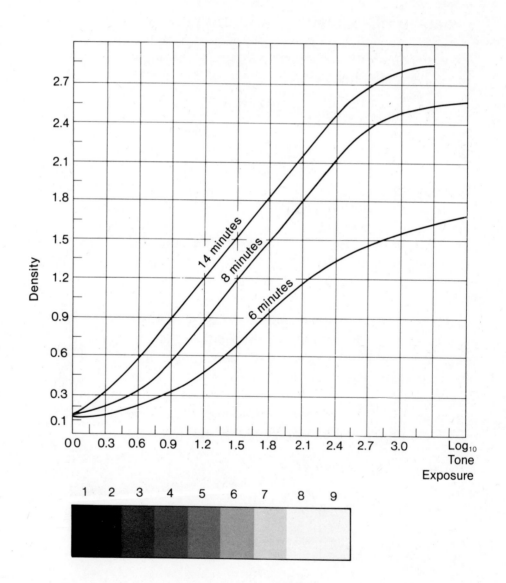

98

ANALYSIS OF THE CHARACTERISTIC CURVE

By plotting the densities (read from a densitometer), the graph page 105 presented on page 60 now takes the form of a characteristic curve. Notice that the low-tone values are not greatly affected by development. The high tones, on the other hand, respond greatly to the development process.

The relative contrast of the negative can be judged by analyzing the midtone section of the characteristic curve. The tones produced in this portion of the curve contain the greatest amount of information and texture and, in effect, give the photographic print its emphasis.

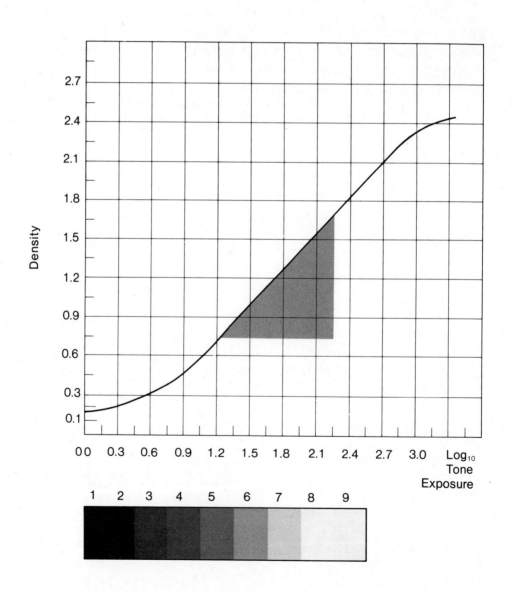

GAMMA

This is a term that is useful to the scientist and the photographic film manufacturer, but is of little or no concern to the practicing photographer. It can be defined, in light of our previous discussion, as the density that would be produced by a given development (normal, N + 1, N − 1, and so on). Gamma is computed by taking any two points on the straight-line portion of the characteristic curve and computing their angle, or slope.

Time-Gamma curves are representations of the amount of time needed to produce a specific gamma for a given film and developer combination. The sensitometrist would say that a film developed for eight minutes in X developer would produce a gamma of .70. The photographer would say that at eight minutes, X film in combination with X developer gives normal development. The sensitometrist would say that X film and X developer at 12 minutes would produce a gamma of 9.5; the photographer, 12 minutes for X film and X developer would produce a normal + 1 development. Time-Gamma graphs are also constructed without regard to the characteristics inherent in enlarger design and function, which further limit the concept from practical consideration.

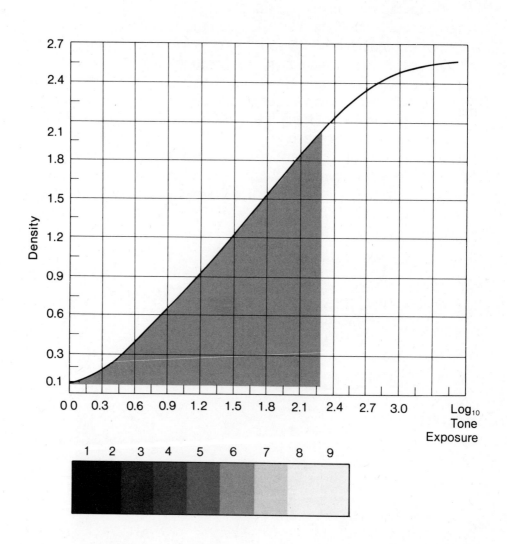

CONTRAST INDEX

In the discussion of gamma, the slope, or angle, of the characteristic curve was defined by taking any two points along the straight-line portion of the curve. This was adequate when film did not have a long toe section and exposure was made primarily on the straight-line portion of the curve. Those negatives were for the most part contact-printed. Today, however, with modern film and condenser enlargers, exposure must take place all along the page 185 curve. As a measurement, gamma has been replaced by the term "Contrast Index" (Kodak) or "Contrast Gradient" (Ilford). It is still defined as the slope of the curve, however; the coordinates are densities of 0.1 and 2.0 above film base $+$ fog level (approximately Tone 2 through Tone 7).

The same objections that were raised to the use of the concept of gamma still apply with the substitution of either Contrast Index or Contrast Gradient.

DENSITOMETER

An instrument that measures negative densities is called a densitometer. This device reads out directly in logarithmic values, so that density curves may be plotted.

The cost of a densitometer, even a relatively inexpensive one, such as the Kodak Model 1A, is several hundred dollars. Therefore, the following is a method you can use to plot your own graphs using your existing equipment. These graphs take into account enlarging and processing techniques.

The vertical gray scale is accurately rendered and represents print reflectances of Polycontrast Paper. The horizontal axis represents units of exposure as well as negative densities from 0 through 2.4.

If you take processed samples and match them against the vertical axis, you can approximate the reflectance of the sample with that of the reproduced tone scale, with a certain degree of accuracy.

Above each tone is its negative density value (determined by a densitometer). This value was determined in the following manner: Calibration 3 (Normal Development Time) was completed; those negatives that produced those tones (now existing as standards) were measured and their densities assigned to the printed tone. This method of comparing the tones you produce to those that are standardized in this book is only valid if all of the tones produced are printed (without variation) at the Standard Printing Time (Calibration 1). Empirically, the results obtained very closely approximate those results that are obtained by densitometer readings.

Negatives are placed within a light path and compared (visually) with a standard incorporated in the device. When the densities of the negative and the standard are the same, the resulting density (in logarithms) is indicated by a scale.

PROCEDURE

page 153

1. After calibration is completed compare your tested samples with those in the *Calibration Manual.*
2. On a blank graph plot the density on the vertical axis against the horizontal axis where exposure has taken place.
3. Draw a curve between the coordinates.
4. If your sample does not match the standard, you should interpolate between the standard densities.

PRACTICAL APPLICATIONS

page 155

In practice it is not necessary to print all nine tones. You need only produce Tones 1, 2, 5, and 8. By following the line drawn between these determinants, the reader will be able to abstract those tones not printed. The production of your own characteristic curves will reinforce and give meaning to the process.

The Calibration Manual contains blank graphs that you can use to record your development process in order to demonstrate film and developer responses to increased or decreased development.

5

Film

It has always been my belief that the true artist, like the true scientist, is a researcher using materials and techniques to dig into the truth and meaning of the world in which he himself lives; and what he creates, or better perhaps, brings back, are the objective results of his explorations.

Paul Strand
Letter to the Editor
Photographic Journal
Volume 103, No. 7, 1963, page 216

CHAPTER CONTENTS

PROPERTIES OF PHOTOGRAPHIC FILM

A discussion of film types and their characteristics should be preceded by an analysis of the constituent parts of the film material.

THE PHOTOGRAPHIC EMULSION

The light-sensitive photographic emulsion is composed of sub-microscopic crystals of silver halide dispersed in gelatin. The crystals are irregular in shape and size, varying from sub-microscopic to a maximum of three to five microns. (A micron is one-millionth part of a meter.) The sensitivity of the crystal is dependent on its size—the larger the crystal, the more sensitive the emulsion.

page 111

The crystals are held in place by gelatin and a colloid—a viscous solution such as glue or albumen. This medium also regulates the size of the crystals formed while increasing the light sensitivity of the crystals by containing by-products that promote increased response to light. The gelatin also forms a coating around the crystals and acts as a barrier, regulating the rate at which the exposed and unexposed crystals react to the developer. The crystals are not pure silver halide—a halide is a compound of two elements, one of which is always halogen—but a mixture of silver halide with small quantities of silver sulfide, colloidal silver, and gelatin.

THE FILM BASE

The photographic emulsion is coated on a film base composed of synthetic resins. This support must meet certain requirements in order to satisfy practical photographic applications.

Although differing demands are placed on the various formats, all film must be transparent and colorless (except where antihalation dyes are used). They must also be dimensionally stable, moisture resistant, and chemically stable (not affected by photographic chemicals).

Roll and 35 mm films must be flexible and thin enough to permit winding and yet be tear-resistant. Sheet films must be thick enough so that they will remain flat and stable under any and all conditions.

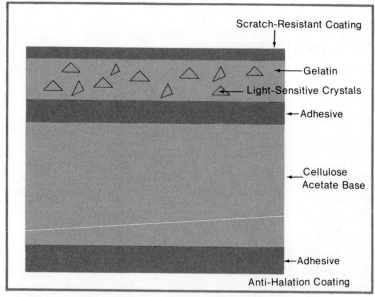

Metallic silver atoms are formed when energy (light) strikes the film. An accumulation of atoms forms a development center, which in turn becomes the latent image (top). A cross section of film, locating the light sensitive crystals (bottom).

THE LATENT IMAGE

There is general agreement that the latent image is composed of metallic silver, although other hypotheses exist as to its formation and, at this writing, are under continued investigation.*

One of the acceptable conjectures regarding the composition of the latent image is called the silver speck theory. It is believed that when light strikes the film, it forces electrons off the halogen atoms in the silver halide crystal. The amount of released electrons is dependent on the quantity of light reacting with the film. If the electron combines with a silver ion, a metallic silver atom is formed. The metallic silver atom in turn "traps" more electrons, which in turn attract more ions, thereby forming silver atoms. When the silver speck is of sufficient size, it becomes a development center, one of many on the surface of the crystal. The speck of silver is said to be the latent image.

GRANULARITY/GRAININESS

Granularity is an objective measurement of the structure of the photographic emulsion. It may be measured on a microdensitometer.

Granularity of the negative is dependent primarily on the emulsion itself, although the basic grain structure may be modified to some extent by the choice of developer. It was previously discussed that in order to make an emulsion more sensitive to light, page 109 the size of the crystal must be increased. It is the fusion of these grains and their size that determines the actual granularity.

The visible grain (graininess) in the print is the result of the granularity of the emulsion. This is a subjective criterion that is influenced by such variables as the degree of enlargement, the actual characteristics of the enlarger, as well as the photographic paper used. It is further qualified by the distance from which the print is viewed and the subject being photographed.

*C. B. Neblette, *Photography, Its Materials and Processes.* New York: Van Nostrand-Reinhold, 1962. Chapter 12 discusses many of these theories.

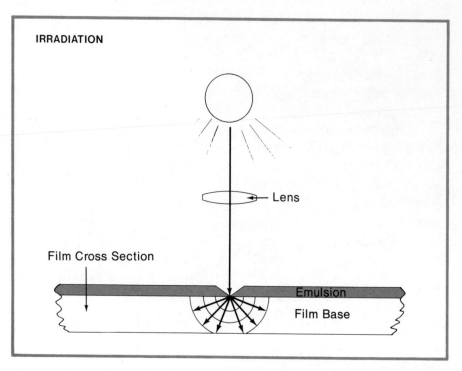

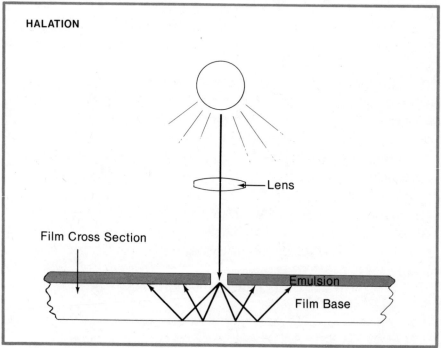

IMAGE DEFINITION

Image definition is the visible sharpness of the photographic image. The term includes the separate but related characteristics of both the emulsion and the various responses that occur when light strikes the film.

Irradiation. This is the scattering of light rays (laterally) within the emulsion. This results in a loss of definition, which is more pronounced in films having a thicker emulsion.

Halation. When light strikes the emulsion, it is absorbed, reflected, or transmitted. When it is transmitted, it passes through the emulsion, producing a halo effect surrounding the direct light ray. Even with the antihalation dyes and backings that are used in all films, a certain amount of halation is inevitable.

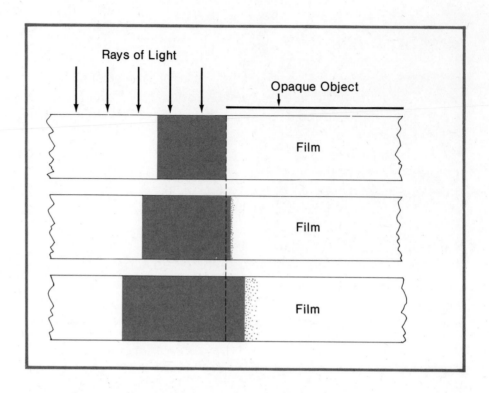

An opaque object is placed directly on the film surface. Increasing exposure and/or development of the negative will be accompanied by a scattering of light rays within the emulsion (top). Light rays are transmitted through the film base and back towards the front layer of the film. This transversing of light forms a secondary density around the area of the greater densities, such as a light source included with the image (bottom).

Acutance. This term defines overall sharpness. It may be measured and is therefore an objective criterion of the definition of the image. The term encompasses the resolving power of the film—its ability to record detail—irradiation, and halation. While it is true that developers have a certain modifying effect, it is primarily the property of the emulsion that controls definition of the image.

SPECTRAL SENSITIVITY

An emulsion can be sensitized so that its response to certain radiated wavelengths (color) can be either accentuated or deemphasized. The color sensitivity of an emulsion determines how objects will reproduce in terms of the tonal scale. Panchromatic emulsions are for the most part sensitive to all colors of the spectrum. In Chapter 9, the relationship of response to color of the eyes (perception) and film emulsions is explored.

Normal Photographic Section of the Electromagnetic Spectrum

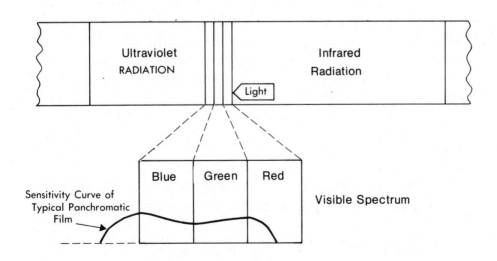

FILM/CHOICE

The choice of film/developer combination depends on the original conception of photographic translation.

Slow-Emulsion Films (ASA Ratings of 50 or Lower). These films exhibit little grain and are intended for the miniature and roll-film formats. They are inherently contrasty and difficult to control. It seems somewhat inconsistent that the very fine-grained films are primarily designed for the small camera format. The relative insensitivity of the film limits the quick response usually associated with these instruments. The miniature roll-film user, because of the comparative ease with which the photographs are taken, should be able to use a film that is more nearly matched to this discipline. With films of low sensitivity, the photographer often must use the camera on a tripod, which immediately lessens the use and effectiveness of the format. Also, the film tends to produce very dense highlight areas quickly, with the mid and low tones not responding similarly. These problems are compounded with a condenser enlarger.

page 185

In various text references, one is advised to use a high-acutance developer* with these films. However, the grain produced by these developers offsets the intended advantage of using these films, namely, that of little or no grain. If these films are used, it should be with discretion and for specialized photographic purposes (for example, copy work), where the overriding consideration is that there should be no visible grain. When these films are used, it makes little sense to use a developer that is incompatible with their emulsion. Rather, use an attendant developer so as to reinforce the relative nongranularity of the film and control the contrast of the negative through dilution of the solution or a chemical modification of developer formula (a weaker alkali).

page 133

Fast-Emulsion Films (ASA Ratings of 400 or Higher). The nominally rated ASA 400 films have limited uses because of their

*Not necessarily fine-grained.

inherent grain structure. No matter what developer formula is used, the grain cannot be suppressed; therefore, unless the photographer uses the grain as an integral part of the photographic conception (with an attendant non-fine-grained developer), the image will fail. When using 4″ × 5″ or larger-size sheet film, this caution does not apply. If enlargements are of modest size, the sheet-film user can use the fast films most effectively. Use the faster films for large-format work, inasmuch as the increased speed of the film compensates for the smaller apertures that are most commonly employed.

page 81

Medium-Speed Films (ASA Ratings of 125). These films are a good choice for all general photographic purposes. Their use solves many of the problems generated by either the slow- or fast-emulsion films. When properly developed, ASA 125 film is capable of great enlargement with minimum grain. It is sensitive enough for use out of doors without a tripod, and its tonal scale reveals great nuances. A great variety of developers is available for films of this rating, without recourse to modification.

FILM SPEED

The ASA (American Standards Association)* rating of a film's sensitivity (the minimum amount of light/energy needed to change the silver halide crystals to metallic silver) is determined under precise and controlled laboratory conditions. These procedures are so exacting that variables such as optical systems and shutters are eliminated. Film is exposed in a device called a sensitometer; however, even within these exacting parameters, the ratings are allowed to deviate by as much as $\pm \frac{1}{3}$ an exposure unit.

These ratings are based on an arithmetic progression. A film with a rating of 200, for example, is one half the speed of a film rated at 400, and twice the speed of a film with a rating of 100.

*The American Standards Association's name has been changed to the American National Standards Institute (ANSI), 1430 Broadway, New York, N.Y. 10018.

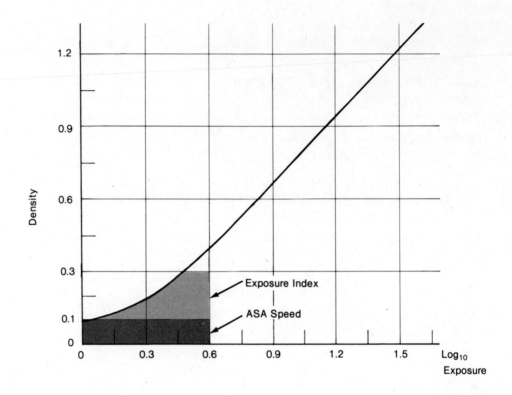

Because these ratings do not take into account the materials and variables encountered during normal photographic procedure—photometer, choice of developer, enlarger characteristics, and the like—the exacting photographer can use them only as guides to establishing personal sensitivity ratings. This personalized measure is termed the Exposure Index (E.I.) to differentiate it from the scientific standard.

THRESHOLD

The ASA speed of a film is defined as a density of .10 above film base + fog level of the film. This in turn is called the minimum threshold density (the least amount of light necessary for the film to react) of a film. However, minimum threshold value is not the concern, as much as is knowing the effective threshold of the film that would produce the first visible tone above the maximum black-silver deposit of which the paper is capable. This is the definition of Tone 2, namely, the effective threshold density or Exposure Index sensitivity rating of a particular emulsion. Therefore:

 Tone 2 = Exposure Index (E.I.)
 = Effective Threshold
 = The first tone above maximum paper black

Calibration 2 determines the film's Exposure Index.

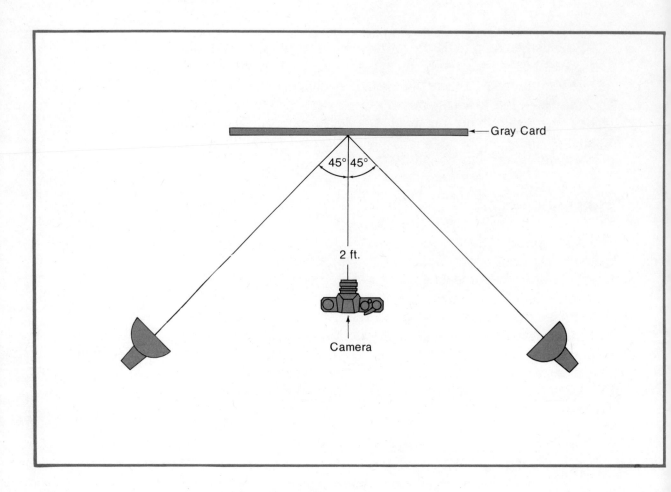

This is the setup that should be used for calibrating exposure index.

CALIBRATION 2: EXPOSURE INDEX

Objective. As discussed in this chapter, the film manufacturers' published ASA speed ratings are of scientific importance but have only passing interest to practical photography, except as a point of departure for the photographer to establish personal sensitivity ratings. This personalized ASA reference is called the "Exposure Index" to differentiate it from the scientific standard. This personalized Exposure Index and sensitivity rating takes into account the photographer's photometer, camera shutter, lens, enlarger, processing chemicals, and techniques.

If any of the above variables is changed to any significant degree, the calibration will have to be repeated. But as long as they remain constant, the Exposure Index becomes a functioning, nonvariable standard and the basis of exposure.

EXPOSURES USING A GRAY CARD*

Frame	Slow Exposure Index	Slow Aperture	Slow Speed	Medium Exposure Index	Medium Aperture	Medium Speed	Fast Exposure Index	Fast Aperture	Fast Speed
1	64	blank	60	250	blank	60	800	blank	60
2		22.0	30		22.0	60		22.0	60
3		2.8	30		2.8	30		2.8	30
4		2.8	30		2.8	30		2.8	30
5	48	blank	60	187	blank	60	600	blank	60
6		18.0	30		18.0	60		18.0	60
7		2.8	30		2.8	30		2.8	30
8		2.8	30		2.8	30		2.8	30
9	32	blank	30	125	blank	30	400	blank	30
10		22.0	30		22.0	30		22.0	30
11		2.8	30		2.8	30		2.8	30
12		2.8	30		2.8	30		2.8	30
13	24	blank	30	90	blank	30	300	blank	30
14		18.0	30		18.0	30		18.0	30
15		2.8	30		2.8	30		2.8	30
16		2.8	30		2.8	30		2.8	30
17	16	blank	30	64	blank	30	200	blank	30
18		16.0	30		16.0	30		16.0	30
19		2.8	15		2.8	15		2.8	15
20		2.8	15		2.8	15		2.8	15

*Assume meter indication of f/8 at 1/30 sec.

122

PROCEDURE

1. Place an 18-percent reflectance gray card on a wall at a height of three to four feet from the floor.

2. Two 500-watt bulbs (4800 K) should illuminate the gray card at an angle of 45° on axis (at the same height). The distance of the lights from the target should give an exposure indication of:

 1/30 sec. at f/8 for slow-emulsion films
 1/30 sec. at f/8 for medium-emulsion films
 1/30 sec. at f/8 for fast-emulsion films

 Measure the four corners of the target as well as its center to assure that the card is evenly illuminated.

3. Place the camera on axis in front of the gray card at a distance of not more than two feet. The camera's entire field of view should consist only of the gray card. (You may have to move the camera closer to the card if a wide-angle lens is used.) The camera should be focused at infinity and must not cast its shadow on the gray card.

4. Expose the film according to the accompanying table.

> **Process the film in freshly compounded chemicals according to the instructions contained in Calibration 1.**
page 54

5. Place the unexposed frame and tested Tone 2 negative in the negative carrier. Expose in the enlarger for the standard printing time and at its predetermined height in accordance with Calibration 1. Print all sets of Tone 1 and Tone 2 negatives in accordance with the outline in Calibration 1.
page 124

> **Do not attempt evaluation until all tones/prints are thoroughly dry.**

Tone 1 Tone 2

Negative Carrier

124

Evaluation. The set of negatives that produces a distinct difference of tones when viewed under standard illumination, as outlined on page 126, will be the Exposure Index. (See *The Calibration Manual* for an accurate rendition of these tones.) By definition, then, Tone 2 is the first tone that is not black. It reflects twice the light as Tone 1.

It would be unusual for the Exposure Index to be greater than the ASA speed indicated by the manufacturer. Typically, the Exposure Index would be on the order of one half the manufacturer's recommendation. However, you should base your Exposure Index on the resultant print that the calibration produces.

Notes. Development action is dependent upon how much exposed silver halide is developed per quantity of developer. For this reason, Tone 8 is used to counterbalance Tones 1 and 2. This will yield a near approximation of a typically exposed roll or sheet of film.

The sheet-film user should maintain a ratio of film to developer. A ratio of one sheet of film to 10 ounces of developer is adequate and recommended. This ratio should be maintained throughout these tests. Because this calibration necessitates the use of 10 sheets of film, and since most tanks hold only 64 ounces, this test should be done in two batches of six sheets each. The remaining two sheets (12 sheets minus 10 for the tests) should be exposed to Tone 5.

page 142

You can further refine this test by exposing for indexes using one-third rather than one-half exposure intervals.

Use the same lens/shutter combination throughout the tests.

Approximate rendering between Tone 1 and Tone 2.

6

Development Chemistry/Procedures

Now if the cloud series are due to my powers of hypnotism, I plead "Guilty." Only some "pictorial photographers" when they came to the exhibition seemed totally blind to the cloud pictures. My photographs look like photographs—and in their eyes they therefore can't be art. As if they had the slightest idea of art or photography—or any idea of life. My aim is increasingly to make my photographs look as much like photographs that unless one has *eyes* and *sees,* they won't be seen—and still everyone will never forget them having once looked at them. I wonder if that is clear.

Alfred Steiglitz
"How I Came to Photograph Clouds"
The Amateur Photographer and Photography
Vol. 56, No. 1819, 1923, page 255

CHAPTER CONTENTS

DEVELOPMENT/REDUCTION

Development of the negative is the procedure in which the latent image is made visible. It is a reduction process by which the exposed silver halide crystals are "reduced" to metallic silver in proportion to the amount of light/exposure that the crystal has received. A photographic developer must therefore be capable of discriminating between those crystals that have received exposure and those that have not.

DEVELOPMENT/PROCESS

The factors that influence the rate and extent of the development procedure must be fully understood in order to control the process.

Developers are either energetic or slow-working: The former produces a heavy silver deposit on the surface of the film; the latter, in time, penetrates deeply into the emulsion. The densities generated by the soft-working developer formulas can equal those of the energetic solutions when development times are increased. Regardless of the type of developer, any increase in development time will produce greater densities. By controlling the time of development and the composition of the developer, the photographer can exert great creative control over the perceived subject.

RATE OF DEVELOPMENT/TEMPERATURE

The rate of development, as in all chemical reactions, is dependent upon the temperature of the solutions. The higher the temperature, the more rapid the process. Development time bears a direct relationship to the processing temperature. Film and developer manufacturers publish graphs showing the time and temperature necessary to produce a given gamma (normal development). The characteristic curve is also a diagrammatic representation of the relationship between exposure, development (time and temperature), and the resultant film density.

page 101
page 97

129

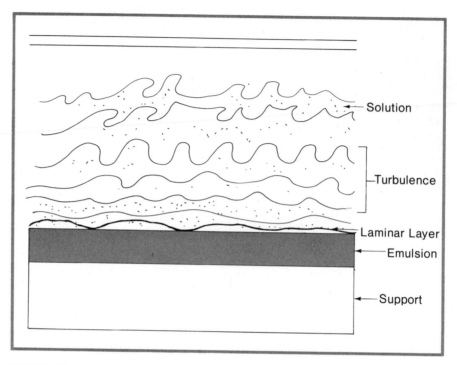

Solution

Turbulence

Laminar Layer
Emulsion

Support

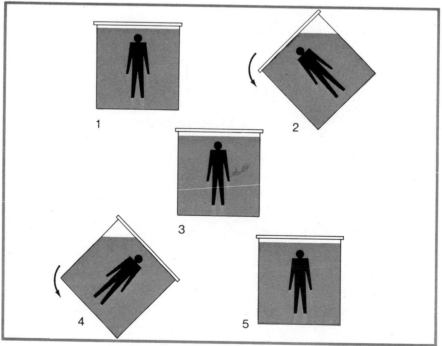

1

2

3

4

5

RATE OF DEVELOPMENT/AGITATION

Agitation as a function of the rate of the development process exerts an influence that is no less important than that of time and temperature. As has been discussed, the process of development takes place within the emulsion to a greater or lesser extent, depending on the energy of the developer, the time, and the temperature. This part of the process is called induction, or page 150 diffusion; in other words, the developer diffuses through the emulsion. However, the absorption of the developer by the emulsion is impeded by a thin liquid barrier formed by the solution in contact with the film. This "barrier" is called the laminar layer, which, owing to the surface of film, can never be entirely eliminated, but which may be controlled by agitation so that it is minimized to the greatest possible extent. Once in contact with the film (constituting the laminar layer), the developer is quickly exhausted and, if not replaced by fresh developer (through agitation), will prohibit further development of the silver halide crystals. Efficient agitation is a combination of vigorous agitation plus a certain amount of turbulence, which reduces the laminar layer to a controllable and minimal factor in the process.

AGITATION PLANS

35 mm and roll film require a complete revolution of the tank:

1. First 30 seconds continuous; every 5 seconds on the half minute, or
2. First 60 seconds continuous; every 10 seconds on the full minute.

Sheet film requires a complete lifting out of the tank every second:

1. First 30 seconds continuous; every 5 seconds on the half minute, or
2. First 60 seconds continuous; every 10 seconds on the full minute.

THE CHEMISTRY OF DEVELOPMENT

It is not within the scope of this text to explore the nearly infinite variations and compositions of the developer formula, nor is it possible to examine the complex chemical structure of the developer and its constituents. Included in the bibliography are several books that will afford you a greater understanding of the process. However, the fact that nearly all developers are composed of the same basic ingredients can lead to some fundamental conclusions.

The chemical constituents of any developer must include a developing agent, a preservative, an activator (pH value), and a restrainer.

Preservative. Exposure to air will quickly oxidize the developing agents employed and exhaust them prematurely. Adding a preservative (sodium sulfite being the most commonly used) substantially reduces the oxidation of the solution. The preservative also prevents the discoloration associated with oxidation and keeps the developer solution relatively clear.

Sodium sulfite, in large quantities, is the classic medium for achieving fine grain in the compounding of varying developer formulas. The sulfite acts as a silver solvent, dissolving some portion of the silver halide crystals, and producing a sharper and more delineated grain structure.

Restrainer. Chemical fog is produced by the developer acting on unexposed silver halide crystals. While the developing agents are usually selective, in that they develop exposed crystals, restrainer is added to insure that the development of unexposed crystals is prevented. Depending on the developing agents used, the

restrainer also slows the rate of development. By suppressing those areas that receive little or no exposure, the restraining action increases the contrast of the negative. Furthermore, by suppressing all densities, restrainers generally will produce a softer negative, resulting in a finer-grained structure. Potassium bromide is the usual choice in the compounding of most developer formulas.

Activator/Accelerator. Most developing formulas that are composed of only a developing agent and preservative (D-23) are page 136 not in themselves potent enough to effectuate the reduction process. An activator added to the formula accelerates and makes possible the development of the silver halide crystal. All developing agents work most efficiently in an alkaline solution (a base solution as opposed to acidic). The activator/accelerator is an alkali which, when added to the developing solution, produces this environment.

Alkalis are generally grouped according to their relative strength:

Caustic alkalis. These are the most powerful, which greatly increases the rate of the development process. They are not used generally, because it is difficult to control their action (for example, sodium or potassium hydroxide).

Alkali carbonates. Less alkaline than the caustic alkalis, they are used in many development formulas (for example, sodium carbonate).

Mild alkalis. The least powerful of the three, these are generally used in the compounding of fine-grained development formulas (for example, borax or Kodalk—a Kodak proprietary chemical).

The activity of the developer can be accurately measured in terms of its pH value: The caustic alkalis have a high pH value; the mild alkalis have a lower value; and the alkali carbonates are somewhere in between.

pH VALUES

The pH values of the various chemicals and their constituents are a measure of their activity. The relative potency of the chemical is assigned a value:

Most Acidic		Most Alkaline
1 2 3 4 5 6	7	8 9 10 11 12 13 14

Each value represents 10 times more or 10 times less than the preceding value. A pH of 9 represents an activity 10 times greater than a pH of 8, or one hundred times less than a pH of 11. A pH value of 7 denotes that the solution is neither acidic nor alkaline, for example, pure water. The accompanying table shows the pH values of the various chemicals most commonly used for photographic purposes. The pH value of a chemical is a function of the chemical constituents and the temperature used for its intended process.

The pH value of a chemical can be determined using either litmus paper or an electrically sensitive meter. While the determination of the pH value of black-and-white chemistry is interesting and of help to those versed in the chemistry involved, its use by the practicing photographer is limited. However, for color chemistry and processing, the use and subsequent determination of pH values is of utmost importance.

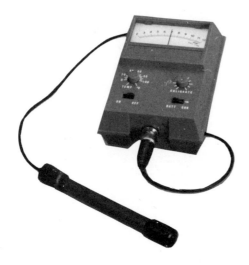

*Ph meter
(L.G. Nester Co.).*

pH VALUES FOR PHOTOGRAPHIC SOLUTIONS*

Developers		pH Values	Other Solutions	pH Values
Super-20		7.5	Indicator Stop Bath	4.0
HC-110	1:7	8.5		
	1:9	8.5	Fixing Bath	4.5
	1:15	8.4		
	1:21	8.4	Clearing Bath	7.2
D-23		9.0		
Ilford Perceptol		7.8	Kodalk 2% Solution	9.8
Rodinal	1:25	11.4		
	1:50	10.8	Borax 1% Solution	9.5
			Sodium Carbonate	
LPD Paper Developer		10.1	5–10% Solution	11.5

*These values are approximate.

BUFFERED CHEMICALS

The term "buffered action" implies that the chemical will retain its activity under various circumstances. The dilution of the chemical, or the addition of an acid or alkali to the solution, produces only a slight change in the fundamental pH value. The alkalis used in compounding the various developing formulas are selected to exert this quality. If a developer did not exhibit this quality, the development process would be subject to variations that would be impossible to control. Developers with buffered action (including HC-110) exhibit a favorable consistency/stability over their useful life.

DEVELOPING AGENTS

Metol. (Elon is the Kodak proprietary equivalent.) Perhaps the most widely used of all developing agents, it is highly soluble, clean working, rapid, reacts well under differing temperatures, and is not easily exhausted. Used alone, as in Kodak Developer D-23, it is capable of producing a semi-fine grain.

Kodak D-23
Metol (Elon) 7.5 grams
Sodium sulfite (des.) 100.0 grams
Water to make 1.0 liter

Hydroquinone. Used alone (with caustic alkalis), it produces extreme contrast; used with alkali carbonates, it becomes less energetic but still produces a contrasty image. Hydroquinone is rarely used alone, however, but is normally combined with Metol in varying proportions, producing a nearly infinite variety of developer formulas. These developers are referred to as M-Q developers, of which Kodak Developer D-76 is the most noted example.

Kodak D-76

Metol (Elon) 2.0 grams
Sodium sulfite (des.) 100.0 grams
Hydroquinone 5.0 grams
Borax . 2.0 grams
Water to make 1.0 liter

Phenidone. An Ilford proprietary developing agent, Phenidone, like Metol, is used in conjunction with hydroquinone. It produces a developer with much the same characteristics as those of the M-Q type. Developers using Phenidone are referred to as P-Q developers. Its major advantage over Metol is that it is less prone to oxidation and is easier to replenish.

Ilford ID-68

Sodium sulfite (des). 85.0 grams
Hydroquinone 5.0 grams
Borax . 7.0 grams
Boric acid 2.0 grams
Potassium bromide 1.0 gram
Phenidone 0.13 grams
Water to make 1.0 liter

Dissolve in the order given. Note that Phenidone is not soluble in water.

Paraphenylenediamine. The standard developing agent, Paraphenylenediamine is used to produce truly fine grain. Edwal Super-20 developer is a commercially packaged developer using Paraphenylenediamine as its developing agent.

Edwal Super-20

Gradol* 5.0 grams
Sodium sulfite (anh.) 90.0 grams
Paraphenylenediamine 10.0 grams
Glycin . 5.0 grams
Water to make 1.0 liter

*Gradol—paraamino-phenal sulfate (a developing agent).

p-Aminophenol. A developing agent, p-Aminophenol is contained in highly concentrated developers that have to be used in diluted form. Rodinal,* a proprietary formula of Agfa Gevaert, uses p-Aminophenol as its developing agent. It produces a rapid, energetic developer. The ANSI standard for the establishment of ASA Indices uses this agent in the following formula:

Monomethyl para-aminophenyl 1.0 gram
Sodium sulfite (anh.). 25.0 grams
Hydroquinone. 2.0 grams
Sodium carbonate (anh.) 3.0 grams
Potassium bromide 0.38 grams
Water to make 1000.0 milliliters

Chlor-hydroquinone. An agent similar in action and response to hydroquinone, Chlor-hydroquinone is more active. It is the developer component used, along with Phenidone, in the composition of Edwal FG-7. This developer, used in varying concentration, is a widely and successfully used semi-fine-grained formula. It is interesting to note in the directions accompanying this developer that for a finer grain, a nine-percent solution of sodium sulfite is suggested in place of water.

page 132

HIGH-CONTRAST DEVELOPERS

The constituents of those developer formulas that produce negatives of high contrast are essentially the same as those employed to produce negatives of low contrast (fine or semi-fine-grained formulas).

	D-11	D-19
Metol (Elon)	1.0 gram	2.0 grams
Sodium sulfite (des.)	75.0 grams	90.0 grams
Hydroquinone	9.0 grams	8.0 grams
Sodium carbonate (mono.)	30.0 grams	52.5 grams
Potassium bromide	5.0 grams	5.0 grams
Water to make	1.0 liter	1.0 liter

*With modern thin-emulsion films, Rodinal produces a semi-fine grain structure when greatly diluted.

Note the increased quantities of hydroquinone in relation to the amount of Metol (Elon) employed. Metol and hydroquinone can, in varying quantities, produce a nearly infinite array of ⋯ haracteristics. Note, too, the ⋯ ponate. The high-contrast ⋯ H levels than do the fine-

page 133

⋯es (HC-110, FG-7, Rodinal) ⋯ at dilutions that are more ⋯ fine-grained development

A ZONE SYSTEM FOR ALL FORMATS

ERRATA

On the second page of the color section the order in which the color patches appear is inconsistent with the caption, however, the gray tones match the colors.

On the last page of the color section the color of K47 filter should be blue. The gray scale is rendered as if it were photographed through a blue filter.

⋯only compresses the tones ⋯on of tone that is not always ⋯ment or a dilute developer ⋯that it compensates for an ⋯aged developers that make ⋯mpensating in this context; ⋯ng formulas which, while ⋯he segregation of tones of ⋯s capable. D-23 is a semi-⋯ch formula (a dilute D-23 ⋯per.

page 136

Water . 750.0 cc
Metol (Elon) 2.5 cc
Sodium sulfite (des.) 25.0 cc
Water to make 1.0 liter

Developing times are long (calibration can start at 25 minutes), and there is serious loss of film speed; however, the formula is worthy of consideration.

WATER-BATH DEVELOPMENT/TWO-SOLUTION DEVELOPERS

These classic techniques to control the high-value negative densities have been used with great success in the past, but have lost much of their ability to control these values with modern materials. These physical/chemical processes depend on the emulsion's absorbing the developer solution. However, the multilayered thin-emulsion film used today cannot absorb sufficient developer to make this technique viable. However, as an example of how the theory of development relates directly to the process, it is worthy of analysis.

Water-Bath Development/Procedure. The negative is first immersed in the developer solution for one minute (with constant agitation) and then transferred into a plain water bath (without agitation) for two minutes. This sequence is repeated until the proper high-value densities have been achieved. The film absorbs the developer, which continues its action when transferred to the water bath. However, there is insufficient developer available to operate successfully on the high values. Instead, the low values continue to develop while the higher values remain proportionally unchanged, thus insuring that the lower values will reach their proper densities while retarding the higher values. The amount of development and alternate water-bath treatment depends on the degree of development required. This can easily be established by tests or, since the film is now desensitized, by inspection under a proper safelight. A slow-working developer not containing hydroquinone is recommended.

SPLIT DEVELOPMENT/TWO-SOLUTION DEVELOPMENT

In this procedure, the film is developed to the point where the high-value densities reach their envisioned densities. The film is

then transferred to a one-percent solution of Kodalk (or Borax), with agitation (according to the plan devised while the film was in the developing solution) for three minutes. The absorbed developer continues to reduce the exposed silver halide crystals in the low-density portions of the material while not being powerful enough to reduce the high-density values. D-23 is usually the standard developer used in conjunction with this procedure. It contains a large amount of sulfite, that acts as an accelerator in saturated solution, providing a very mild alkalinity in which the absorbed developer is able to continue its reduction of the low-tone values.

page 136

page 132

DEVELOPERS/CONCLUSIONS/CHOICES

As was noted in the chapter dealing with the structure of the negative emulsion, the granularity inherent in the negative is incapable of being greatly modified by use of the varying developer formulas. Under no circumstances can a fine-grained developer produce as fine-grained an image with high-speed film as it can with a slow-speed emulsion. It has been the accepted practice in recent years, however, to mate a fine-grained developer with a fast-emulsion film and, alternately, a semi-fine-grained developer with the slower emulsions. If the subject/photograph demands a rendering that calls for tones and detail unencumbered by grain, then only a fine-grained film in combination with a fine-grained developer should be used. Conversely, a subject that would be more meaningfully translated if grain were an integral part of the whole should employ a high-speed film and a developer capable of producing a sharp but not necessarily fine-grained negative structure.

PROCEDURES/DEVELOPMENT/REPLENISHMENT

During the development process, developing agents are consumed and the formula is thereby weakened. Residual by-products (bromides), caused by the reduction process, are released into the solution, further limiting the action of the developer. By adding a specific amount of a replenisher solution, the formula can be brought back to its original strength. Usually these solutions are a close approximation of the formula that they are designed to complement; however, they often contain a higher concentration of developing agent as well as an increase, by weight, of the activator component.

When properly used, replenishment reactivates the solution but should not be used to excess. At a given point, the residuals can no longer be counterbalanced, and the solution must be discarded. Follow the replenishment instructions supplied by the manufacturer or by formula. Do not replenish to the theoretical limits; rather, limit the procedure to half the recommended amount.

A replenisher formula produces a finer-grained negative. However, as the bromide residual builds, the loss of effective threshold speed becomes apparent, and the trade-off in improvement of the grain structure becomes less advantageous.

QUANTITY OF DEVELOPER SOLUTION

The energy of the developer solution is affected by the quantity of film it has to reduce. It is evident that enough solution must be supplied to the emulsion in order for the exposed silver halide crystals to turn to metallic silver. Too little solution, and the developer will quickly exhaust itself. It is far better to have an excess amount of developer to insure that all the exposed crystals will be thoroughly reduced. With 35 mm and roll-film tank development, the practical volume of solution is determined by the amount of developer the tank can hold. For sheet film, the ratio of one sheet of 4″ × 5″ film, or 20 inches of film to 10 ounces of developer, is recommended.

PROCEDURES FOR COMPOUNDING FORMULAS

Quality of Water. The impurities of tap water will affect the quality and composition of most formulas. For most photographic purposes, however, these impurities can be disregarded, except for developers and wetting agents, or unless the condition of the water is very severe.

When compounding developers, use distilled water. Relatively inexpensive still or distilled water in gallon bottles can be purchased. Because of their highly concentrated formulas, wetting agents (Kodak Photo-Flo, Edwal Quik-Wet), must be diluted with chemically pure water in order to achieve negatives that are devoid of water marks.

Temperature of the Mixing Solution. Nearly all formulas call for water to be heated to 125 F. The developer or formula being compounded will decompose, and oxidation will be accelerated if this caution is not heeded. Most instructions found in chemical formularies call for three quarters of the final amount of water to be used in the actual mixing of the formula. After the formula is mixed, water is then added to make up the required volume. It is unnecessary to add heated water. Very cold water is often added to make up the formula if the chemical is to be used immediately. However, precipitates may form if the entire solution is cooled too rapidly or left in a cold place.

WEIGHTS, MISCELLANEOUS

Percentage Solutions. In order to maintain accuracy in the mixing of small chemical quantities (under 0.7 grams), the use of a percentage solution is usually indicated. A 10-percent solution of a solid is compounded by taking 1 ounce/1 gram and making up to 10 ounces/grams with water. A 10-percent solution of a liquid is produced by adding 10 ounces/10 cc and adding water to make 100 ounces/100 cc.

TABLE OF U.S. CUSTOMARY AND METRIC EQUIVALENTS

| U.S. Customary to Metric Length | | | | |
Yards (yd.)	Feet (ft.)	Inches (in.)	Millimeters (mm)	Meters (m)
1	3.	36.	914.4	0.9144
0.333	1	12.	304.8	0.3048
0.0277	0.0833	1	25.4	0.0254
0.00109	0.00328	0.03937	1	0.001
1.0936	3.2808	39.37	1000.	1

| Avoirdupois to Metric Weight | | | | |
Pounds (lb.)	Ounces (oz.)	Grains (grain)	Grams (g)	Kilograms (kg)
1	16.	7000.0	453.6	0.4536
0.0625	1	437.5	28.35	0.02835
		1	0.0648	
	0.03527	15.43	1	0.001
2.205	35.27	15430.	1000.	1

| U.S. Customary Liquid to Metric Measure | | | | | |
Gallons (gal.)	Quarts (qt.)	Fl. Ounces (fl oz.)	Fl. Drams (fl dr.)	Cubic Centimeters (cc)	Liters (liter)
1	4.	128.	1024.	3785.	3.785
0.25	1	32.	256.	946.3	0.9463
		1	8.	29.57	0.02957
0.000975	0.0039	0.125	1 (60 mins.)	3.697	0.003697
		0.03381	0.2705	1	0.001
0.2642	1.057	33.81	270.5	1000.	1

Fahrenheit to Centigrade. From the indicated Fahrenheit temperature, subtract 32, multiply by 5, and divide by 9. Example:

$$100 - 32 = 68 \times 5 = \frac{340}{9} = 37$$

Sodium Carbonate. Referred to in the various chemical texts, it is in one of three forms: desiccated (or anhydrous), crystalline, or monohydrated. The terms are indicative of the amount of their water content. In the United States, the chemical is usually sold in its monohydrated form, which is more stable than the others. A table of their equivalent measures can be tabulated.

Desiccated or Anhydrous to Monohydrated

Metric		Avoirdupois			
Des. Grams	Mon. Grams	Des. Oz.	Des. Grains	Mono. Oz.	Mono. Grains
0.5	0.58	¼	128
1.0	1.17	145	170
1.5	1.73	165	193
2.0	2.34	175	205
3.0	3.51	½	256
4.0	4.68	265	310
5.0	5.85	300	351
6.0	7.02	¾	384
7.0	8.19	350	410
8.0	9.36	360	421
9.0	10.53	365	427
10.0	11.70	385	1	13
15.0	17.55	1	1	74
20.0	23.40	1¼	1	202
25.0	29.25	1½	1	330
30.0	35.10	1	260	1	378
35.0	40.95	1¾	2	20
40.0	46.80	2	2	149
45.0	52.65	2¼	2	278
50.0	58.50	2½	2	406
55.0	64.35	2¾	3	95
60.0	70.20	3	3	223
70.0	81.90	3¼	3	351
80.0	93.60	3½	4	42
90.0	105.30	4	4	298
100.0	117.00	5	5	372
110.0	128.70	6	7	9
120.0	140.40	7	8	83
130.0	152.10	8	9	193
140.0	163.80	9	10	228
150.0	175.50	10	11	306

Crystal to Monohydrated

Metric		Avoirdupois			
Cryst. Grams	Mono. Grams	Cryst. Oz.	Cryst. Grains	Mono. Oz.	Mono. Grains
1.0	.43	¼	47
2.0	.87	165	71
3.0	1.29	175	76
4.0	1.73	½	95
5.0	2.17	265	¼	6
6.0	2.60	300	¼	20
7.0	3.03	¾	¼	32
8.0	3.47	350	¼	41
9.0	3.89	360	¼	46
10.0	4.33	365	¼	49
15.0	6.40	385	¼	58
20.0	8.67	1	¼	79
25.0	10.83	1¼	½	16
30.0	12.90	1½	½	64
35.0	15.07	1	260	½	82
40.0	17.34	1¾	¾
45.0	19.55	2	¾	47
50.0	21.67	2¼	¾	95
60.0	25.99	2½	1	33
70.0	30.34	3	1¼	18
80.0	34.67	3¼	1¼	65
90.0	38.90	3½	1½	4
100.0	43.34	4	1½	100
110.0	47.67	5	2	74
120.0	52.01	6	2½	43
130.0	56.24	7	3	13
140.0	60.67	8	3¼	96
150.0	65.01	9	3¾	61
160.0	69.33	10	4¼	36
175.0	75.84	15	6¼	66
200.0	86.68	20	8½	73

STOP BATH

The function of the stop bath is to arrest development evenly and to render inert the developer solution that would ordinarily be carried over to, and contaminate, the fixing bath. In recent years, there has been discussion over whether the purpose for which the stop bath is intended is not neutralized by the danger of using an incorrectly compounded solution, especially for miniature film; for if the solution is too potent, it will cause the film to blister and produce pinholes within the emulsion; if, on the other hand, the formula is too weak, it will not serve its intended function. By diluting by one quarter the amount of concentrate called for in the compounding instructions, any danger of film blisters or pinholes can be eliminated. After removing the film from the stop bath, wash it immediately for one minute before immersing it in the fixing bath. This insures that the acid as well as any remaining developer is removed. As in developing, film agitation is of utmost importance, as is the temperature, which should correspond to that of the developer solution.

FIXING BATH

The purpose of the fixing bath is to remove and dissolve those silver halide crystals that were not exposed and therefore not reduced (developed). Any of the commercially available formulas is adequate. Use of a hardening solution, either compounded with the fixing bath or used as a separate stage in the process, is definitely recommended. The same precautions involving time, temperature, and agitation should be followed.

The classic recommendation calls for film to remain in the fixing bath for "twice the time that it takes the film to clear." This can easily be determined by taking an unprocessed sample of film (for example, the leader of a miniature film), placing it in the solution, and timing the process to see how long it takes for the emulsion to be rendered as clear film base. Multiply the resultant duration by two. This procedure can also be used to determine the

freshness of the bath as well. The manufacturers' recommendations are accurate and should under no circumstances be exceeded. If exceeded, the low-density values will be dissolved, and the entire negative will deteriorate in time.

WASHING

The complex silver salts formed during the fixation must be removed, or the remaining salts will cause the negative to fade. In recent years, manufacturers have produced devices that are most efficient in the washing of roll- and sheet-negative materials. They are inexpensive and serve their purposes. The wash time can also be greatly reduced by using commercially available hypo clearing agents. These formulas make the silver salts more soluble in water and thereby reduce the amount of time necessary for the fixing chemicals and salts to wash out. A thorough wash is also necessary to remove the antihalation dyes contained within the emulsion. In an efficient washing device, it takes approximately eight minutes to completely remove these dyes. In certain areas of the country, it is prudent to install a filter in the water line to remove rust and calcium deposits. The water should be kept within ± 5 degrees of the other processing chemicals.

PREPARED/PACKAGED DEVELOPERS

Manufacturers of developer products and chemistry have produced a variety of formulas, which for all practical purposes should satisfy the most demanding photographer/craftsman. However, on occasion, the photographer may require certain highly specialized developers and should therefore be able to compound any of the various published but unpackaged formulas.

You should use one easily prepared liquid concentrate developer (HC-110 or FG-7) until you fully understand the process. Experimentation to achieve differing effects can be employed after knowledge/experience is gained.

1. *Water Still (Aqua Spring New Medical Techniques Co.)*
2. *Kindermann Tank and Loader*
3. *Film Washer for roll film (East Street Gallery Co.)*
4. *Film Washer for sheet film (Hurricane Film Washer Co.)*

DEVELOPMENT/PROCESSING TECHNIQUES

Practical development/processing procedures are easily adapted to photographic theory. Processing techniques, on the other hand, evolve from the photographer's knowledge/understanding of the process, progress in the design and manufacture of equipment, and the standards/criteria the photographer/craftsman sets.

The following information represents procedures evolved over many years of employing equipment. It is also based on current standards/criteria that are constantly undergoing transformation as new knowledge and comprehension of the process are acquired.

TANKS

Roll Film. For miniature and roll film, the Kindermann stainless-steel developing tanks are used, as well as the "automatic" loader manufactured for their use. The covers of these tanks are made of PVC plastic, which forms an excellent waterproof seal. Stainless-steel tanks are preferred over plastic because of their ease in cleaning.

Reels for 20-exposure rolls of film are available as well as the standard 36-exposure reel.

Sheet Film. Four hard-rubber tanks are used. Each tank is labeled and used for that chemical only. These tanks hold 64 ounces of solution and will contain six film holders comfortably.

AGITATION

After loading the tank, but before closing it, a small piece of plastic tubing is placed on top of the reel, which prevents the reel from moving in the tank and setting up opposing agitation currents. Proper agitation is easily accomplished with the reel in a stationary position.

After each agitation cycle, the tank is rapped sharply to dislodge any air bubbles that may have formed during inversion of the tank.

INFUSION BATH

page 131 Regardless of the previously determined development time, proceed with a one-minute immersion of the film (roll film or sheet film) in a temperature-controlled/filtered tap-water solution, with intermediate agitation. This has the effect of softening the film base/emulsion for a more even diffusion/induction time.

DEVELOPMENT CHEMISTRY/NOTES

1. Always compound developer with distilled water.
page 146 2. Use the indicator type of stop bath—three quarters the amount of manufacturer's recommendation.
page 146 3. Use fixer solution with hardener.
4. Keep all chemistry for processing and washing at a constant temperature of 70 F.

Between the stop bath and fixing cycles, the film is washed in temperature-controlled filtered water for one minute. This rids the film base/emulsion of any carried-over developer and/or stop-bath solution. This step also maintains the proper pH of the fixer and stabilizes its condition.

WASHING PROCESS

After fixation, the negative material is washed in a film washer for five minutes, followed by a one-minute submersion in a hypo clearing agent. The film is then placed back into the washer again and washed for an additional 20 minutes.

The East Street Gallery Film Washer (illustrated) is no longer available; however, similar products are. The major functional

consideration of these units is whether they utilize air turbulence. By inducing air into the water flow, turbulence is created, which produces a shortened wash time.

The washer for sheet film (illustrated) is manufactured by Hurricane Washers. It has an input water tube at the bottom of the unit, attached to a row of plastic tubing embedded along the length of the bottom of the unit. Water flows through this tubing and is evenly distributed throughout the tank. Unfortunately, however, there is no air turbulence; nevertheless, it is a most efficient washing device.

WETTING AGENT

After washing, the film is immersed in a wetting agent (compounded with distilled water) for one minute, and agitated during the first 10 seconds. The film is then placed back into the washing unit for five seconds, to remove air bubbles caused by the wetting agent.

FILM-DRYING

Roll Film. After removing the film (which is still on the reel) from the wetting agent, it is shaken vigorously to remove any excess water that may have adhered to its surface. It is then placed in a Kindermann Film Dryer (illustrated), which uses filtered air at room page 152 temperature. It takes approximately 20 to 35 minutes (depending upon atmospheric conditions) for the film to be thoroughly dry. Because it dries on the reel, the film has a pronounced curl to it. The film is then hung up, with weights attached to the bottom to remove the curl, for one or two hours (again depending on atmospheric conditions).

Sheet Film. The film material is placed in a Falcon Roller Squeegee (illustrated) to remove any excess water, and is then transferred to a drying cabinet that was constructed to house a Jo-bo Drying Unit. (This unit can also dry roll film.) The device consists of a heating element and fan. Air is drawn through the top of the unit by a fan. It is then heated and passes through to the cabinet, where it circulates around the drying holders. (These hangers—Kodak Sheet Film Hangers #6—do not have channels to hold the film; rather, the film is held in place by two stainless-steel clips.)

This instrument can be modified by placing an cn-off switch on the heating element. The heat will be too intense (though only approximately 100 F), and therefore the film will dry too rapidly, resulting in uneven and water-marked negatives. Modified, it can be used successfully with the heating element turned off.

Roll Film Dryer

CALIBRATION 3: NORMAL DEVELOPMENT

Objective. "Normal development" is defined as that amount of development (measured in units of time) that will produce a specific density/gamma (in this case Tone 5) using the photographer's equipment, processing techniques, and formulas. It is a point of reference/departure for determining development contractions and expansions (minus and plus development). It has further significance in that the photographer renders the tones/reflectances as they are "placed," or as they "fall," in terms of the gray scale.

PROCEDURE

1. Use the same lighting configuration as in Calibration 2.
2. Expose the negative material at the Exposure Index (E.I.) as determined in Calibration 2, according to the accompanying table.

EXPOSURE GUIDE

35 mm Film		Roll Film		Sheet Film	
Frame	Tone	Frame	Tone	Sheet	Tone
1	blank	1	blank	1	1–2
2	2	2	2	2	9
3	3	3	3	3	5*
4	4	4	4	4	5*
5	5	5	5	5	5*
6	6	6	5*	6	5*
7	7	7	5*		
8	8	8	5		
9	9	9	6		
10	5*	10	7		
11	5*	11	8		
12–20	Repeat 1–9	12	9		

*See page 155.

Note the following example: The basic meter indication (using the Exposure Index from Calibration 2) is 1/30 sec. at *f*/8.

METER INDICATION

Frame no.	Speed/Aperture Indicator	Tone
1	blank	1
2	1/30 sec. at *f*/22	2
3	1/30 sec. at *f*/16	3
4	1/30 sec. at *f*/11	4
5	1/30 sec. at *f*/8	5
6	1/30 sec. at *f*/8	5
7	1/30 sec. at *f*/8	5
8	1/30 sec. at *f*/8	5
9	1/30 sec. at *f*/5.6	6
10	1/30 sec. at *f*/4	7
11	1/30 sec. at *f*/2.8	8
12	1/15 sec. at *f*/2.8	9

3a. *35 mm and Roll Film.* Develop and process the film in freshly compounded chemicals according to the instructions outlined in Calibration 1 and further detailed in this chapter.

b. *Sheet Film.* Develop each Tone 5 negative in half-minute intervals, with the development time used in Calibration 2 (six minutes) as the axis.

TONE 5 DEVELOPMENT

Sheet No.	Development Time
1	5 minutes
3	5½ minutes
4	6 minutes
5	6½ minutes
6	7 minutes

4. Place the Tone 1 and Tone 2 negatives in the negative carrier, according to the instructions outlined in Calibration 2. Print the set of negatives and compare them to the sample verified in Calibration 2. (The calibrated sample should be immersed in water before the examination.) This will serve to validate the exposure and development techniques employed for this calibration.

5a. *35 mm and Roll Film.* Print those Tone 5 negatives that are asterisked (*) in the table on page 153.

 b. *Sheet Film.* Print all Tone 5 negatives.

Do not attempt evaluation until all tones/prints are thoroughly dry.

6. Trim off the print borders.

7. Place the test sample Tone 5 directly on the 18-percent reflectance gray card.

8. Holding a monochromatic viewing filter (Wratten #90 Filter) against your eye, evaluate the tested sample. There should be no difference in tone between the two. If the tested sample is too light, the time of development must be shortened; if too dark, development must be lengthened.

9a. *35 mm and Roll Film.* After the proper development time is determined (by subsequent exposure and development), print all nine tones and mount them on an 18-percent reflectance gray card.

 b. *Sheet Film.* After the proper development time has been determined, expose and process nine sheets of film, each for a specific tone, and mount them on an 18-percent reflectance gray card.

Evaluation. As stated, the objective of this calibration is to determine how much time is needed to produce a specific density. Tone 5 is the pivotal reflectance because it is affected by development to a greater degree than the low tones, but to a lesser degree than the high tones.

The specific tones (1 through 9) that were generated by this calibration should give you a surer understanding of the exposure and development process. More importantly, it provides a concrete demonstration of the reproduction process. Prints in this book, as well as others, should be analyzed with this tone scale brought in contact with the tones/prints under examination. Meaningful analysis is now possible, for no verbal or illustrated example of tonality is as valid as your own model.

7

The Darkroom

At times I make photographs for the sheer magic
of its process and the good feeling about the very
stuff needed: light, chemical combinations, some
imperceptible forces at work behind the scene. I
am intrigued with it always, I am a part of the
drama which takes the guise of photography.

Paul Caponigro
Aperture Monograph, Copyright 1967

CHAPTER CONTENTS

THE DARKROOM

The darkroom/laboratory, as an entity, should be considered a logical extension in the chain of photographic apparatus. The same care that was exercised in choosing camera/lens, photometer, and processing equipment should also be apparent in the design, construction, and execution of the area. Ideally, the room should contain the flow of processing procedures and mirror the craft implicit in the medium. It should also be a space designed for comfort and inner well-being. Photography, like any other creative endeavor, is a solitary pursuit; nowhere is this more evident than in the darkroom.

It is apparent that there is a direct relationship between the quality of design of the space and the quality of execution of the print. The craftsman who understands materials and technique— whether he be a painter, sculptor, or machinist—is able to integrate his surroundings to his work, resulting in a more controlled and efficient procedure.

The darkroom illustrated and referred to in the following pages grew out of my needs and procedures. Its design was a culmination of ideas, successes, and failures of earlier laboratories. It was designed to grow and change as needs underwent transformation.

As new equipment is introduced, resulting in procedural change, the craftsman/photographer's technique must of necessity undergo conversion. So, too, the vehicle that houses and holds the process should be thought of as a growing, functioning environment.

Having read the preceding chapters, you will understand at once how this design was arrived at. It reflects the flow of work exactly. Process/environment form a unified whole.

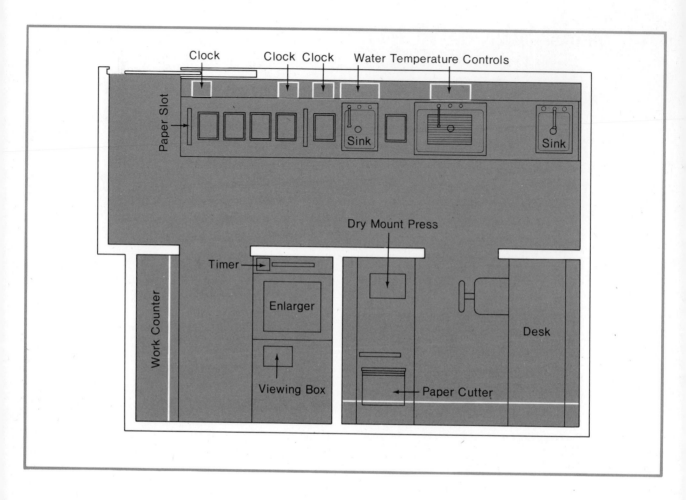

160

CONSTRUCTION/GENERAL CONDITIONS

Generally, the dimensions of the darkroom and the maximum print size that the photographer wishes to produce are interrelated. For example, if the desired print size is to be 16″ × 20″, the trays the photographer would use will measure approximately 18″ × 22″. At least four trays would be needed, and an area for washing the prints adjacent to the counter holding the trays would total some 10 feet. Other configurations may be devised that could be entirely satisfactory. However, any plan should be oriented to the size of the prints desired. On a counter that measures 14 feet, you can comfortably maneuver an 11″ × 14″ print, at maximum.

It is of utmost importance that the dry (printing) areas be removed and at some distance from the processing sinks. Many times an enlarger is placed too close to the wet areas, inevitably resulting in contamination of unexposed/exposed papers as well as processing errors.

FLOORING/WALLS

The prime consideration in the choice of wall and flooring materials should be their dust-generating/collecting characteristics. Resilient flooring (linoleum) is generally recommended, both for its ease of cleaning and its relatively non-dust-collecting traits. If wooden flooring is used, coat the floor with polyurethane (a liquid plastic), which allows for easy maintenance. Avoid bare concrete floors; they collect and generate dust and are most difficult to maintain.

A dry wall (sheet rock) with good insulation is recommended. Concrete or old plaster walls must be covered, as the dust that will be generated from them will cause untold problems. It has been suggested that the problem of flare and safelight fog could be serious if the darkroom walls and ceiling are painted white. The safelight tests on pages 53 and 167 will either confirm or deny this theory for the individual darkroom.

ELECTRICAL CONNECTIONS

In designing a darkroom, make absolutely certain that all electrical wiring is in conformance with existing building-code specifications. All electrical receptacles should be installed so that no electrical cord is farther than three feet from a socket. As a matter of fact, most connections should not be exposed at all, and should be designed and placed behind walls immediately adjacent to the specific electrical apparatus. All outlets should be carefully grounded. Equipment that draws heavy electrical loads (dry-mounting press, print dryer) should be placed on separate circuits. Unless the photographer is qualified, it is certainly best to leave the electrical work to a professional electrician.

WATER LINES

Depending on the area and existing local conditions, the use of a water filter is usually necessary. A filter reduces (but does not entirely eliminate) rust, contaminants, and chemicals from the water supply. However, a filter will not make the water softer or harder; special water conditioners are available for that purpose. Consult your local water department as to the quality of the water in your area; you must take steps to rectify a bad water source. If you use water-temperature control units, have them checked to see if they comply with local plumbing ordinances (specifically, check the valves that are used in their manufacture). PVC-type plumbing lines will not be affected by black-and-white photographic chemistry, but certain locales still prohibit their use.

VENTILATION

The installation of a ventilating fan is an absolute must. It should be able to clear an area of at least 3 cubic feet per minute per square foot of floor area (minimum of 150 cubic feet per minute.)* This will rid the room of odor and fumes. Air-cleaning devices are available that will remove airborne particles as small as .01 micron in diameter. They are more expensive than an exhaust fan but are not replacements for such fans; however, they are an invaluable addition to the darkroom when used in conjunction with a proper ventilating fan.

CONSTRUCTION/CABINETS

Most commercial laboratories rightly use type 320 stainless-steel sinks and counters. The professional photographer can substitute other materials for their construction, as long as they exhibit the following characteristics: They must be waterproof, able to resist chemical stain, capable of easy maintenance, and able to withstand heavy usage.

You can use particle board "skinned" with plastic laminate in your darkroom. The joints where the work counter meets the backsplash should be carefully waterproofed. Plastic laminate is able to withstand sustained use, although in time it will inevitably scratch. Recently, a new laminate was introduced, which is said to be better able to resist abrasion. Black-and-white chemistry will not affect the surface, and any commercially available laminate can be expected to remain free from stain.[†] If possible, the laminate should be bonded to the wood with white glue rather than with the contact adhesive usually sold for the purpose, as it makes a better bond.

The height of the counter is important and should be considered in advance. Stock kitchen cabinets are 36 inches high

*Assuming no natural ventilation openings. New York City Building Code, 1972.
†Exceptions are paradiamine (Edwal Super-20) and selenium toner.

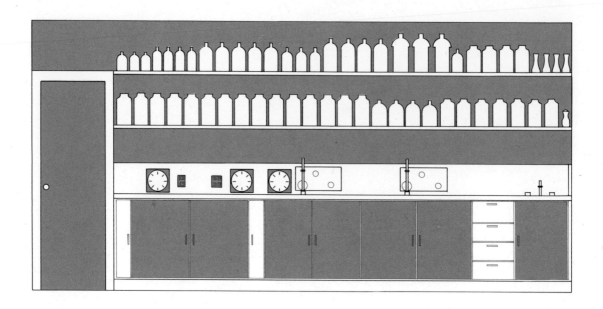

(inclusive of a 4-inch base and 2-inch countertop) and 24 inches deep. If this height is uncomfortable, a custom-designed cabinet can be substituted, using the 36-inch measurement as a point of departure. Commercially available stainless-steel kitchen sinks are adequate. The chemistry used for black-and-white processing will neither stain nor corrode these products. Sinks may be constructed using fiberglass and marine plywood; however, get advice from a professional cabinetmaker. Carefully determine the size and purpose for which a specific sink is being designed.

page 168

The cabinets shown are modular in design, inasmuch as they do not share common sides. They can be moved around and rearranged, added to or eliminated, if necessary. They are entirely functional and have adjustable shelves for equipment and chemical storage. Needless to say, the general darkroom area should be as free from clutter as possible.

CONSTRUCTION/ENLARGING CABINET

Special attention should be given to the construction of the cabinet or stand that holds the enlarger. The base should be considered as an integral part of the enlarger: It should be so stabilized that floor vibrations will be absorbed; it must be steady enough so that it will not cause the enlarger to move; and it should be constructed in such a manner that it is isolated from the components surrounding it.

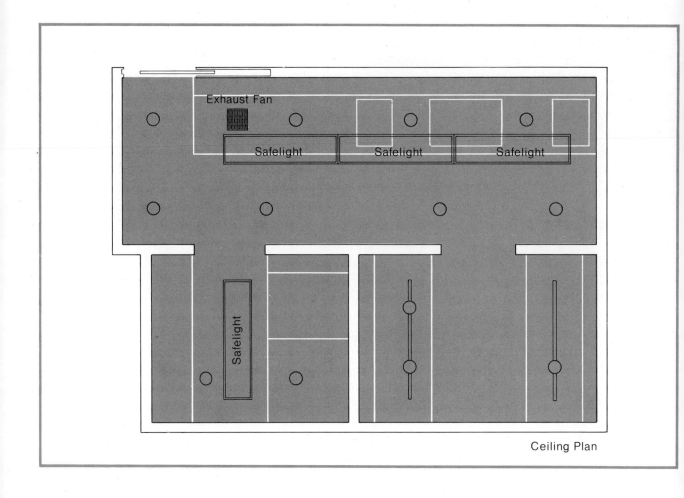

Exhaust Fan

Safelight Safelight Safelight

Safelight

Ceiling Plan

166

SAFELIGHTS/GENERAL ILLUMINATION

The level of safelight illumination should be of sufficient intensity to allow for safe movement in the darkened room and to provide enough light for retrieving equipment and supplies. A print should not be judged by the light emanating from a safelight, and therefore the use of high-intensity lamps is not recommended. The location of the lamps is of utmost importance (especially in the printing area) and should be given deliberate consideration.

You can use a fluorescent-type bulb in your darkroom. These lamps, manufactured by the Chemical Products Company,* are covered with a plastic material that renders them safe for nearly all general types of sensitive paper emulsions. The recessed installation guarantees that the lights are at least four feet from the countertops as well as an equivalent distance from any sensitive materials.

The general-purpose lamps can also be recessed in the ceiling and can consist of 75-watt reflector floodlamps. They can be strategically placed over the areas where evaluation of the print (in its various stages of process) occurs.

The type of light source used for the evaluation of the toning process should be similar to the general illumination utilized for viewing the framed print. If the quality of the light is primarily daylight, then use a daylight (blue) bulb; if the illumination is primarily artificial, then use a tungsten bulb.

SAFELIGHT ILLUMINATION TEST 2

". . . With continued use, safelight filters can degrade, allowing progressively more light or light of a different spectral quality to reach the work surface. Consequently, safelights may become progressively less safe during long periods of use. Also, the output of the lamps used within safelight fixtures can vary due to fluctuations in line voltage and with the age of the lamps. Thus, for various reasons, darkroom illumination can change from hour to

*North Warren, Pa.

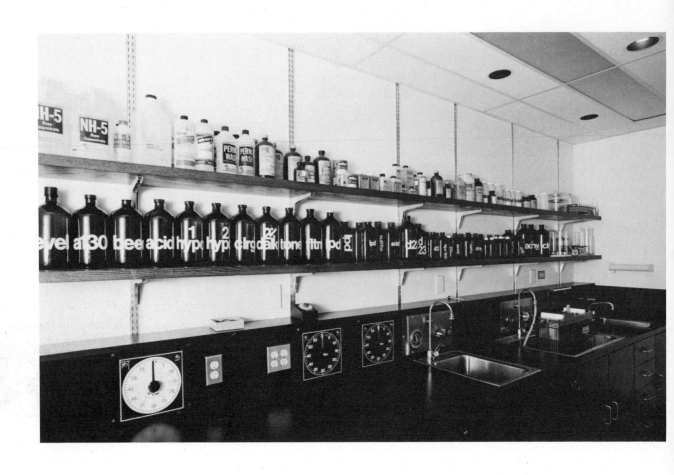

hour and day to day without any conscious changes introduced by the operator. The values reported in accordance with the standard methods are one half the actual safety times found in given tests with the equipment and materials in question.

"Materials that are not photographically exposed can withstand darkroom illumination for longer times before detectable changes occur than can the same materials that are given photographic exposure. This signifies that safety time for unexposed materials is the least sensitive measure. . . . Therefore, under normal circumstances, it would be more useful to determine the values of . . . exposed materials. . . ."*

PROCEDURE

1. Place the Tone 9 negative (generated in Calibration 3) in the enlarger and print it, making sure there is no apparent reflectance density.
2. Using 4" × 5" sheets of paper, expose the first to the Tone 9 negative. After exposure, place a coin on the surface of the paper (still on the enlarger baseboard) and allow it to remain there for one minute. Repeat, allowing the exposed paper to remain there for progressively greater periods, that is 2, 4, 8 minutes.
3. Process the exposed samples. If safelight illumination fog is present, the outline of the coin will be apparent.

*Adapted from American National Standards Institute (ANSI PH2.22-1971).

8

The Print

... First, there is the amazing precision of definition, especially in the recording of fine detail; and second, there is the unbroken sequence of infinitely subtle gradations from black to white. These two characteristics constitute the trademark of the photograph; they pertain to the mechanics of the process and cannot be duplicated by any work of the human hand.

The photographic image partakes more of the nature of a mosaic than of a drawing or painting. It contains no lines in the painter's sense, but is entirely made up of tiny particles. The extreme fineness of these particles gives a special tension to the image, and when that tension is destroyed— by the intrusion of handwork, by too great enlargement, by printing on a rough surface, etc.— the integrity of the photograph is destroyed.

Finally, the image is characterized by lucidity and brilliance of tone, qualities which cannot be retained if prints are made on dull surface papers. Only a smooth, light-giving surface can reproduce satisfactorily the brilliant clarity of the photographic image.

Edward Weston
"Seeing Photographically"
The Complete Photographer
Vol. 9, No. 49, pages 3200–3206

CHAPTER CONTENTS

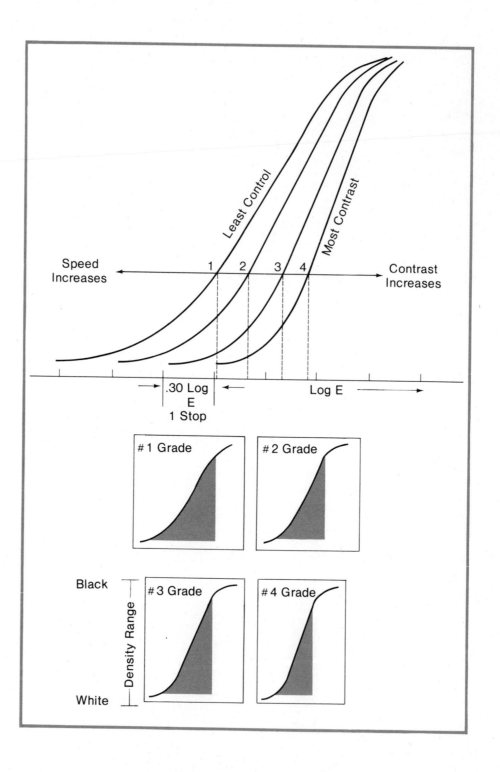

PHOTOGRAPHIC PAPERS/SENSITOMETRY

The concepts and definitions that were explored and developed relative to the sensitometry and measurement of film have their counterpart in the analysis of paper. Differences exist relative to the materials rather than to the theory involved.

With photographic paper, the sensitometric curves are reversed. The toe of film correlates to the shoulder of paper, and the shoulder of film relates to the toe of paper. The straight-line portion of the paper curve is much steeper than that of film. Units of measurement are called reflectance density.

Variable development (expansion and contraction) is not readily applicable to photographic paper. Generally (and for the sake of this discussion), paper does not respond to changes in development. Time-temperature graphs are therefore inapplicable. Paper is supplied having different contrasts, which are inherent in the manufacture of the emulsion. The paper grade is somewhat analogous to the Contrast Index (Contrast Gradient) of film. Further, a specific negative's Contrast Index implies a specific grade of paper. Throughout this text, however, it is urged that the negative be scaled (exposed/developed) in order that its range of tones can be accommodated by a normally scaled paper (grade #2 or equivalent contrast paper).

PHOTOGRAPHIC PAPERS/SPEED–SENSITIVITY RATINGS

By examining the curves produced by the differing paper contrast grades, it is possible to draw several meaningful conclusions:

1. The paper curves move left (the least contrast and most sensitive) to right (the most contrast and least sensitive).
2. The maximum black or white reflectance density that a paper is capable of producing is not dependent on its contrast grade.

3. A line drawn parallel to the horizontal axis (exposure) intersects each curve at a point 0.60 on the vertical axis (reflectance density). This is defined as the "speed point" of the paper. The paper having the least contrast is the most sensitive.

This is a relatively new standard, and it relates directly to the exposure scale of paper. It was determined that for a visually meaningful comparison of photographic tones, the midtone region of print values (reflectance densities) was the most appropriate. Therefore, 0.60 (approximately Tones 4 and 5) was chosen as the point of reference.

PHOTOGRAPHIC PAPERS

Photographic papers can be classified by their chemical and physical characteristics as well as their scale and contrast.

Chemical Properties. The chemical composition of the paper emulsion concerns the practicing photographer only insofar as it affects the final translation of the photographic concept that led to the negative and to the print.

Photographic papers are initially categorized by their constituent chemical compositions. Broadly speaking, the major classifications are: silver chloride, silver bromide, and an amalgam of the two, chlorobromide or bromochloride, depending upon the preponderance of each constituent. There are certain characteristics inherent in each type.

Silver chloride. A slow paper, silver chloride is used mainly for contact printing.

Silver bromide. A fast paper, silver bromide's manufacture in its pure form has been largely discontinued.

Chlorobromide. A medium-speed enlarging paper, chlorobromide produces a warm-toned image.

Bromochloride. A medium-speed paper (although more sensitive than the chlorobromide derivation), bromochloride is inherently cold-toned.

Physical Properties. The physical characteristics of photographic paper are:

1. Weight—either single or double weight. There are intermediate classifications, such as light or medium weight.
2. Surface—either glossy or matte (with seemingly infinite variations in-between).
3. Color—the color of the paper stock upon which the emulsion is impregnated. Colors range from an ivory blue-white to a buff paper base.
4. Tone—either warm or cold. The tone of the print is greatly influenced by the composition of the emulsion and, to a great extent, by the developer used to produce the print. The tone can be modified through a toning procedure.

page 206

EXPOSURE SCALE

Film is transparent and thus transmits light. It is therefore able to record a greater tonal range than paper, which reflects light. (The light actually passes through the paper emulsion and reflects back from the paper base through the emulsion.) Film will record a ratio of light from approximately Tone 1 through Tone 11 (two full exposure units more than Tone 9), a ratio of approximately 1:1000. At best, glossy photographic paper is capable of recording a tonal range of 1:50. This range of tones produced on the photographic paper emulsion is called the exposure scale of the paper. The effective scale is defined as the maximum black the paper is capable of generating to the faintest perceptible tone (Tones 1 through 8). It is not important that the high negative densities (Tones 9 through 11) reproduce as anything but paper base white. What is imperative is that the high tones that were manipulated by exposure/development appear in the print as originally perceived and desired.

The exposure scale of photographic paper is directly related to the development of the negative; the two function interdependently. The film must be exposed/developed to a specific density (gamma, or Tone 5) that will reproduce as it was perceived.

Because of the differences that exist in the tonal ranges of the two materials, the development of the negative must correspond to the capabilities of the paper. In effect, this was accomplished in Calibration 3. If the calibration was performed successfully, the Contrast Index obtained would be about 0.60, or the density obtained would be equivalent to 60 percent of a specific exposure. Thus exposure/development of the negative has been compressed to fit the lesser scale/range of photographic paper.

page 95

PHOTOGRAPHIC PAPERS/SURFACE

page 241

Matte photographic paper (textured) contains both diffuse and specular reflectances but tends (depending on the irregularity of its surface) toward the diffused measure. Glossy photographic paper, on the other hand, leans toward the specular characteristic of the scale. Both papers are inherently capable of producing an equivalent range of tones (easily observed when the papers are wet). However, once the matte paper dries, the irregular surface reduces the range of tones. The small, irregular variations (texture) of its surface reflect small, specular highlights, which make the extreme ends of the tonal scale (black to white) appear lifeless and gray.

PRINT EXPOSURE

The exposure time for prints has traditionally been recommended to be the amount of time needed to produce a faintly perceptible tone below paper base white, while the shadow areas are manipulated by either a change in contrast grade or composition of the paper developer. This concept is similar to that of negatives, where exposure is based on the shadow values, while the high tones are manipulated by development.

The quality of a print, should depend on the production of low-tone values. This instinctive and very subjective viewpoint is confirmed in the book *Photographic Sensitometry:**

*Hollis N. Todd and Richard Zakia, *Photographic Sensitometry.* Hastings-on-Hudson, New York: Morgan & Morgan, 1969, pages 82–84.

An experiment was done to determine the print characteristics for the images preferred by a panel of observers. In general, it was found that only a part of the paper curve was used in making excellent prints. Specifically, almost no preferred print contained the maximum density of which the paper was capable.... The inference from this discovery is that for pictorial prints, viewers want to see detail in the shadows, even at the expense of the deepest possible tone.

The location of the highlight point in the preferred prints was more variable than the shadow point. In some prints called excellent by the viewers, the lightest tone was in fact the base itself; in others, the lightest tone has a small density. The best available experimental evidence indicates that the correct exposure level in printing should be based on the shadow reproduction.

If all procedures have been followed and successfully performed, you can begin your exposure determination by printing at the standard printing time (allowing for differences in lens-to-paper distance) on a normal, or grade #2, paper. If a higher- or lower-contrast paper is determined to be necessary at this juncture, the exposure time will have to be changed. However, the standard printing time with normal graded paper would serve as a reference point. Departure from this standard should be for emphasis of tone, not for the creation of a new tonal structure.

Enlarging times should be kept within an 8- to 16-second range. Less exposure does not permit enough time for any burning-in or dodging manipulations. Too long an exposure will result in an unsharp image, caused by inevitable vibrations induced by factors often not under the photographer's control—outside traffic, movement in the darkroom, and the like.

page 215

EXPOSURE/DRYING DOWN

When viewed in solution, prints will exhibit a higher reflectance density than when they are dried. Low- and high-tone separation/delineation are greatly pronounced when the print is wet. Adjustments in exposure time must be made for this drying-down effect. Experience will be the determining factor.

EXPOSURE/PRINTING DOWN

Printing down refers to the procedure of giving the paper more exposure than would ordinarily be needed to produce a "normal" print. You should be keenly aware (especially after having completed Calibration 1) of the major change that is produced in the low-tone print values by increasing the exposure slightly. Essentially then, printing down will lessen the delineation between the low tones disproportionately more than is the case with the higher print values, causing an increase in contrast. The effect is more pronounced with the condenser-type enlarger.

PHOTOGRAPHIC PAPER/CHOICE/SELECTION

The choice of photographic paper and the realization that is evidenced in the photographic print are intertwined, as is the entire photographic procedure. This selection entails an analysis that encompasses the full translation/perception process. All the procedures and concepts that have been examined have, in effect, been influenced by this decision.

Hard-and-fast rules are nonproductive, for differing photographic problems need to be studied for the best approach that would lead to the full realization of the process.

In general, I prefer a double-weight glossy paper (matte-dried), which, when toned, affords a print of maximum tonal range as well as a brilliance that underlines the precision of the camera/lens and gives full expression to the fine photographic print. This is not to say that other papers and procedures cannot afford the creative photographer a nearly limitless means of expression. Paul Strand used matte paper, which he varnished, and which, in its subtlety, afforded great beauty and depth to his prints. What is of utmost importance, however, is that the photographer should choose and use a paper that is fully capable of realizing the potential and understanding of the medium.

There are many types of photographic paper. You can try Kodak Ektamatic SC Paper, which is primarily designed for use

with a stabilization processor; however, when used in the conventional tray procedure, it is capable of producing a print of extreme brilliance. Artificial brighteners have been added to the emulsion (to counteract the reduction of brilliance that occurs when the prints are processed in a stabilizer), which add to the overall effect. Ektamatic SC also produces beautifully rich tones when toned in selenium. The problems encountered concern the softness of the emulsion when the print is tray-processed. This can be overcome by the judicious use of hardening agents; nevertheless, great care must be exercised in processing this paper, regardless of the above modification of formula. The contrast of the paper is modified by using the same filters as those employed with Polycontrast Paper. The overall contrast of this paper is greater than that of Polycontrast, and a #1 or #1½ filter is used as "normal." Ektamatic SC is more sensitive (approximately two times faster) than Polycontrast Paper.

page 213

Variable-contrast papers, which are dependent upon the color of a tungsten light source, do not operate well with a cold-light diffusing-type enlarging light source. The color of the diffused light source must be modified by color-printing filters. These filters are quite dense, and the resulting enlarging times become unwieldy. Kodak Kodabromide Paper can be used whenever this light/diffusing source is employed. This is a relatively fast enlarging paper (to make up for the smaller light output from the cold-light). Depending on its grade, Kodabromide Paper is capable of great brilliance when toned in selenium.

page 183

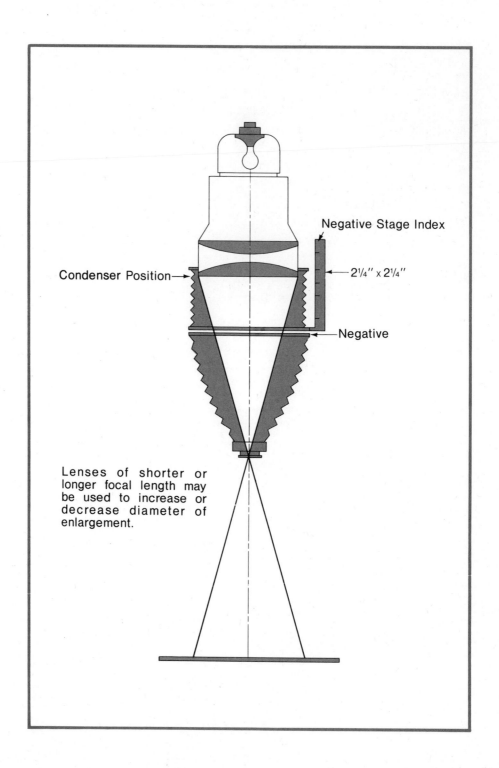

Negative Stage Index

2¼″ x 2¼″

Condenser Position

Negative

Lenses of shorter or longer focal length may be used to increase or decrease diameter of enlargement.

THE ENLARGER

The photographic enlarger is the pivot around which the successful darkroom functions. The characteristics of the individual enlarger design (not to mention the singularity of one's own enlarger) play no less a part in the production of the print than the camera/lens. The enlarger is the touchstone upon which the entire darkroom procedure is dependent.

Two types of enlarger design are employed for general photographic use, each characterized by the light source (illumination) used to project the negative.

Diffuser Source of Illumination. The cold-light enlarging design incorporates a cathode tube (similar to a neon light) closely aligned against a diffuser panel (in the typical application, a piece of opaque plastic). The light emanating from the diffuser is the light source. The negative is thus illuminated evenly over its surface and projects through the enlarging lens toward the easel.

page 184

Focused Rays (Condenser Source of Illumination). Strictly speaking, a true condenser design (point light) is not in general use today, other than in commercial graphic arts printing plants. The devices used for the general photographic field are a fusion of both a diffuse source and the condenser type, although the design tends toward the latter—hence its designation. In this format, a frosted bulb scatters its rays against the matte surface of the lamphouse, which in turn reflects downward through a pair of condensers (lenses). The light rays are at that point collimated (focused) toward and pass through the negative.

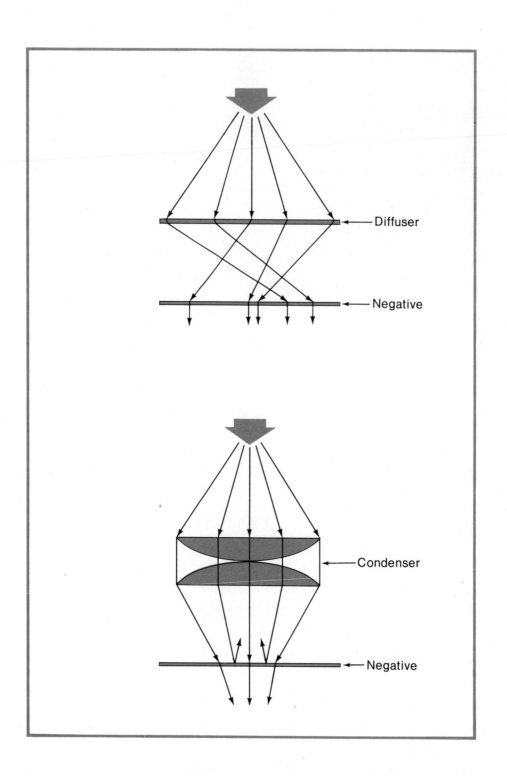

THE CALLIER EFFECT

The Callier effect is a phenomenon named after André Callier, who first recognized that collimated light (condenser-type illumination) produces greater contrast than light whose rays are not focused. He formulated the theory that when focused rays strike the denser part of the negative, they are scattered/reflected back toward the light source. Therefore, the transmission of light through the negative is nonproportional, or nonlinear. The higher the density, the fewer the rays that will project toward the paper, causing an artificial (but very real) decrease in the higher print values. For example, Tone 8 projects/transmits proportionately less light than Tone 7 because of (a) exposure, (b) development, and (c) the Callier effect (applicable to the condenser enlarger).

With a diffused light source, the rays are not focused/collimated and can be classified as random at their source. Therefore, proportionately equal amounts of light pass through the negative, resulting in an image that closely approximates the original negative densities.

You have (if condenser illumination is being employed) compensated for this dysfunction by developing the negative (Calibration 3) to a lower density (gamma) than would be obtained if a diffusing light source were being standardized.

The effect is most pronounced at Tones 5 through 9—proportionately greatest at Tone 9. There is little or no consequence at the lower tones.

CHOOSING AN ENLARGER

The selection between the two competing types of enlargers is surely one of the most important photographic decisions that can be made. Each type offers the photographer advantages and corresponding disadvantages that are both real and far-reaching, and that must be weighed and balanced to make a knowledgeable judgment.

The condenser variation is certainly the most widely used and popular of the two. Its claimed benefits include greater sharpness and contrast, especially when using miniature film materials.

First, sharpness must be defined. The functions of contrast and sharpness, in this context, are interdependent—sharpness is a function of contrast. A negative containing an image of a lens resolution chart, for example, will show little or no difference in terms of resolution. (These charts are usually black lines closely spaced on a white background.) However, the apparent sharpness when a continuous tone subject is being enlarged is greater with the condenser type because of its greater inherent contrast. This is most evident in the low values of the print. The low tones generated by the condenser source of illumination have a depth and delineation that are lacking in those made under a diffused light source. On the other hand, the high-tone print values are more even and less likely to be "blocked" under a diffused light source. This can be offset to a large extent in the development of the negative, if compensation has been made for the Callier effect.

Lastly, negative defects, such as dust and scratches, are maximized with the condenser enlarger and minimized with a diffused light source. Grain is also more pronounced with the condenser-type enlarger.

The Omega and Beseler enlargers have provisions for interchangeable light sources. Although neither firm produces a cold-light source, you can order a diffusing head from Aristo Products, which supplies such devices for these and several other brands of enlargers.

ENLARGER/TESTING PROCEDURES

For uniformity of illumination:*

1. Set the enlarger for maximum magnification.
2. Install the largest negative carrier that the enlarger is capable of housing (the carrier should be empty).
3. Use a lens that is approximately equal to the diagonal of the negative carrier opening.
4. Set the lens for its maximum aperture.

Method a. Use a photometer (either an enlarging meter or a spot photometer) to measure the center (usually the brightest point) and the corners (usually the darkest point).

Method b. Adjust the length of time necessary to produce a print (without a negative in the carrier) at maximum lens aperture that would result in approximately a Tone 6 print value. High-contrast paper will give the best results.

Uniformity can be improved upon by:

1. Refocusing the condensers.
2. Centering and/or replacing the enlarging bulb.
3. Using a longer-focal-length lens.
4. Using a smaller lens aperture.

*Adapted from American National Standards Institute (ANSI) *PH3.31-1958* (R1971).

ENLARGER/TESTING PROCEDURES

Alignment of Optical Axis, Negative, and Easel.* When there is a difference in magnification between one side of the print and the other, parallel lines in the negative are reproduced out of parallel in the image. The one condition that causes this effect is if the negative is not parallel to the easel. The maximum out-of-parallel condition occurs for lines that are perpendicular to the line of intersection of the plane of the negative with the plane of the easel. A negative can be made having pairs of widely spaced parallel lines running in several directions. Each pair should be symmetrical with respect to the center of the negative. If the projected lines of any pair are not parallel from one side of the image to the other, the negative is not parallel to the easel.

There are causes/corrective procedures:

1. The negative is not parallel to the easel.
2. The lens board is not parallel to the negative and easel.
3. The lens is defective.
4. The flange of the lens is not parallel to the mounting surface of the board.

*Adapted from American National Standards Institute (ANSI) *PH3.31-1958* (R1971).

THE ENLARGING LENS

The enlarging lens is the last but equally important link in the optical photographic chain. Both camera lens and enlarging lens should be matched in quality. It makes little sense to have the "best" camera optics and yet use an enlarging lens of inferior quality; the final and ultimate print quality would then be dependent upon its weakest link.

The description of what is considered "normal" in terms of focal length of the enlarging lens is now subject to some dispute. The usual rule of thumb that the lens be equal to the diagonal of the negative has come into serious question. The current alternative recommendation is that the focal length of the lens be greater than that of the diagonal of the negative. For example, an 80 mm lens would be considered "normal" for 35 mm negatives instead of the 50 mm optic, 135 mm for 2¼" × 2¼", 150 mm for 4" × 5". By using the longer-focal-length lens, image quality will be improved to a certain extent. More importantly, however, illumination over the field will be greatly improved (especially true with condenser-type sources of illumination).

This recommendation is useful, but there are some minor reservations. First, enlarging lenses today are very well corrected, and lens falloff—uneven illumination at the corners of the projected image—is minimal. Second, the increased exposure times that will have to be accommodated due to the longer lens-to-easel distance might be detrimental to the resolution of the projected image. As is the case with any lens, the enlarging lens' sharpest and most corrected aperture is two to three stops below the maximum lens aperture.

page 54

The most important consideration in the choice of a lens is not the resolution of which the lens is capable, but rather the contrast inherent in the lens design. Contrast, in this context, is not only a function of lens design, but of lens coating. Different focal-length lenses from the same manufacturer have differing contrast characteristics, and you should choose this piece of optical equipment with the same care and thought that was used in buying a camera lens.

ENLARGING METERS

In operation, these devices are analogous to the photometer. However, instead of translating any tone within their field of view to an 18-percent reflectance, they read out and base exposure on information supplied by the user. If, for example, you wish to produce a Tone 2 print value from a specific area of a projected negative, you would set the calibrating dial on the meter (after having established the proper setting), place a probe on that projected negative density, and read out an exposure, based either on aperture or enlarging time, which will produce that key tone. These meters, depending upon their operation, are sensitive either to the highlight or the shadow areas of the negative. The more expensive devices will read both in order to establish contrast range (indicating contrast grade).

These meters can be used when it is necessary to make a large number of prints that must have specific tones matched to each other. After one successful print is produced, the key tone is measured and the meter calibrated. Regardless of the ensuing enlarger height, differences in the quality of the negatives, and the like, you will be able to reproduce that particular tone with assuredness, speed, and little effort.

From a practical viewpoint, however, these calibrating settings must be repeated during each printing session and for each type (grade as well as manufacturer) of paper. Developers, paper, and all the variables encountered during the photographic process can never be standardized to a point where these settings are truly repeatable.

The problems with their use (other than the amount of time needed for their calibration) are philosophical rather than technical. There is a temptation to set the meter and to unquestioningly accept the exposure determination. Within a given exposure, however, there is room to subtly alter print values. If you accept without analysis the exposure produced by the meter, the device would be counterproductive. If, however, you use the exposure indication as a starting point for further exploration, then the device fulfills a useful function.

FOCUSING DEVICES

Generally, these devices being manufactured today focus on the aerial image projected by the negative. The magnification is sufficiently large to enable the user to focus on the grain of the negative. After adjustment for the individual's eyesight, these focusing devices are accurate and a necessary addition to the darkroom.

The Micromega Focusing Aid is a fine optical instrument. It is unusual in that in conjunction with a large reflecting mirror, its eyepiece can be tilted, allowing for measurement of any area on the print surface. Other devices do not have this ability, and focusing is limited to the center of the projected image. Focusing is accomplished with the lens at its widest aperture, which is the most critical inasmuch as there is no allowance for depth of field. The Micromega Aid is able to respond to low-light levels as well, so that focusing is also done at the selected lens stop. It is possible with this aid to photograph a resolution chart and use the resultant negative to check for the sharpest aperture inherent in the design of the particular enlarging lens. The focusing devices should be elevated to the same height as a piece of enlarging paper, so that when focusing, the device is on the same plane as the paper. This is easily accomplished by securing a piece of enlarging paper to its base.

TIMERS

The recently introduced electronic timers are a much needed addition to the photographic procedure. These devices are capable of an accuracy far exceeding normal photographic demands. Moreover, their consistency allows new standards to be set and maintained. The older mechanical timers (even though they are electrically driven) are not as accurate and, more importantly, not as consistent. The consistency of a given timer is of greater benefit than its accuracy. Without repeatability, it is impossible to set meaningful standards.

ENLARGING EASELS

The minimum requirements for these devices, although rarely met in practice, are that they should be capable of holding the paper flat and securing adjustable, squared print borders. The type that allows for variable borders is preferable over the single-size easels. The surface of the easel should be treated to enable the printer to view the projected negative image upon it.

CONTACT PRINTERS

This discussion is limited to that type of device used for assessing an entire roll of film, although four 4" × 5" sheets of film can also be printed at once in these units.

Contact printers have a hinged glass cover that holds the negatives and paper in contact with a foam-covered board. The entire unit is placed under the enlarger and receives an exposure that will produce as many images as are being printed.

The contact prints are examined (with a magnifier in the case of 35 mm film), and the better negatives are then selected for subsequent enlarging. This is especially important if the photographer is unsure of his technique and is therefore forced to "bracket" his exposures.

These devices should be used for portrait work, where it is difficult to "read" the expression of the subject in the negative.

PAPER CUTTERS

The rotary-type paper-cutter blade is an improvement over the knife-edge type of cutter. However, in both cases, the blades must be capable of being sharpened, or else the emulsion will crack along the cut edge. The alignment of the various components of the unit—cutter (or blade), ruled top edge, and side edge—must be checked periodically. A razor-type knife, used in conjunction with a straightedge, produces a clean cut, although great care must be exercised in this procedure.

ELECTRICAL CONSIDERATIONS

Voltage Regulators. While absolutely mandatory in the color darkroom, these devices are useful in the production of black-and-white prints only if the voltage in the darkroom is subject to wide fluctuations. Loss of voltage may be caused by the utility in the area, inadequate wiring, or too many devices on the circuit.

Rheostat. This is a device that limits the voltage going into an electrical apparatus. In the case of an enlarging bulb, it reduces its output/intensity. The rheostat is an integral element in the design of the Beseler enlargers—a useful addition to all enlarger designs. You can purchase one at most hardware stores. By reducing the current, and with the subsequent loss of bulb intensity, the rheostat acts as an infinitely variable neutral density filter. This allows the enlarging lens to be used at a specific aperture while maintaining a constant exposure time. When voltage is reduced, however, the color of the light is subject to change, which at extreme levels will cause a shift in contrast with variable-contrast papers. Testing will be required.

page 181

NEGATIVE PREPARATION

Before it is inserted into the enlarger, the negative should be thoroughly cleaned and neutralized so as not to attract airborne dust particles. The cleaning must be done with great care, for there is danger of scratching the emulsion.

Clean negatives with a soft cloth (Ilford Antistaticum) expressly made for this purpose. After this treatment, spray the negative with compressed air generated by a small compresser. Finally, use an antistatic device (the Zerostat) that operates by producing both positive and negative electrical charges. This device is intended for phonograph records, but it operates with great efficiency when used to neutralize a negative.

The enlarger should be grounded, preferably to a cold-water pipe or a grounded electrical outlet; this will help to eliminate the dust-collecting proclivity of the negative.

DEVELOPMENT/CHEMISTRY

The chemical ingredients involved in the compounding of development formulas for print materials are essentially the same as those used for negative emulsions. The constituents of the formula perform equivalent functions; however, proportions differ, due to differences in materials and application. In essence, those qualities that are meaningful in the development of the negative (for example, grain, contrast) are of little or no consideration in the compounding of a print developer. Rather, those qualities that are enhanced through the chemical interactions (print color, fog levels) are emphasized. In short, the visual quality of the negative is of little concern; the visual quality of the print is of primary importance.

From an analysis of two widely used formulas, the distinctions and similarities can at once be observed.

	D-76	D-72
Metol (Elon)	2.0 grams	3.0 grams
Sodium sulfite (des.)	100.0 grams	45.0 grams
Hydroquinone	5.0 grams	12.0 grams
Borax	2.0 grams	
Sodium carbonate		80.0 grams
Potassium bromide		2.0 grams
Water to make	1.0 liter	1.0 liter

Metol (Elon). The "standard" developing agent, Metol is usually compounded with hydroquinone.

Sodium Sulfite. Sodium sulfite is an anti-oxidizing agent. In saturated solution, it acts as a silver solvent for the development of the miniature/roll-film format. For paper materials, its use is primarily restricted to its preservative function.

Hydroquinone. In combination with Metol, hydroquinone produces greater contrast than Metol alone. In print formulas, it builds

up greater silver densities in the lower print values. In the compounding of print formulas, the ratio of hydroquinone is greater than in negative emulsion solutions. The proportions are, however, variable, producing a nearly infinite range of print contrast.

Borax. A mild alkali, borax is used in the compounding of negative emulsion formulas so that the rate of development can be more easily controlled.

Sodium Carbonate. An active alkali, sodium carbonate is commonly used in the compounding of print developing solutions. Its use should be carefully controlled. This chemical increases the rate of development, thereby reducing the possibility of safelight fog.

Potassium Bromide. Chemical fog (as opposed to safelight fog) in the developed print image is of far greater importance than in negative materials. In the latter, fog (the reduction of unexposed silver halide crystals) is evidenced in the low tones (Tones 1 through 3), which has the effect of artificially increasing their density. However, this condition is relatively easy to compensate for either in the printing process or by chemical reduction. Print fog, on the other hand, can seriously reduce the contrast range of the image, reducing the overall brilliance of the print.

page 256

Use of the modern antifoggants (Kodak Anti-Fog #1 [benzotriazole], Edwal Liquid Orthazite) is recommended instead of the more traditional potassium bromide. The latter produces prints with objectionable print color, whereas use of the former improves the color of the print. Both chemicals should be used with caution.

Ansel Adams suggests that formulas be compounded without their inclusion and tests performed to determine the correct amount of restrainer to use. As the restrainer is added to the formula, the result would be increased image contrast; too, there would be a decrease in the effective paper speed, making

developing/exposure times unduly long, with the resultant problems associated with prolonged development times (safelight fog, print color).

Test to determine appropriate quantity of restrainer:

1. Perform the calibration for safelight fog levels.
2. Expose the Tone 9 negative at the standard printing time.
3. Develop the tested sample in a solution that does not contain either potassium bromide or an antifogging agent.
4. Develop for 1½ minutes, then compare the sample with an unexposed and undeveloped but fixed piece of paper. This will be the standard.
5. Expose 3 sheets of paper as in Step 2, and develop each for 3, 4, 5 minutes, or any sequence up to and including the first stage at which the chemical fog is apparent.
6. At the first sign of development fog, add either 5 cc of potassium bromide or 1.0 percent Kodak Anti-Fog #1 to each liter of solution.
7. Repeat the above sequence (Step 5), starting at a point where the fog level became apparent.

Analysis of Restrainer Level/Fog Test. Your concern is the total practical time of immersion of the paper in the developer solution.

THE PRINT/RATE OF DEVELOPMENT

The concern with the development of the negative was to produce those negative densities that related either literally or figuratively with what was seen/perceived at the time of exposure. Exposure/development of the negative should be thought of as one functioning unit. This degree of dependency should not be an overriding consideration with regard to the print.

The rate of development of the print image must be balanced to produce full rich blacks without producing fog. By decreasing the development time from the standard (1½ minutes), the low-

tone negative densities will not produce full blacks, while the higher print values will be streaked and mottled.

Increasing the development time over the established standard lessens the delineation between the lower tones (Tones 1 through 3 will appear as Tone 1), while the high-tone print values will not be appreciably deepened (do not confuse print fog with a deepening of the higher print reflectances), thereby decreasing the contrast of the image.

BEERS FORMULA/VARIABLE CONTRAST

While this formula has gradually fallen into disuse and has been replaced functionally by the variable-contrast-paper materials, it is included here to show how the various chemical constituents employed in the composition of the print formula operate in concert with each other. Also, using this formula with modern variable-contrast papers as well as with other paper materials can provide you with an element of control that can spell the difference between an ordinary print and one that has exceptional beauty.

	Solution A	Solution B
Metol (Elon)	8.0 grams	
Sodium sulfite (des.)	23.0 grams	23.0 grams
Hydroquinone		8.0 grams
Sodium carbonate (mon.)	23.4 grams	31.5 grams
Potassium bromide	*	*
Water to make	1.0 liter	1.0 liter

progressively greater contrast →

Use	1†	2	3	4	5	6	7
A	8	7	6	5	4	3	2
B	0	1	2	3	4	5	14
Water	8	8	8	8	8	8	0
	16	16	16	16	16	16	16

*Tests should be made to determine the proper amount of restrainer.
†Further dilution can give decreasing amounts of contrast.

page 196

ANSCO A130 DEVELOPER
(Metol, glycin, hydroquinone)

This formula is included because it produces an image of extraordinary beauty. It is a good choice for exhibition prints. When used in conjunction with Kodak Ektamatic SC Paper, it produces images of great clarity and depth—the prints seem to "glow." The differences are subjective and emotional (subtle, at best), but considerations and explorations such as these are the true mark of a craftsman.

Metol (Elon) 2.2 grams
Sodium sulfite (des.) 35.0 grams
Sodium carbonate (mon.) . . 78.0 grams
Glycin 11.0 grams
Postassium bromide *
Water to make 1.0 liter

This is Ansel Adams' variation of the published formula, which is successful. Adams further suggests that if more contrast is needed, the following hydroquinone formula should be employed:

Sodium sulfite (des.) 25.0 grams
Hydroquinone 10.0 grams
Water to make 1.0 liter

PACKAGED DEVELOPERS

There are many commercially prepared developers that will produce prints of beauty and scale under nearly all circumstances. The compounding of developers from formularies should be undertaken only after one of the packaged formulas has been fully explored and analyzed. Formulas that are not commercially available should be used with caution, and only to emphasize those qualities that cannot be produced with packaged products.

*Tests should be made to determine the proper amount of restrainer.

The translation process should take into consideration those variations from the norm that can be produced by the compounding of developer formulas, and should use them creatively.

A commercially prepared developer (Ethol LPD) is long-lasting and capable of producing prints of great brilliance and long scale. The color of the print can be changed by the dilutions recommended by the manufacturer. This developer is replenishable, and its strength can be easily maintained.

STOP BATH

The stop bath serves the same function in the processing of printing papers as in the processing of film. It neutralizes the developer solution carried over by the developer-saturated print and halts the development process immediately and evenly. The acid activity of the bath will be affected by the amount of developer carried over to it as well as the subsequent dilution caused by the developer. The bath must not be allowed to exceed a pH of 7.0 (neutral). Certain baths have dyes incorporated in their formulas that change the color of the solution once this condition takes place. These dyes are the liquid equivalent of the pH paper used to determine the acid/alkali content of a given chemical formula. The usual indicator employed for this purpose is Bromocresol Purple, an orange-yellow dye when the bath is fresh and has a pH of 5.2, but which turns purple at a pH of 6.8 or when the bath is nearly exhausted. Often the components of the formula will include a hardening agent (usually chrome alum) to harden the emulsion, making it relatively impervious to the handling that the print must undergo during the subsequent stages of processing.

FIXING BATH

The function of the fixing bath in the processing of the print is the same as for film. The solution dissolves the unexposed/undeveloped silver halide crystals. It is, however, impossible to verify this visually, unlike film, which becomes "clear" and is easily verifiable. It is important, therefore, to understand how the process works and, more importantly, why it fails.

When the unexposed silver halide crystals are treated in a fresh hypo solution, they are first dissolved and then converted to a silver-sodium-thiosulfate compound, which is further dissolved in the bath. (If these compounds are not eliminated, they will cause the print to fade.)

Once the fresh hypo formula is used, these compounds concentrate, and the solution becomes saturated with them. The hypo bath is then incapable of dissolving them. The salts are absorbed by the paper and, because they are not soluble in water, cannot be removed.*

The two-bath procedure has been recommended to cure this dysfunction. The first hypo bath dissolves most of the silver halide/silver-sodium-thiosulfate compounds, while the second hypo bath insures that any remaining salts are dissolved. When the first bath is exhausted, the second bath in turn is used as the first, while a fresh bath is compounded for use as the second solution, with the result that a fresh bath is available at all times. There have been differing recommendations as to the length of time that a print should remain in solution. The two baths should not be used for any more than eight minutes (four minutes each). This is the maximum length of time that a print should be so treated, as too long an immersion will damage the print. The image might fade, and the hypo absorbed by the paper fibers will be impossible to remove during the washing procedure.

*Hypo is soluble in water; silver-sodium-thiosulfate is not.

200

PRINT WASHING

Washing photographic prints is perhaps the easiest part of the process/procedure to understand and yet one of the most difficult to accomplish. Essentially, the wash must rid each print of the fixing solution and its by-products.

The manual procedures you can use are often time-consuming but offer a reasonable guarantee of success. Prints washed this way must be agitated constantly in fresh running water. The water supply must generally be free of contaminants (especially rust), or else the prints will stain. A water-filtering device is strongly recommended.

page 162

Print-washing devices are available, which claim to be able to achieve this goal "automatically." However, very few can readily attain the degree of washing that the process requires. Most such implements do not afford a method to separate the prints, and without this application, the prints can never be washed satisfactorily. Also, if the prints are allowed to circulate during the cycle, there is a danger of their damaging each other.

The East Street Gallery Archival Print Washer satisfies, with utmost simplicity, any objections that are raised concerning print washers. Dividers are set in what is essentially a large tank, and the prints are placed within these partitions. The water flow comes into the tank from the bottom and spills out the top. Air is introduced into the water flow, causing turbulence and enabling the print to wash relatively quickly.

page 242

Tests have determined that the temperature of the wash water should be between 75 and 80 F. If the water is warmer than this, the print emulsion will become too soft; if colder, an excessive amount of time will be needed to wash the print. The water exchange rate should be once every five minutes.

The amount of wash time depends upon the degree of permanence required. Double-weight papers need three to four times more washing than single-weight papers to reach the same level of permanence. A wash time of 30 minutes, using a device such as the East Street Archival Print Washer, is adequate for most double-weight papers.

HYPO ELIMINATORS/HYPO CLEARING BATHS

page 243 Hypo eliminators, such as Kodak HE-1, reduce the complex silver-sodium-thiosulfate salts to sodium sulfate, which is easily soluble in water. These formulas do not decrease wash time; rather, they chemically remove any traces of residual thiosulfate left after a thorough wash.

Hypo clearing baths, on the other hand, are mild alkalis and perform as washing aids. They increase the solubility of the complex salts and allow for shorter wash time. These formulas, such as Edwal 4 & 1, Heico Perma-Wash, or Kodak Hypo Clearing Bath, are highly recommended for all photographic prints; the hypo eliminator is necessary for archival processing. The two are complementary but cannot be substituted one for the other.

PRINT FLATTENING

A print-flattening solution should never be used for archivally processed prints, and its use with prints that are not up to this standard should be judicious.

Print flattening can easily be accomplished by using a dry-mounting press. Place the prints between 100-percent acid-free rag paper at a temperature of approximately 250 F for 30 seconds. Flattening can also be done by applying weight evenly over the print. The Seal Manufacturing Company produces weights that are not primarily designed for this purpose, but will work quite satisfactorily. Using a fine mist spray on the back of the dried print before placing the print under weight will also prove helpful.

PRINT DRYING

Much literature has been written in recent years concerning the drying of prints. This concern has come about due to the increased attention being paid to archival processing.

page 243

It is the consensus that under no circumstances should a heated drum-type dryer be used. The reasons may be briefly summarized as follows:

1. Excessive heat will cause damage to the prints.
2. The apron that is used to hold the print in contact with the drum is likely to be fouled by hypo residuals and will contaminate subsequent prints. These aprons are difficult to clean.
3. The color of the print is subject to change.

It is the current practice to recommend that prints be dried on fiberglass screens. (The Archival Print Dryer manufactured by the East Street Gallery commune is typical of these devices.) The print is first squeegeed with a rubber blade (which must be done carefully to avoid damage) or an apparatus such as the Falcon Print Squeegee. The print is placed on the screens, emulsion side up, and left to dry. Drying time depends on the relative humidity of the print-drying area and the amount of excess water left after the print has been squeegeed.

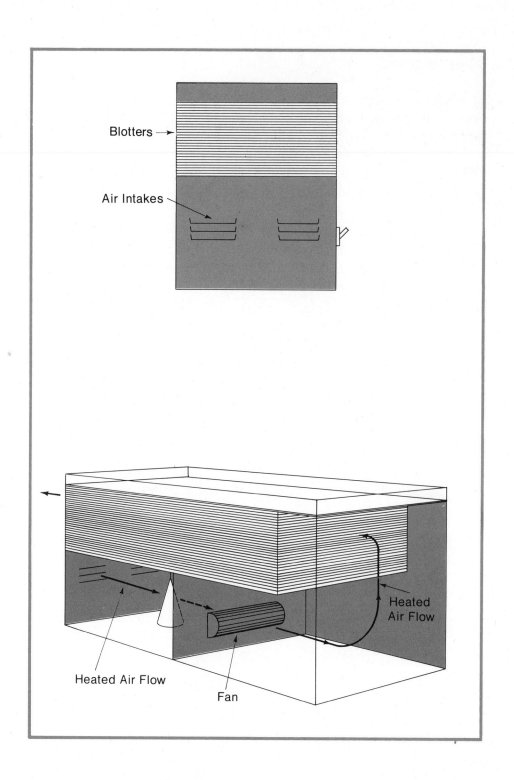

Blotters

Air Intakes

Heated Air Flow

Heated Air Flow

Fan

MIDGO BLOTTING OVEN

Although this dryer has been discontinued, it can be constructed by any craftsman either by exact duplication or by adopting the basic functions into a design of one's own.

Essentially, this device blows air through photographic blotters containing the prints. The blotters, sold and distributed by Kodak, are of photographic grade. The blotter package consists of muslin-coated as well as plain blotting paper. After it is squeegeed, each print is placed emulsion side down on the muslin surface and covered by the plain blotter. Each set (two blotters with the prints in between) is separated from another by corrugated cardboard. The entire package, consisting of as many sets as needed, is subjected to an air flow (heated air is optional) provided by a powerful fan. Double-weight prints will dry perfectly flat in one hour.

In practice, you can use two sets of blotters: the first for all prints that have been archivally processed; and a second for those prints that are not up to this standard. The blotters can be checked for hypo residuals using the test outlined on page 244. There is an inevitable buildup of residue, and when this occurs, the blotters reserved for archivally processed prints are transferred for use for the prints that have not undergone the full archival procedure. Kodak sells these blotter packs either as blotter rolls or single sheets. If the blotters are purchased in roll form, they should be cut down, or else the dried prints will have a pronounced curl. If purchased in single sheets, you will have to purchase the corrugated cardboard separately. These corrugated separators are available through stationery stores.

TONING

In the context of this section, toning does not refer to the imparting of an obvious color to the image; rather, it is a modification of existing print color. Most modern photographic papers, regardless of the designation regarding print color supplied by their manufacturers, exhibit an off-green tone. Through toning, the emulsion acquires a more pleasing color and an enhanced brilliance that not only give the print more emphasis, but lend depth to the image. Many prepared and packaged toners are available, but the simplest and most effective toner is selenium (Kodak Rapid Selenium Toner). This toner imparts a rich, cold, purple-sepia hue to the print and, in doing so, intensifies the low and midtones, giving the print an enhanced contrast, and also makes the photograph pyschologically more brilliant.

The tone of the final image is the result of the following:

1. The chemical composition of the paper. Chloride papers tone quickly; bromide papers not at all; chlorobromide papers slowly. Kodak Polycontrast tones slowly (regardless of Kodak's recommendation). Kodak Ektamatic SC Paper tones quickly. Selenium has no effect on the Ilford papers, which are bromide based. A two-solution formula, such as Ilford Toner IT-1, can be employed.
2. The composition of the developing formula. Cold-toned developing solutions work somewhat more slowly than warm-toned developers.
3. The length of development.
4. The composition and the amount of fixation.

The actual procedure is outlined on page 210, steps 7 and 8.

Those papers that tone quickly should receive treatment in a two-percent Kodalk solution. This will remove any excess acidity present in the print and will allow the print to tone more evenly.

At the first hint of a change of tone, immediately transfer the print into a plain-water solution for further evaluation, since toning occurs quickly at this point. The midtones will exhibit the first notable change, followed by the low tones, and then, to a very limited extent, the high tones. The color will be modified after toning by the following procedural steps:

1. The print will lose some color in the wash subsequent to the toning procedure.
2. The print will experience the same "drying-down" considerations as an untoned print.
3. Application of high heat during drying will modify the tone.

In short, experience is the best judge of a toned print still in solution.

It is imperative that the prints be well fixed and thoroughly washed, or else they will stain. Use the following toning formula:

```
Kodak Selenium Toner . . . . . . . . . . 2.0 oz.
Heico Perma-Wash . . . . . . . . . . . . 1.5 oz.
Water to make . . . . . . . . . . . . . . 32.0 oz.
```

THE PRINT/PROCEDURE–TECHNIQUE

The procedure for producing a print should be approached as the final stage of a process that began with the realization of the thought that prompted the tripping of the shutter. The underlying concept of the Zone System is to be able to produce a negative that is easily printable and, as such, requires little or no darkroom manipulation. In a narrow sense, the production of a print should be quite mechanical: The negative has been scaled for the paper and is considered the input; the printing paper is therefore a neutral receptor. It should be emphasized, however, that this is a standard that is rarely attained in practice—nor should it be. Rather, the negative should be conceived of as a point of departure—a beginning on which all manner of interpretation (albeit subtle interpretation) can be imposed. The tonal values secured through proper exposure/development can be expanded or compressed, giving or taking away emphasis as desired.

Following, in outline form, is an abbreviated explanation of the procedures employed. You are invited to modify/supplant the steps into a procedure that is more easily adaptable to the physical considerations of the darkroom/equipment you utilize. However, any modifications that interfere with the general conception/form are unacceptable.

1. A 4″ × 5″ sheet of paper is exposed, utilizing the standard printing time (allowing for either an increase or decrease of exposure depending upon the distance of the enlarging lens to the paper surface).

2. The test print is processed in the developer solution for 1½ minutes (inclusive of a 10-second drain). Agitation is moderate but continuous. A stop bath is employed for 20 seconds, followed by a 10-second immersion in plain water to remove the acidic bath plus any remaining developer. The test print is then transferred to the hypo bath.

3. The print sample is examined after two minutes in the fixing solution, using an overhead 100-watt floodlight five feet from

the tray. (With experience, you can make allowances in the evaluation for the "drying down" of the test print.) Questions posed at this point should consist of the following:

a. Was the enlarger properly focused? Is the print free from dust/scratches?
b. Is there adequate detail in both the shadow and highlight areas?
c. Do the midtones operate in concert with the shadow and highlight tones?
d. Is the overall tonality acceptable and, most importantly, is it indicative of what was seen/felt at the time of the photographic realization?

If dissatisified with the initial test print, you can easily manipulate the tonality of the print. (The concept of fault/error should be avoided inasmuch as it implies a processing defect; what concerns you is a modification of tone.) Available remedies would include the following:

a. Increase/decrease exposure. By increasing exposure ("printing down"), you are in effect producing more contrast. page 180
b. Change paper grades.
c. Choose a different paper developer.

The final test print—the sample that encompasses all that was perceived/translated at the time of exposure—is kept and processed as one would any print (see below).

4. A print is made, having at least one-inch borders. These serve to protect the print surface and, more importantly, help "key" the highlights; in other words, they are a standard by which to compare the highlight tones of the print.

5. The finished print is immersed in two hypo baths for four minutes apiece. The hypo-saturated print is then transferred to a

wash tray in which continuously running, temperature-controlled (70 F) filtered water cascades gently over the print surface. The print is washed in this manner for at least 10 minutes—the minimum amount of time for another print to go through the process.

6. The print is then transferred from the wash tray and placed in a hypo clearing solution for three minutes. Agitation is continuous for the first minute, intermittent for the remainder of the sequence. It is removed from the hypo clearing tray and placed in a washing device (the East Street Gallery Archival Print Washer) for 30 minutes. The temperature-controlled water is kept at 80 F.

page 242

7. After the final print has washed for one hour, all the prints are transferred to a two-percent solution of Kodalk, where they are agitated by bringing the bottom print to the top continuously for two minutes.

8. The prints are toned in selenium. At this stage, a light over the toning tray is switched on. This 100-watt floodlight is five feet from the tray. The test sample is held near the tray while the print is being toned, and the two are constantly compared. The change in print color is subtle and cannot be judged without a comparable untoned standard. The toning process with Polycontrast Paper can take anywhere from two to seven minutes, depending on the amount of silver deposit, the degree of tone desired, and the composition of the developer used.

9. The toned print is returned to the washing device and washed again for 30 minutes. The print is then removed and damp-dried using a squeegee (the Falcon Print Squeegee) and placed in a dryer.

PRINT SIZE

The size of the print has a profound effect on the viewer as well as an overwhelming effect on the quality of the print.

The smaller the enlargement, the more detail, and delineation of tone will be evident in the final print. This is true for both types of

enlarging light sources. A properly exposed/developed 35 mm negative should not be enlarged to a greater print size than one having a diagonal of 7″; for a medium-size-format 2¼″ × 2¼″ negative, 10″; for a 4″ × 5″ negative, 14″. Also, the problem of grain becomes more apparent as the size increases. Any enlargement will reduce the quality inherent in the negative.

The size of the enlargement has a great emotional effect on the viewer. The photographer can easily alter the viewer's perception of the photograph (and subject matter) by altering the degree of enlargement. One example will suffice: A portrait that is greater than life size has quite a different impact than if the image were normally scaled. The former would have an effect of superreality, while in the latter, the intensity of the subject would be less, but perhaps more compelling, as the viewer can relate to it with greater ease.

Cropping. The cropping of a projected image should be done for emotional and aesthetic reasons. Eliminating subject matter to save a poorly seen negative can never result in a quality print. (Exposure and development determinations would be faulty, and the increased size of the grain would destroy the remaining quality as well.)

It is fashionable today for photographers not only to print full frame, but, in order to show the "purity" of their vision, to allow the negative borders to be printed as well. This shows a lack of understanding of the translation process. In essence, photographers who insist on printing full frame limit their vision to size standards that are imposed by the manufacturers of film and camera.

Photographers should be able to compensate and plan in the viewfinder the desired print dimensions regardless of format size. The dimensions of a print are a function of the translation process, not of the physical limitations imposed by equipment manufacturers. Photographers should be aware of final print size as an end result as the photograph is being composed and formulated. Cropping should only reinforce and emphasize these considerations.

A schematic of a theoretical stabilization processor. The rollers guide the stabilization paper through two solutions to produce a damp-dried but still semi-permanent print within 10 seconds.

Ilford Stabilizer

STABILIZATION PROCESSING

The stabilizing method of print production uses a specially prepared photographic paper with the developing agents incorporated in the emulsion. At the heart of the system is a processing machine that accepts the normally exposed paper and, via a system of rollers, transports the paper through an activator and a stabilizing solution. The procedure takes less than 10 seconds, after which a damp (not wet) print emerges. The print is not fixed in the sense that it will not fade. Actually, if left exposed to light, the print will fade in a matter of months; if it is filed away, it is capable of lasting in its stabilized state for many years. Because the print is incapable of any manipulation past the enlarging/printing phase of the process, the entire procedure is in accord with the general theory of the Zone System.

The processor was primarily designed for rapid-access work—news events, military uses, and the like—but at the level of creative photography, it is a useful and creative tool.

The paper employed in the process can also be used as conventional photographic paper. Kodak Ektamatic SC Paper (using the same filters for variable-contrast as Kodak Polycontrast Paper) is an excellent emulsion (processed in trays for exhibition-quality prints; processed in the stabilizer for reproduction or work prints). The paper has a warm black tone when the stabilizer process is employed, a rich, neutral black when tray-processed. The Ilford materials (Ilfoprint) are graded as normal photographic paper and produce a very cool black tone when stabilized. The Kodak paper may be toned in selenium; the Ilford papers will tone only in a split-toning formula.

page 180

The stabilized prints can be made permanent by fixing in any normal hypo bath (only one bath is necessary) and then washing as with conventional prints. It is absolutely imperative that the stabilizer be kept clean, as stabilized prints are highly susceptible to stain. One last caution: Stabilized prints that have not been made permanent should never be stored with normally processed prints, or else they will render the latter impermanent. Stabilized prints should be so marked, especially if they are used for reproduction.

My original conception was to have the window area to "read," without the detail of the thin window shades, providing an entirely blank area to counterbalance the gray wall. After some time, however, I thought that it might be interesting to see how the area would counterpoint the other ones if it had detail. The result, achieved by "burning" in the blind, was not successful. First impressions are usually, if not always the strongest. Modifications, in order to achieve results that are at odds with the original conception, are rarely achieved.

BURNING-IN AND DODGING

By using these corrective procedures, areas of a print can be given either a greater exposure (burning-in) or a lesser amount (dodging), allowing for a possible major modification of tone.

Any procedure of this type should be kept to a bare minimum. The print values should (if properly translated by exposure/development) bear a certain natural relationship to each other; they become unbalanced by obvious print manipulation.

Following are the most common uses for these corrective procedures:

Lens Falloff. All taking and enlarging lenses are susceptible to light falloff. This is evidenced in the print if the corners are less dense (lighter) than the surrounding areas.

Uneven Sky or Foreground Areas. Both correction procedures should be used with discretion. The manipulation should underline existing print values rather than create new tones.

NEGATIVE DEFECTS/PRINT SPOTTING

In the context of this chapter negative defects simply mean those physical faults caused by processing procedures rather than errors of judgment made during the translation process (exposure/development determinations). Trying to correct the latter invalidates the approach outlined in this book; correcting the former is relatively easy to accomplish and is acceptable/encouraged within the framework of this reference.

Print Spotting. Negative defects caused by poor processing/handling/drying or improper cleaning of the negative, prior to insertion in the enlarger, can be cured by applying a dye, the color of the surrounding tone, to the spot. These dyes will either penetrate the print emulsion or, in the case of pigment colors, lie directly on the print surface.

Nonpenetrating Dyes. Dyes such as those manufactured by Kodak, are sold three colors to the package—black, white, and olive. The tones to be produced by these dyes are generated by dipping the spotting brush in water and blending the dyes until the correct tone is attained. It is suggested that a wetting agent (Kodak Photo-Flo) be employed in the mixture, as the colors will more readily adhere to the print surface (especially important if the surface to be spotted is glossy).

Penetrating Dyes. These liquid dyes (Spot Tone) are available in various shades of gray and are mixed to achieve the correct tone. Use of a wetting agent is also recommended.

The black dye in either form (penetrating or nonpenetrating) is not sufficiently deep in tone (nor glossy enough) to match a Tone 1 area. A substitute you can use is a single black dye, (Gamma Glossy Black®) manufactured by M. Grumbacher, Inc. Either type of dye should be used after the print has been toned and washed, as subsequent washing of the spotted print tends to remove the dye.

PRINT SPOTTING/PROCEDURES

Following is a list of necessary materials:

1. Step tablet. Prepare one with as many tones as possible. This is easily accomplished by taking an 8" × 10" piece of enlarging paper (of the same type upon which the spotting is to be done) and giving one-second exposures while moving a piece of cardboard across its surface. (An 8" × 10" piece of paper with each tone occupying one inch will, if exposed lengthwise, yield 10 distinct tones.
2. Magnifying glass.
3. High-intensity light source.
4. Artist's watercolor tray (for penetrating dyes).
5. Spotting brush. The key element in the selection of a brush is that it be able to maintain a sharp point. A woman's eyeliner brush gives very satisfactory results.
6. Small sponge to sharpen the spotting brush point.

Follow these procedures for print spotting:

1. Place the step tablet directly on the area to be spotted, thus making the correct step-tablet tone easily identifiable.
2. Mix the dye directly on the tablet.
3. After the tone is mixed/matched, transfer it by a stippling effect onto the print. The dye should never be brushed on.
5. Perform the above under a magnifying glass, with an intense light source illuminating the area.

Pinholes/Scratches. These defects are caused by the negative's losing some part of its emulsion, either in processing (blistering caused by too powerful a stop bath) or in the mishandling and scratching of the wet/dried negative. These defects produce black areas that are difficult to remedy. If the area is first spotted with a white dye, it can be subsequently treated as if the blemish were caused by an opaque defect in the negative (for example, dust).

THE PRINT/PRESENTATION

The universally accepted method of presenting a print has been, until recent years, to dry-mount the print on a board manufactured specifically for this purpose. However, with the advent of concern regarding print permanence, the process has come under increasing attack.

page 243

Opponents claim that in order for a print that has been processed to archival standards to remain in its pure state, it must not be allowed contact with a board whose acid content is not readily determinable. Most boards do in fact contain sulphur, which, if allowed to make contact with the print, would in time turn it brown. They also argue that the heat inherent in the process is injurious to the paper fibers. Moreover, that the thermoplastic adhesive (dry-mounting tissue) itself has not undergone sufficient testing to demonstrate what its ultimate effect would be to the print to which it is bonded.

Proponents of the dry-mounting process argue that while the criticisms leveled have resulted in the judicious use of the procedure, the process as a whole has certain realizable benefits over those claims which are both hypothetical and untested.

The counterarguments are as follows:

1. Purchase museum-quality mounting boards (manufactured by Bainbridge and Strathmore) that contain no acid.

2. There is no evidence available to indicate that the thermoplastic adhesive is unsafe. Quite the contrary, the thermoplastic, when melted, forms a barrier between the print and the board, insulating the print and further protecting it from injury.

3. The greatest single benefit of the process is its protection of the print.

4. It also serves to isolate the print, thereby giving it emphasis.

218

DRY-MOUNTING/PROCEDURE

The board chosen should be of the finest quality, and 100-percent acid free, absolutely neutral in color (white),* with no surface texture. The neutral board insures that nothing will interfere with the tonality and surface of the print.

Placement of the Print. Center the print left to right and slightly off center top to bottom. (It is a convention that the bottom border should be slightly larger than the top.) Any other placement calls attention to itself and inevitably detracts from the impact of the print. The size of the mounting board and its relation to the size of the print depend upon the photographer. Large borders, which tend to isolate the print can be used; borders of less than one inch are used by some photographers. It is not advisable, however, to allow the print to "bleed" (where the print has no borders), for it can easily be damaged. For a nominally sized 8" × 10" print, use a 14" × 17" board. However, bear in mind that a sense of preciousness emerges with too large a border.

DRY-MOUNTING/PROCESS

Attach the thermoplastic tissue to the untrimmed print using a tacking iron designed expressly for this purpose. Manufacturers of dry-mounting tissue (notably Seal Manufacturing and Kodak) are now producing nearly exclusively a tissue that is compatible with resin-coated and color print paper materials.[†] The tacking iron must be the type that has a Teflon-like coating on its heating surface, or else it will adhere to the tissue itself. Trim the print and the adhered tissue together, removing the borders of the print as well as the excess tissue.

*On occasion, and for highly selected purposes, a colored mount board is effective; however, these should be used with the utmost discretion. The 100-percent acid-free boards are exclusively white; any others, no matter what the manufacturers claim, cannot be considered archival and in time will adversely affect the print.

†These plastic-based papers will be harmed if too much heat is applied.

Position the print on the mounting board and hold it there by tacking one corner of the print to the board.

Never place the iron in direct contact with the print; rather, place a "cover sheet," manufactured by the Seal Company, on top of the print and apply the iron to this protective covering.

With the print attached to the mounting board, place the cover sheet on the print in a dry-mounting press. The cover sheet is absolutely necessary, as the platen of the press must never be allowed in direct contact with the print. The temperature* of the press must not exceed the limits specified by the tissue manufacturer. If the press is too hot, the thermoplastic tissue will melt around the print; if too cool, the print will not adhere. Follow the manufacturer's recommendations for the length of time that the platen should remain in contact with the "package." Too long a time will result in a change in tone (similar to "drying down"); too short a time and the print will not properly bond to the mounting board. When the print is removed from the press, put it under weight until it cools. Seal Manufacturing supplies weights expressly for this purpose.

*The temperature setting on the thermostat should not be followed literally; thermostats are often incorrect. The Seal Company manufactures temperature strips which, when the proper heat is applied, cause a portion of the strip to melt. Verify the temperature setting at least once a month, depending on the frequency of use of the press.

CALIBRATION 4: EXPANSION OF NEGATIVE DENSITIES

There are three general techniques available to increase the contrast range of the negative. The methods are applicable to all formats, although special care must be taken with miniature roll film to avoid excessive grain.

Calibration 4a. Polycontrast #3 Paper (with a #3 filter) may be considered the practical equivalent to a normal +1 development. The filtered paper operates in such a way that the low tones lose a very small amount of separation when printed, while the high tones are raised and meld together. Graded papers, on the other hand, lose definition in the low tones as well as the higher tones, limiting their usefulness for this calibration in general and for miniature roll film in particular. A Polycontrast #4 Filter is not recommended inasmuch as the loss of definition of the low tones is too great.

Calibration 4b. Increase development time, and/or change developer and/or developer concentration (less dilution in the case of HC-110).

Calibration 4c. Vary the placement of subject tonality by raising the key tone measured to that of a higher tone (with increased development as well, if needed).

PROCEDURE FOR CALIBRATION 4a

Use the set of negatives generated in Calibration 3 (normal development).

1. Place the Tone 1 and Tone 2 negatives in the enlarger.
2. Print a 4″ × 5″ sheet of paper (without a filter) and process it.
3. Place a Polycontrast #3 Filter between the enlarging lens and the enlarging light source. Never place the filter below the lens.
4. Expose a print on a 4″ × 5″ sheet of paper, using double the standard printing time. Compare it to the standard that was produced in Step 1 above. The comparison can be made with both prints wet.
5. Vary the time of exposure until the tones match precisely. Once correctly generated, the time needed to produce Tones 1 and 2 will become the standard printing time using a Polycontrast #3 Variable-Contrast Filter.
6. Print all tones using the filter; when dry, compare to that set of tones obtained by normal development (Calibration 3). The high tones (Tones 7 through 9) will have expanded by approximately one full tone. The effect is equivalent to a normal +1 development.

Analysis of Calibration 4a. By using a Polycontrast #3 Filter, both normal and normal +1 exposure/development indications may be accommodated on the same roll of film.*

*This method is of course not limited to the miniature roll-film user; it can be used successfully with any format.

PROCEDURE FOR CALIBRATION 4b

1. Make a series of exposures of the gray card, as in Calibration 3. Develop (if using HC-110) at a dilution of 1:7, with an attendant increase in developing time 25 percent greater than that obtained in Calibration 3. page 97
2. Compute a new standard printing time inasmuch as the film base + fog level has now been raised. Compute the standard printing time in accordance with the instructions outlined in Calibration 4a using a Polycontrast #3 Filter.
3. For a normal +2 expansion,* Tone 7 (generated by this test) should match Tone 9, as obtained by the normal development calibration. Adjust development time until the two are equal. For a normal +3 expansion,† Tone 6 should match Tone 9. This is accomplished by a decrease in the dilution of the formula (or changing to a more energetic developer) and an increase in development time.
4. Print all the tones after the operation is completed. You can now compare the normal scale, as generated by Calibration 3, to that of the tones obtained in these calibrations. At this point, expansions can be fully visualized, as photographic theory now has great practical significance.

*An N+2 or N+3 development is now equivalent to an N+1 and N+2 development using a Polycontrast #3 Filter.
†Not recommended for miniature roll film.

NOTES ON CALIBRATION 4c

Expansion of negative densities is attained through both exposure and development. In general, expansion of negative contrast, using 35 mm roll film,* should not be greater than a normal +2 development. Use of a Polycontrast #3 Filter (equivalent to a normal +1 development), with an attendant increase in development to raise the high values to a normal +2 development would, in effect, produce the outer limits of which the film was capable without a serious loss in negative quality caused by excessive grain. The placement of the shadow areas of a scene requiring greater than a normal +2 development should be raised to a higher tone, that is, given more exposure.

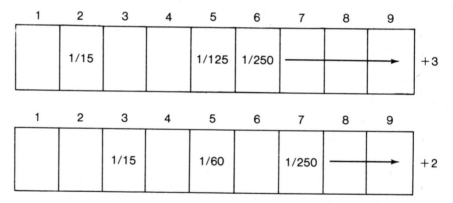

When the negative is printed, adjustment can be made by "printing down," which has the visual effect of expanding contrast to an even greater degree. The low values will be returned to their proper visualized tone, while the high values will not change appreciably.

page 180

*This method is of course not limited to the miniature roll-film user; it can be used successfully with any format.

224

CALIBRATION 5: COMPRESSION OF NEGATIVE DENSITIES

There are two general techniques available to decrease the contrast range of the negative. The methods are available to all formats and are either physical in nature (reducing development time or diluting an existing developer formula) or chemical in application (changing to a different formula, for example, a soft-working or compensating-type developer, or changing the constituents of an existing developer [less hydroquinone, accelerator, or restrainer]).

Calibration 5a. The simplest and most common method of compressing negative densities is to reduce the time of development. However, the amount of time must not be reduced to less than four minutes (with an infusion bath), as the developer will not have sufficient time to permeate the emulsion and operate evenly over the entire tonal scale. Generally, by diluting the developer formula, the amount of developer available to produce the higher negative densities is restricted, affecting the higher tones proportionately more than the low tones. Great care must be exercised, however, in that an attendant decrease in film speed is inevitable.

page 150

page 229

Calibration 5b. Compensating or soft-working formulas are available, which, by their inherent composition, limit the high values from reaching their full densities. Compression of contrast may also be achieved by changing the constituents of an existing formula. The common M-Q developer is not recommended for compression of the high values, due to the inclusion of a relatively high proportion of hydroquinone, which produces contrast. A developer that is either intended for fine-grain use (Edwal Super 20 and Minicol), or a formula such as D-23, can be used with success. The M-Q type of highly concentrated developer (Kodak HC-110) responds favorably to dilution.

PROCEDURE FOR CALIBRATION 5a

1. Make a series of exposures of a gray card, as in Calibration 3. Develop them (if using HC-110) at the same dilution (1:9) as previously outlined. Decrease development time to no less than four minutes (using an infusion bath). Once developed, compare the resultant Tone 8 to Tone 7, as generated in Calibration 3. If the two do not match equally because the compression was insufficient, increase the dilution further; increase development time if the compression was too great.

2. Print all the tones after the development time/dilution change is verified.

3. A normal −2 development is accomplished by further increasing the dilution of the formula and/or changing the development time. (As a starting point, HC-110 can be diluted to 1:18 for a normal −2 development; 1:30 for a normal −3.) You will need to make an attendant increase of half an exposure unit (one-half aperture increase) in order to maintain the effective speed of the film. A normal −2 development has as its goal the matching of Tone 9 to Tone 7.

4. A normal −3 development is accomplished by comparing Tone 10 (one full exposure unit more than Tone 9) to Tone 7, with an attendant increase of one full exposure unit (full aperture opening) to maintain the Exposure Index of the film.

page 229

page 229

NOTES ON CALIBRATION 5b

If a different formula or an adaptation of an existing formula is preferred, you will have to repeat Calibration 2 in order to establish a new Exposure Index. Calibration 3 would not necessarily have to be redone, because the primary concern is in the compression of film densities rather than the reproduction of normal scene reflectances.

9

Notations in Passing

... a knowledge of photography is just as important as that of the alphabet. The illiterate of the future will be ignorant of the use of camera and pen alike.

Laszlo Moholy-Nagy
"Light—A Medium of Plastic Expression"
Broom, Vol. 4, 1923, pages 283–284

CHAPTER CONTENTS

EXPOSURE/DEVELOPMENT—CONSIDERATIONS/ REFINEMENTS

The fundamental concept of exposure and the subsequent determination of development have been formulated on the basic concept of the low-tone placement not being seriously affected by the variable development procedure. However, the low values do respond to extreme deviations from the norm. In either mode (compression or expansion of values), modifications in exposure will have to be made in order to accommodate the shift caused by either a greatly extended or retarded development. As a working guide, the following table may be used as a basis for the further refinement of Calibrations 4 and 5.

pages
221–226

EXPOSURE REFINEMENTS

Development Indication	Change in Exposure
Normal −3	1 stop more
Normal −2	½ stop more
Normal −1	no change
Normal	
Normal +1	no change
Normal +2	½ stop less
Normal +3	1 stop less

EXPOSURE LATITUDE

There is often a misconception that film has a certain latitude for either under- or overexposure. Rather, this tolerance is dependent upon the standards one sets for oneself. Evident throughout this book is the feeling that film materials have no useful leeway. Too little exposure will render the shadow (low-tone) areas without substance and detail. Too great exposure, and the highlights will be rendered without detail and appear lifeless. Furthermore, with too great an exposure, the granularity of the film becomes all too prevalent.

However, it is surely better to slightly overexpose than to underexpose. The former condition can be tolerated by either decreased development of the negative or by manipulation of the print. The highlight areas can be controlled by using a "softer" paper, a diffused light source, or by printing down.

The low-tone values, on the other hand, cannot be controlled through subsequent printing. If there is no substance in the shadow area (caused by underexposure), then there is nothing you can do to generate tone and detail.

In short, it is better to err on the side of overexposure, with the general admonition that it is far better to operate on the basis that film has no latitude, and that exposure should mirror exactly what was seen or felt.

EXPOSURE/FIXED DEVELOPMENT

Exposure determination often has to operate in conjunction with a development time that is predetermined by factors outside the photographer's control. These factors include, but are not limited to, the following:

1. Development of roll film is determined by the first (or a series of) exposures made; development of the subsequent frames is therefore not subject to modification.
2. The development of color film as well as most Polaroid materials is not subject to development control.

The following table illustrates how exposure can be manipulated in order to accommodate a fixed development.

EXPOSURE FOR FIXED DEVELOPMENT

Normal Development								
Tone 1	2	3	4	5	6	7	8	9
Scene N +1		1/15		1/60	1/125→			
Modification			1/15	1/30		1/125		

Normal Development								
Tone 1	2	3	4	5	6	7	8	9
Scene N −1		1/15		1/60		←1/500		
Modification	1/15			1/125		1/500		

Normal +1 Development								
Tone 1	2	3	4	5	6	7	8	9
Scene N		1/15		1/60		1/250		
Modification	1/15			1/125	1/250→			

Normal −1 Development								
Tone 1	2	3	4	5	6	7	8	9
Scene N	1/15			1/125		1/500		
Modification		1/15		1/60		←1/500		

EXPOSURE DETERMINATION/GRAY-CARD READINGS

Often it is impractical or impossible to measure a key tone within a scene. This condition occurs when the object seen is either very small and contains little differentiation between tones, or an object is too far away to allow the photographer to successfully measure (with a wide- or narrow-angle meter) a key tonality. By substituting a gray-card reading, the photographer can make an exposure with a reasonable amount of success. The exposure determinants generated by this method should not be confused with an average reading; rather, the method is similar to an incident-type measurement, with the further refinement that the camera/lens/film/development combination is calibrated to produce a neutral-gray tonality by definition.

The procedure entails the placement of an 18-percent reflectance gray card within the body of the scene. If the object is small, put the card in the exact position of the subject. The reading is then taken, the gray card removed, and the exposure made using the combination aperture/time derived from the gray-card indications. For a distant object, place the gray card in front of a key tonality, and use the subsequent reading for exposure.

In either case, the development indications will have to be determined by an educated estimate. The exposure techniques outlined on page 73 will be helpful although, as with any rule, they must be approached with understanding and intelligence.

As the distance increases from the camera position it becomes more than likely that exposure would have to be reduced because of aerial haze. Haze has the effect of raising all the tones in the scene, which must be compensated for in exposure. The skylight filters while reducing the haze do not affect the translation of exposure into tone.

PRE-EXPOSURE

The sensitivity of a given emulsion is established during manufacture and is not subject to significant change during the development process. Those modifications involving extreme development times should be limited solely to a creative intent. The speed of the film should be considered as unalterable.

There are, however, instances when the low-tone values will be submerged into Tone 1 in order to preserve the mid- and high-tone values. The procedure known as pre-exposure can raise the low subject values, which renders them as visible tones above the minimum threshold densities while not influencing the mid- or high-tone negative densities. page 99

The procedure entails exposing the film frame to a neutral gray card, using an exposure that will produce over the entire negative a density equivalent to a Tone 1½ or Tone 2. Set at infinity, the lens should encompass the entire evenly lit card as in all the calibrations. After the film is thus exposed, continue exposure in the normal manner, using the exposure/development indications that would normally be required.

The following table illustrates the concept:

PRE-EXPOSURE VALUES

Tones	−1	1	2	3	4	5	6	7	8	9	
Scene (as measured by exposure units) *	−1	0	2	4	8	15	30	60	125	250	
Pre-exposure units		2	2	2	2	2	2	2	2	2	
Total *		1	2	4	6	10	17	32	62	127	252

*The reciprocal of these exposure units would be the applicable shutter speeds.

In this example, Tone −1 would be elevated and would record (if development were normal) to a point midway between Tones 1 and 2; Tone 1 would record as Tone 2; Tone 2 would record between Tones 2 and 3. However, Tones 3 through 9 would record in accordance with the original exposure plan.

The process is well suited to sheet-film formats, but with care can be adapted to the roll-film user by either pre-exposing an entire roll of film in a controlled laboratory atmosphere or by using a camera capable of intentional double exposure.

Polaroid films and color materials can also benefit from this procedure. In the latter instance, the process is often called "flashing."

With all films, there is a decrease in contrast, which must be carefully controlled lest the brilliance of the print be destroyed. As with any technique, there must be purpose and understanding behind the manipulation. If the effects are obvious, the subtleties gained by the procedure will be negated.

THE POLAROID PROCESS

Through their corporate involvement and support of serious photography, the Polaroid process and materials are now being recognized as constituting a valid art form unto itself as well as providing the photographer with the capability to instantaneously verify exposure, lighting, and composition.

The ongoing evolution of the many film types and their attendant processes does not permit for a detailed analysis in this text. However, certain traits common to most of the generally used film materials may be summarized.

The effective tonal range of the Polaroid print is not as great as it is with conventional film materials.

Polaroid Materials	2	3	4	5	6	7	8	

Conventional Materials	1	2	3	4	5	6	7	8	9

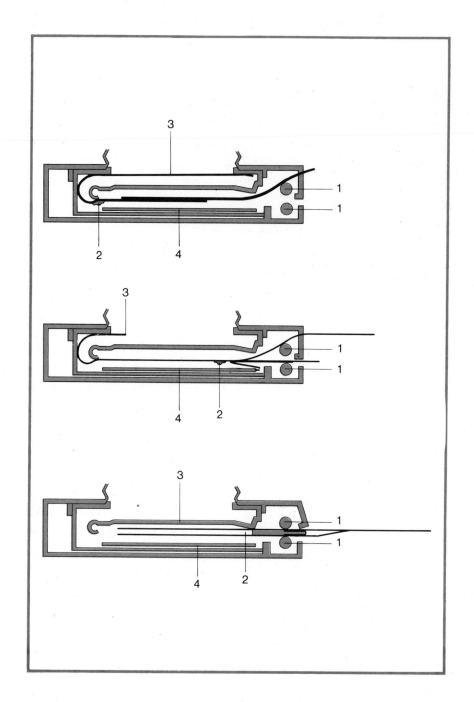

A diagramatic representation of Polaroid film holder and operation.

Development manipulations are slight, and if not used with caution will ruin the print, thus:

1. Too little development will result in mottled and unevenly developed prints.
2. Too great development will result in the loss of highlight detail.

It should be noted at this point that the temperature at which the film/print is developed is at least as important as the amount of developing time employed. Packaged along with Polaroid films are publications on development times to compensate for any temperature variations beyond the norm.

With most film types (except the positive/negative materials), certain generalizations regarding slight increases/decreases of development times can be made:*

1. If the high print values are correct but the low values weak, *increase development time.*
2. If the high values are correct but the low values too heavy, *decrease development time.*
3. If the high values are gray and the low values correct, *increase both exposure and development time.*
4. If the high values are gray and the low values too deep, *increase exposure and apply same development time.*
5. If the high values are gray and the low values weak, *increase exposure and give maximum development time.*

 (Maximum represents that amount of development time beyond which no apparent additional increase of print value is obtained.)

*Ansel Adams, *Polaroid Land Photography Manual.* Hastings-on-Hudson, New York: Morgan & Morgan, 1963.

Ansel Adams has been a consultant for the Polaroid Corporation for many years. His work using these materials is truly remarkable. *Singular Images,* a book of his photographs using the process, and published by Morgan & Morgan, should be studied by all serious photographers, lest they feel that the materials are incapable of producing prints that can hold their own with conventional materials. They can, with an extraordinary, albeit unique, quality. It is this quality which must be seen in the original to be truly appreciated.

POLAROID FILM MATERIALS/CALIBRATIONS

Effective Film Speed. Because the development of the film is considered "fixed," Calibrations 2 and 3 may be combined as follows:

1. Use the same configuration of gray card, camera, lights, and so on, as was established for Calibration 2.
2. At the published ASA rating index, expose one sheet of film for Tone 5.
3. Compare the print and the gray card, using a monochromatic viewing filter (Wratten Series #90).
4. Reexpose at different exposure indices until the two exhibit the same reflectance.

page 236

Positive and Negative Materials. Polaroid offers two film types, differing both in their size and process, which provide the user with a negative of high resolution and little grain. For the 4″ × 5″ format, Type 55 film and processor #545 are used. For roll-film cameras (each with an accessory back), Type 665 film (formerly Type 105) is used. In either case, the negative must be cleared in a concentrated sodium sulfite solution, washed, and dried in the normal manner before use.

The calibrations required entail two sets of testing, each for the material under examination—the negative and the positive. The calibrations for the positive are the same as with other Polaroid materials; however, the testing of the negative materials have to be approached in the same manner as with conventional materials.

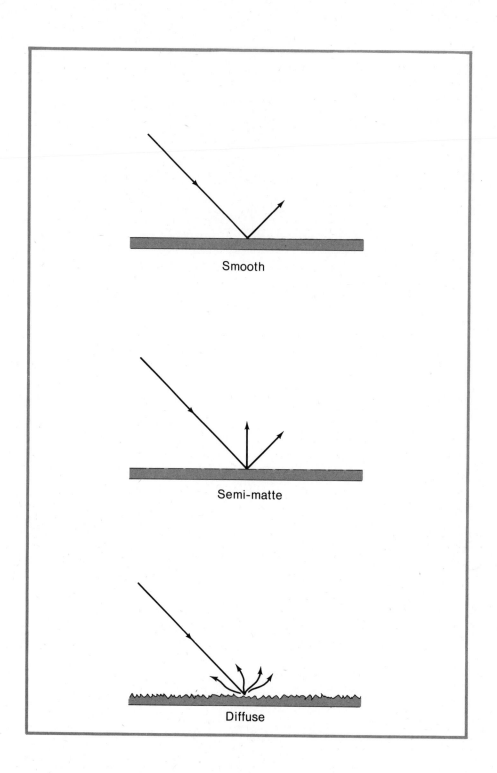

Smooth

Semi-matte

Diffuse

DIFFUSE/SPECULAR REFLECTANCE

Diffuse Reflectance. A matte surface, such as blotting paper, would spread the intensity of the incident light (light source) evenly over its surface and would not exhibit any tendency to reflect the light source. A diffuse surface reflects all light in all directions, regardless of the angle from which the incident light is falling upon it. It is the diffuse reflectance characteristic of an object that produces texture and tonality.

Specular Reflectance. A glass surface, or a highly polished metal, will tend to preserve the directional quality of the incident illumination and will create a mirror of the light source. As the angle of the incident light changes, so does the intensity and the area of reflection.

Most objects exhibit both specular and diffuse reflectances,* either characteristic becoming more prevalent as the angle of the light source changes in relation to the object. The practical considerations of this phenomenon are extremely important in the control of both texture and tone in the photographic print.

The light reflected from the object seen (be it rocks, leaves, human skin) is absorbed by the diffuse component of the object and produces both tone and texture; the specular characteristic (depending on the angle of the light source illuminating the object) produces the highlight, which, unless carefully monitored, will produce an area with neither tone nor texture. This specular highlight can signify great brilliance if used successfully; however, if improperly translated, it can alter (by its very brilliance) the entire character and quality of the image.

*The term "spread reflection" indicates a distribution that is within these extremes.

Diagramatic representation of the East Street Gallery Archival Print Washer.

ARCHIVAL PROCESSING

In the past few years, there has been wide interest and research in the processing of negatives and prints for maximum permanence. The procedures already outlined in this book, while assuring results of very high caliber, cannot be considered archival in the truest and most current sense. The addition of one more stage in the processing procedures outlined on pages 151 and 209 will, however, enable the photographer to achieve the necessary permanence which by definition can be called "archival."*

pages
151, 209

Negative Materials. Wash the negative in an efficient device for 15 minutes. Use a washing aid (misnamed hypo clearing agent) according to the manufacturer's instructions. A subsequent wash for 15 minutes will insure negatives of lasting quality.

Print Materials. Using Kodak Hypo Elimination Treatment (Kodak HE-1) after the print has been thoroughly washed (with the attendant use of a hypo clearing agent/washing aid) and toned will totally eliminate any vestiges of residual hypo absorbed by the paper fibers. The solution renders the complex sodium sulfite–silver-sodium-thiosulfate salts to sodium sulfate, which is soluble in water. Immerse the print in the solution for six minutes, applying constant but moderate agitation. Rewash the print for 20 minutes following this treatment.

Water	500.0 cc
Hydrogen peroxide	125.0 cc
Ammonia solution	100.0 cc
Water to make	1.0 liter

Ammonia and hydrogen peroxide may be purchased in drugstores. Ammonia is available as a 10-percent solution. The chemical should not be stored and should be mixed immediately prior to use.

TESTING FOR PRINT PERMANENCE

A silver nitrate solution (Kodak HT-2) used in conjunction with Kodak Hypo Estimator will afford the darkroom technician a ready means of determining the amount of wash and subsequent treatment necessary to reach specific levels of hypo elimination. The Estimator is available from Kodak, although the solution must be compounded by the user.

Water (distilled) 750.0 cc
Acetic acid (28%). 125.0 cc
Silver nitrate 7.5 grams
Water to make (distilled) 1.0 liter

Store this solution in a dark amber bottle and keep it away from light until you are ready to perform the test.

1. Process a blank piece of paper in accordance with the instructions outlined on pages 208 and 243.
2. At a timed point in the cycle, place a drop of solution in the middle of the print.*
3. Compare the stain left by the chemical to the stain samples on the Kodak Hypo Estimator. Additional washing causes the stain to appear progressively lighter. For archival standards, there should be no visible trace or discoloration.

NEGATIVE/PRINT STORAGE

Along with the current concern for archival processing, there has been a corresponding interest in the storage of both negative and print materials. It follows that the gains made in producing an archivally processed negative/print should not be invalidated due

*The midsection of photographic paper washes less rapidly than the edges.

to poor storage conditions that will affect the materials in no less a way than if they were improperly processed. Unfortunately, at this writing, there are few storage methods available that will guarantee the equivalent degree of permanence that is afforded in the negative/print processing procedure.

Negative Storage. The use of glassine envelopes, which are sold for the purpose of negative storage, must be approached with extreme caution. The adhesive used to bond the seams of these holders contains chemicals that can seriously affect the negative. Moreover, the paper used to manufacture the envelope is chemically treated, and the effect of such chemicals on the negative cannot be underestimated. The polyethylene sleeves (entire rolls of 35 mm or 2¼″ × 2¼″ film or 4″ × 5″ sheets of film are compartmentalized on one sheet) are not recommended. Negatives have a tendency (under high humidity and/or temperature conditions*) to stick to the plastic, causing a ferrotype effect on the emulsion side of the film. The sleeves also tend to scratch the negatives unless caution is observed in their handling. The acetate envelopes sold by Kodak are also susceptible to adherence to the negative emulsion; nevertheless, this envelope is preferable to other types of containers because of the relative ease in handling. Do not seal the negative folders to enable air to circulate in the storage area or box.

Print Storage. Humidity can also affect the print if it is stored in an envelope and the ambient temperature and humidity are excessive (generally the same as for negatives). Avoid wooden containers (or, for that matter, wooden picture frames), cardboard boxes, and any wood substance, as the sulphur in the fibers of these products will react with the silver emulsion, causing damage to the print. Rather, metal storage containers are recommended.

*A temperature of 70 F and humidity of 40 percent are considered optimum.

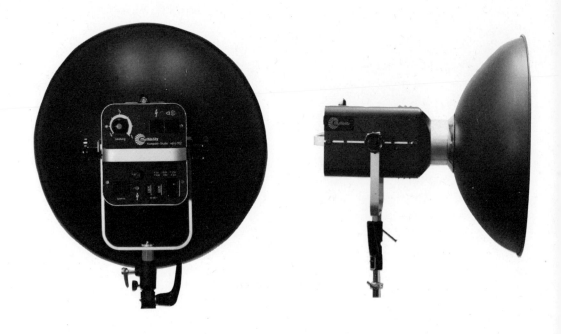

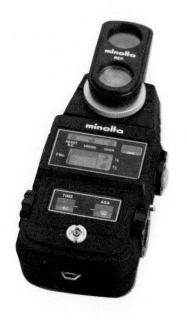

ARTIFICIAL LIGHTING/EXPOSURE

Until recently, the plotting of exposure, and the subsequent indicated development procedure as embodied in the Zone System, was limited to a continuous light source. However, two recent innovations have extended the practice of exposure and development determination to electronic light sources.

The first was the introduction of a reflected-light photometer that measures instantaneous bursts of light. This meter is best exemplified by the Minolta Flash Meter II. The meter employs a silicon photocell and a digital display of aperture values. Its accuracy and stability under a variety of conditions are quite remarkable. An accessory viewfinder with a 10° angle of acceptance is offered as an optional accessory. The limited field of view encompassed by this accessory is sufficient for studio work. The theory promulgated throughout this text is of course applicable in every way, although new calibrations will have to be performed, owing to the characteristics of the light source as well as the differing response of film materials.

The second development that allows the concepts explored in this text to extend to electronic flash instruments is the variable-intensity modeling lights that are now incorporated into several of these units. The modeling lamps are directly proportional to the light output of the unit. Therefore, exposure determinations may be made with an ordinary reflected-light meter by measuring the object illuminated by the modeling lamp. While the light output of the modeling lamp is proportional to that of the main unit, it is not as great; therefore, provision must be made to accommodate this variance. For example, the indicated exposure at two seconds (using the modeling lamp) may be found to be equivalent to an exposure of 1/60 sec. using the electronic flash. Tests to determine the ratio between the two are easy to conduct.

CAMERA CHOICE

There are many different criteria to use in the choice of the most applicable camera format. It is surely apparent that the use for which the camera is employed should be the governing factor, although it is also true that the differing formats overlap and complement each other as well.

The large-format view camera has classically been a contemplative instrument. Its use requires a discipline that is at once demanding and yet inherently simple. The photographer cannot afford to endlessly make exposure after exposure, hoping for one negative that will satisfy his creative intent. Rather, he must use the camera not as an instrument of exploration, but as an instrument of revelation. The translation of the subject into a print must be well thought out in advance. The comparative print quality achieved with this format requires less precision than with the others due to the relatively small magnification needed to produce the final print. Today, there is an increasing and welcome use of the field camera for outdoor work over the more conventional view camera (monorail). This type of camera is best exemplified by the various instruments produced by the Deardorff Company. These cameras lack the capability of extreme camera adjustments, for example, swings and tilts. However, these extreme adjustments are seldom needed, except for architectural photography or where great depth-of-field problems are encountered in product photography. These cameras are relatively lighter in weight and more easily maneuverable/controlled than the monorail. Many of the accessories available for the view camera are adaptable to the field camera, which increases the scope of their performance. Their growing popularity today is an endorsement of their relative ease of use.

The miniature roll-film camera is an instrument of exploration. With it, the photographer can expose quickly and choose those frames which most nearly match his creative intent—although this "intent" might be the result rather than the cause of the original

conception. The format requires the utmost precision to accomplish quality prints that can be favorably compared to the larger-format camera.

The medium-format instrument lies somewhere between the two extremes, depending on its use and the photographer's own prejudice. This format can easily match the inherent quality of the larger-format camera and the relative ease of operation associated with the miniature camera.

All things being equal,* there is no question that the larger the camera format, the greater the quality of the image. This extends to the delineation of detail as well as the separation of tone. This is, of course, a function of the magnification employed in the making of the print: The greater the enlargement, the greater the subsequent decrease in print quality. The qualitative comparisons between the three major film and camera formats as to the improvement between them (if the final print size is held constant) are subjective and greatly influenced by the photographer's own prejudice.

I feel the greater improvement lies in stepping up from the miniature to the medium format rather than from the medium to the large-format camera. In other words, there is a greater qualitative increase at the first level than at the second. The deciding factor is not limited to the enlargement ratio alone, but is based upon empirical explorations as well as the inherent differences in camera, lens, and film.

*Quality and condition of the lens and camera, film/developer combination, correct exposure, and the like.

LENS CHOICE

Most successful creative photography can be accomplished using two lenses of different focal length. Limit your use (and purchase) of others to specific problems that are out of the sphere of these two primary lenses. At first, limit your choice of lens to those that are approximately one half or two times the "normal" focal length of the camera format. For the 35 mm camera, they would be 28–35 mm and 100 mm lenses; for the medium-format camera, 50 mm and 150 mm lenses; for the larger 4" × 5" cameras, 90 mm and 250 mm lenses. With this set of two lenses, most of a photographer's creative intent can be fully realized. The addition of a close-focusing lens (macro/micro) is optional but often necessary. Such lenses are corrected for near distances and should be handled judiciously for "normal" work.

page 19
The choice of these focal-length lenses is based upon theoretical and practical aspects of creative photography. In the case of the double the nominally normal-focal-length lens, the problems associated with the bias of perception (size constancy) are somewhat lessened. Concentrating the eye on an object subjectively magnifies the image on the brain. By employing a moderately long lens, the recorded image more closely approximates that of the perceived object. The practical aspect of using this lens is that the enlarged image is of finer quality, due to the decreased magnification needed to generate a print of like size.

With lenses of something less than half the nominally normal focal length, the field of view more nearly approximates the eyes' perceived field of view. However, a lens having the same angle of acceptance as the eye often produces distortion (inherent both in the design of the lens and that produced by a camera that is not leveled properly). Moreover, the image is usually too small. With a lens having the same field of view as the eye, the quality of the print will invariably suffer, due to the great magnification needed.

For many years, the quality of a lens was assumed to be judged on its resolution characteristics. (How sharp an image can the lens produce? How many lines of a resolution chart can it distinguish? and so on.) Today, even with a relatively inexpensive lens (most are computer designed), the resolution ability of the lens is dependent on the film used rather than the lens employed. The film (and its attendant grain) is now the limiting factor—the weakest link in the optical photographic chain. It is advisable to examine the contrast-generating qualities of a lens. This is a function of lens design and the coating employed during its manufacture. The multilayered coatings on most lenses today page 263 make them relatively free from flare—the most important single contrast-reducing element in the optical chain.

RECIPROCITY LAW FAILURE/NEGATIVE MATERIALS

Exposure at its most fundamental level is understood to be a combination of both aperture and shutter, as evidenced by the following equation:

$$\text{Exposure} = \text{Aperture} \times \text{Time}$$

Although the formula holds true for the majority of cases, it does "fail" when the "time" quantity of the equation is either of a very short span (1/1000 sec. or less) or longer than one second. If the aperture can be manipulated so that the shutter speed remains within these parameters, reciprocity failure will not occur. If adjustment is impossible, then the photographer will have to make changes in order for the correct exposure/development calculations to be effective.

The following table, based upon the more popular Kodak films, will give you a starting point for your own calibration:

Reciprocity Effect Exposure Time Adjustment Curves

Average Adjustment for Most Kodak General Purpose Black-and-White Films

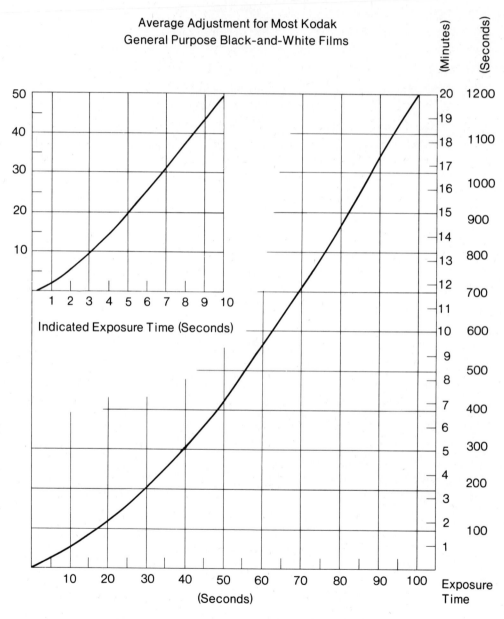

Indicated Exposure Time (Seconds)

(Seconds)

Exposure Time

Exposures of Greater Than One Second. The tones requiring a long exposure (from an exposure point of view) need even greater exposure to reach their intended densities, while those areas that do receive sufficient light do not need this reinforcement. However, by increasing exposure, tones not requiring this increase will fall to a higher tone, necessitating a reduction in development.

If the light intensity is very high and of short duration, the amount of exposure needed to produce the higher tonal areas is insufficient (although "correct" in the photographic sense) to produce densities equivalent to what they would receive if the light were more nearly normal in nature. With the use of some electronic flash units (usually the small, portable type), increased exposure is often needed as well.

Tone	1	2	3	4	5	6	7	8	9
Actual			8		2		1/2		
Increase for Reciprocity Factor			16	8	4		1/2		

RECIPROCITY LAW FAILURE/PAPER MATERIALS

Paper materials are as susceptible to reciprocity failure as are negative materials. The causes/effects of the former parallel those of the latter. When the printing exposure is of excessive duration, the following will occur:

1. The high values will be rendered without detail.
2. The separation of the low-tone values will decrease.
3. The maximum black that the paper is capable of producing will begin to reverse and become lighter.

An exposure time of more than 30 seconds (depending on the emulsion) can be considered as the threshold level. More exposure, and the onset of reciprocity failure will be apparent. Contrast increases as the threshold level is approached; continued exposure leads to a decrease in contrast.

BELLOWS-EXTENSION FACTOR

When a lens is focused on an object that is less than eight times the focal length of the lens, the amount of light reaching the film is decreased, causing underexposure. This problem is more pronounced with the view camera, but pertains to the miniature and roll-film formats as well (most notably in lenses used for close-up photography [micro/macro] and with extension tubes; consult the manufacturer's literature).

The standard formula used to compute an increase in exposure is:

$$\frac{\text{Indicated aperture} \times \text{bellows extension (lens to film plane distance)}}{\text{Focal length of the lens}} = \text{Effective aperture}$$

In practice, however, the use of this formula is unduly cumbersome. By carrying the card reproduced below you can easily make the necessary exposure adjustment. In use, the card (which is two inches wide) is focused upon (while on the plane of the object being photographed). The focused image is then measured directly on the ground glass and the correction is immediately made. Further, if the ground glass has etched lines, these can be drawn on the card as well, eliminating the need of transferring the measurement from card to camera.

For example, if the etched lines of the ground glass are one centimeter apart, the card, when focused upon is measured on the ground glass as one-and-one-half centimeters; verification from the card concludes that one-and-one-half centimeters produces a bellows-extension factor of 1.6 or an exposure increase of two thirds of an exposure unit.

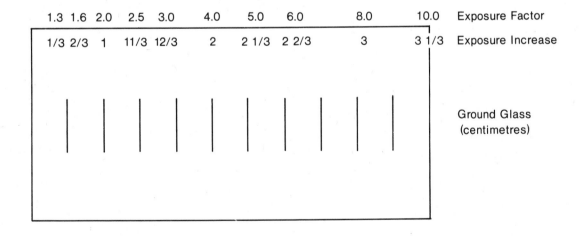

| 1.3 | 1.6 | 2.0 | 2.5 | 3.0 | 4.0 | 5.0 | 6.0 | 8.0 | 10.0 | Exposure Factor |
| 1/3 | 2/3 | 1 | 11/3 | 12/3 | 2 | 2 1/3 | 2 2/3 | 3 | 3 1/3 | Exposure Increase |

Ground Glass
(centimetres)

REDUCTION/INTENSIFICATION

The reduction/intensification of the negative/print can be considered the chemical equivalent of the physical process of burning-in/dodging. In either case, the formed silver halide undergoes, by chemical means, either a reduction or intensification of existing densities. Reduction is the process wherein the silver deposit (density) is dissolved. Intensification is the strengthening of the silver deposit (density), although the intensifier cannot reinforce areas where no density was present (for example, shadow areas due to lack of exposure). The procedures involved should be thought of as corrective rather than interpretive, and the processes should be employed to correct a technical defect in the negative/print rather than to force an intent that was not present in the original conception of the photograph.

REDUCTION/INTENSIFICATION: THE NEGATIVE

	Reducers to correct for	Intensifiers to correct for
Proportional (for all negative densities)	overexposure/overdevelopment (Contrast remains unchanged)	underexposure/underdevelopment (Contrast remains unchanged)
Superproportional (for high negative densities)	overdevelopment (Decreases contrast by lowering high densities)	underdevelopment (Increases contrast by increasing high densities)
Subproportional (for low negative densities)	overdevelopment (Increases contrast by lowering low densities also called "cutting" reducer and used to eliminate negative fog)	underdevelopment (Decreases contrast by increasing low densities)

Most packaged formulas are moderate in their effect. The published formulas, on the other hand, provide the user with a great range of strength and control. Investigate these formulas in any of the published formularies available.

Three effective formulas are Kodak In-5 Proportional Intensifier, Kodak R-4a Cutting Reducer, and Kodak R-4b Proportional Reducer.

Kodak In-5 Proportional Intensifier. The following formula is the only intensifier known that will not change the color of the image on positive film on projection. It gives proportional intensification and is easily controlled by varying the time of treatment. In-5 acts more rapidly on fine-grained materials and produces greater intensification than on coarse-grained materials. The formula is equally suitable for positive and negative film.

Stock Solution No. 1
(Store in a brown bottle)

	Metric	(Avoirdupois)
Silver nitrate, crystals	60.0 grams	(2.0 oz.)
Distilled water to make	1.0 liter	(32.0 oz.)

Stock Solution No. 2

	Metric	(Avoirdupois)
Sodium sulfite (des.)	60.0 grams	(2.0 oz.)
Water to make	1.0 liter	(32.0 oz.)

Stock Solution No. 3

	Metric	(Avoirdupois)
Sodium thiosulfate (hypo)	105.0 grams	(3.5 oz.)
Water to make	1.0 liter	(32.0 oz.)

Stock Solution No. 4

	Metric	(Avoirdupois)
Sodium sulfite (des.)	15.0 grams	(0.5 oz.)
Elon developing agent	25.0 grams	(365.0 grains)
Water to make	3.0 liters	(96.0 oz.)

Prepare the intensifier solution for use as follows: Slowly add one part of Solution No. 2 to one part of Solution No. 1, shaking or stirring to obtain thorough mixing. The white precipitate that appears is then dissolved by the addition of one part of Solution No. 3. Allow the resulting solution to stand a few minutes until clear. Then add, with stirring, three parts of Solution No. 4. The film should be treated immediately, as the intensifier solution is stable for approximately 30 minutes at 20 C (68 F).

The degree of intensification obtained depends upon the time of treatment, which should not exceed 25 minutes. After intensification, immerse the film for two minutes with agitation in a plain 30-percent hypo solution. Then wash thoroughly.

The stability of the mixed intensifier solution and the rate of intensification are very sensitive to changes in the thiosulfate concentration. A more active but less stable working solution may be obtained by substituting for Stock Solution No. 3 a solution prepared with 3 ounces of hypo per 32 ounces (90 grams per liter) instead of the quantity in the formula. The directions for preparing the working solution are the same as before, but it will not keep over 20 minutes at 20 C (68 F).

For best results, the intensifier should be used in artificial light; the solution tends to form a precipitate of silver quite rapidly when exposed directly to sunlight.

Kodak R-4a Cutting Reducer. Probably the most generally used reducer is the subtractive R-4a, also called Farmer's Reducer, named for Howard Farmer, who introduced it in 1884.

Stock Solution A

	Metric	(Avoirdupois)
Potassium ferricyanide	37.5 grams	(1.25 oz.)
Water to make	500.0 cc	(16.0 oz.)

Stock Solution B

Sodium thiosulfate (hypo)	480.0 grams	(16.0 oz.)
Water to make	2.0 liters	(64.0 oz.)

For use, take 1 ounce (30 cc) of Stock Solution A, 4 ounces (120 cc) of Stock Solution B, and add water to make 32 ounces (1 liter). Add A to B, then add the water and pour the mixed solution at once over the negative to be reduced, which preferably should be contained in a white tray. Watch closely. When the negative has been reduced sufficiently, wash thoroughly before drying.

For less rapid reducing action, use one half the above quantity of Stock Solution A, with the same quantities of Stock Solution B and water.

Solutions A and B should not be combined until they are to be used. They will not keep long in combination.

Kodak R-4b Proportional Reducer. Farmer's Reducer also may be used as a two-bath formula to give almost proportional reduction and to correct for overdevelopment. The single-solution Farmer's Reducer gives only cutting reduction and corrects for overexposure.

Solution A

	Metric	(Avoirdupois)
Potassium ferricyanide	7.5 grams	(0.25 oz.)
Water to make	1.0 liter	(32.0 oz.)

Solution B

Sodium thiosulfate (hypo)	200.0 grams	(6.75 oz.)
Water to make	1.0 liter	(32.0 oz.)

Treat the negatives in Solution A with uniform agitation for one to four minutes at 18 to 21 C (65 to 70 F), depending on the degree of reduction desired. Then immerse them in Solution B for five minutes and wash thoroughly. The process may be repeated if more reduction is desired.

Reduction/Intensification: The Print. With paper, it is advised that you redo a print rather than try to "correct" for either under/overexposure or under/overdevelopment. However, the processes can be employed to reinforce and improve the print quality that is not ordinarily capable of improvement by either exposure and/or development. Again the gentle admonition that the procedure should be employed to strengthen the brilliance of the image—a means to an end rather than an end unto itself.

The formulas for reduction/intensification of the print are adaptations of those used for the negative. For reduction, the solution should be diluted 1:3, with increasing dilution providing decreasing strength. For intensification, a doubling of the strength of the solution is recommended as a starting point.

Reduction (Clearing the Whites). The smallest amount of fog will seriously reduce the brilliance of the image. This condition is often the result of prolonged development as well as exposure to unsafe safelights. The reduction process will "clear" the fog, allowing the print to be restored to its inherent brilliance. This procedure must be employed before the toning process.

Intensification. The toning process in and of itself acts to intensify the tonalities inherent in the print. For a greater reinforcement of values, the intensifiers used for negative materials may be employed; however, the print is subject to serious print discoloration if this is done, with little help afforded by a subsequent toning process.

THE PERCEPTION OF TONE

page 21
Two methods are available that can, if employed with understanding, help to compensate for the subjective perception of tones.

The first is to view the scene with the lens set at a small aperture. The eye will now strain to envision the tonalities being examined and, in so doing, will alter the perception of the scene. As a secondary benefit, the shadow areas will be perceived without the delineation that is not apparent to the unaided eye. The placement of the low tone for exposure is more easily accomplished; the low tones will now be perceived as flowing together without separation. Exposure is determined by that separation which is now deemed to be important.

The second method is to view the scene with a monochromatic viewing filter (Wratten Series #90). Held up to the eye
page 264
(never placed in front of the lens) the filter will lessen the aggressive and regressive nature of color. It reduces the bias in the perception of color to the monochromatic equivalents of the colors.

FLARE

The causes and effects of flare are poorly understood and therefore need clarification. Flare (regardless of its source) is the random reflection of light. These rays scatter within either the negative or print emulsion. Its causes can be traced from the beginning to the end of the photographic chain. The random scattering of light is evidenced in the negative by an overall fog (most apparent in the low tones), thereby reducing contrast and delineation. In the print, it is most obvious in the highlight areas, suppressing the brilliance of the image. By application of the calibrations contained in this text, the unavoidable and uncorrectable aspects of flare are factored into the results and standards.

With older, noncoated lenses, the problems associated with lens flare were immense and the subject of great concern. However, with the modern, multilayered lens coating (and a properly designed lens shade) lens flare is a matter of little consequence. The flare caused by internal camera reflections is, however, of lingering interest and concern. This problem is greatest with the view camera* (due to its bellows) and least with the miniature camera (although with a poorly designed small camera the problems can be monumental).

Flare in the darkroom is produced by reflections from the enlarger, a poorly maintained enlarging lens, an improperly designed negative carrier, and so on. The remedies are self-evident.

*It has been suggested that using a view camera with a reducing back (for example, a 5″ × 7″ camera with a 4″ × 5″ back) can eliminate much of the inherent internal camera flare.

COLOR PERCEPTION

The least understood but certainly among the most important aspects of the translation process are the theoretical and practical implications of rendering a multicolored subject into mono-chromatic tones. Knowledge of how the visual and nervous systems react to these perceptual influences of color contrasts (which cannot be measured), and their subsequent embodiment in terms of the monochromatic photographic print, marks the caring and creative photographer.

Color. The color metric value of a substance (which can be quantified) can be defined by the following:*

1. Hue—the color (wavelength) of the subject.
2. Brightness—the amount of color/light transmitted to the eye.
3. Saturation—the purity/intensity of the color; for example, pale blue (containing white) or strong blue (containing no white).

The factors that make the problems of color perception so difficult can be categorized in the following manner:

1. Hue contrast.
2. Brightness contrast.
3. Hot-cold contrast.
4. Quantity contrast.

page 262

To fully understand the perceptual problems involved, use a Wratten #90 (gelatin) Filter. This filter reduces colors to their monochromatic equivalents. It is a viewing filter and should never be used over the camera lens. While the filter should be used for the following procedures, it should also be used to view natural objects in their native surroundings to give the photographer a better and more precise idea of how the colors photographed will translate into terms of their monochromatic equivalents.

*In the Munsell Notation System, the equivalent terms are hue, value, and chroma.

COLOR THEORY

The Additive Process. This is a method of producing color by the mixture of lights. The additive primary colors are green, red, and blue (light). When superimposed in equal amounts upon each other, the primaries will produce white light; conversely, when a white light (either tungsten or daylight) is passed through a prism, the light is segmented into the component additive primaries. In unequal amounts, the superimposition of the additive primaries will produce an infinite array of colors. The colors produced by a color television are mixtures of the three additive primaries. Similarly, a monochromatic tone scale can be produced by the equal amounts (and progressively more intense) of additive primaries.

The Subtractive Process. This is a method of producing colors by using pigment (dyes, inks, and the like) blends that absorb (subtract) some portion of one or more of the primary colors. The subtractive primaries are cyan, magenta, and yellow—also called the secondary primaries. Each subtractive primary is a mixture of two of the additive primary colors.

```
Cyan     = Blue + Green
Magenta  = Blue + Red
Yellow   = Red + Green
```

In the photographic process, the subtractive process is the more relevant of the two, because a photographic filter transmits light of its own color and absorbs (subtracts) light of other colors.

PHOTOGRAPHIC FILTERS

Neutral Density Filters (ND). These are filters that absorb all colors; equally useful when a slower shutter speed or smaller aperture is deemed necessary for the successful completion of the photographic print.

Color-Compensating Filters (CC). These filters are generally employed in color photography to match or to change the color balance of the film (negative or reversal) for a literal or creative effect.

Conversion Filters. These are filters that allow color film to be used under an illumination for which the film is not balanced, for example, daylight film under tungsten illumination.

Correction Filters. These filters give a better and more realistic gray-scale rendering of color with black-and-white film (yellow for daylight illumination, green for tungsten illumination).

Polarizing Filters. These filters eliminate the specular reflections on nonmetallic surfaces such as water, glass, skin. The filter operates within a limited angle of 35° at which the reflection is photographed.*

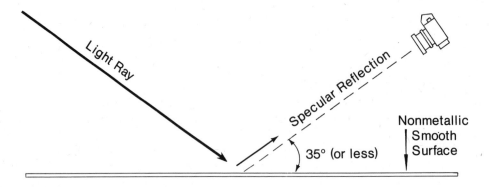

*If the light source itself can be polarized, this limitation does not apply.

Polarizing filters can also deepen the sky in color photography (as in black-and-white) without changing the color balance of the photograph. Their use in color photography is also expanded by the heightened saturation of the rendering of all colors in the spectrum. The effect of the polarizer can be predicted by rotating the filter on the lens and watching the changes directly on the focusing screen.

FILTER FACTORS

A filter factor is a designation (usually supplied by the manufacturer) of the light absorption and subsequent exposure increase needed to maintain a gray-card rendering; in other words, how much additional exposure is needed in photographing a gray card to preserve its correct tonality/reflectance. These factors are provided only as a guide and should not be relied upon for accurate exposure determination. The true factor depends upon the aesthetic purpose for which the filter is intended. Also, because the filter transmits and absorbs light, an analysis of the colors absorbed/transmitted must be made. In general, the filter factors supplied by manufacturers are in fact too large; and you can reduce the designated exposure increase by one half (for example, a filter factor of 2, which would indicate a doubling of exposure, should instead be reduced by approximately one-half stop). In short, a filter is intended to lighten or darken a tone, and the factor applied should correspond to this intended purpose.

FILTERS/PRACTICAL CONSIDERATIONS

The use of filters should be limited to instances where a particular effect can be achieved only by their application. The side effects caused by their use often cancel out the benefits.

In the first place, the resolution of the camera/lens is diminished to a great extent. The resolution, being only as good as the weakest link in the optical chain, is now limited by an inferior (compared to most quality lenses) glass (or gelatin) surface. Second, the air-to-glass surface caused by placing the filter on the lens also limits the quality of the inherent resolution and contrast of the lens. Third, while the filter can be used to emphasize/deemphasize a certain tonality, its use is usually accompanied by the subversion of other tonalities, which are of no less importance. That is, a red filter will deepen to the tonality of the sky (absorb blue) but will also eliminate much shadow detail contained in a green (landscape) foreground. Lastly, the filter effects, unless moderate in their application, can cause a rendering/translation of the scene that can be at wide variance with what was intended. A scene that includes light, wispy clouds (a light and airy mood) will be seriously affected by the addition of anything greater than a light-yellow filter (which might not be sufficient to cause the desired degree of change) in order to preserve the feeling of lightness that was intended.

In summary, then, the intelligent use of filters also includes the equally important decision not to use them.

10

Afterword

One of the more common claims made about photography, often proffered by way of exculpation, is that it is a very young medium. It is, after all, only 135 years old. What that assertion overlooks is the fact that the history of photography encompasses a period of quantum change in the arts; those 135 years span what C. S. Lewis has called the Great Divide, a decisive and immeasurable seismic shift in the nature of aesthetic sensibility and artistic production. The extent of this change is perhaps most dramatically demonstrated in literature: Joyce is at least as far removed from Dickens as Dickens is from Chaucer. Something similar seems to have happened with photography or, more accurately, with the world and attitudes it reflects. Contemplating the immense distance between William Henry Fox Talbot's *Lacock Abbey* and Diane Arbus' *42nd Street* one could conclude that photography is not so much a young medium as one that is prematurely aged.

Geoffrey James
"Responding to Photographs"
Artscanada, December 1974

SYSTEMS

The great danger that exists in the application of the principles and application of any system (as exemplified by the Zone System) is discussed and analyzed by John Gall in his book *Systemantics (How Systems Work and Especially How They Fail).* * While Dr. Gall summarizes his findings with humor, this veneer only partially disguises some problems that, if not dealt with, can undermine the effort spent in the development of procedure.

Systems are seductive, they promise to do a hard job faster, better, and more easily than you could do it by yourself. But if you set up a system, you are likely to find your time and effort now being consumed in the care and feeding of the system itself.

New problems are created by its very presence.

Once set up, it won't go away, it grows and encroaches.

It begins to do strange and wonderful things.

Breaks down in ways you never thought possible.

It kicks back, gets in the way, and opposes its own proper function.

Your own perspective becomes distorted by being in the system.

You become anxious and push on it to make it work.

Eventually you come to believe that the misbegotten product it so grudgingly delivers is what you really wanted all the time.

*John Gall, *Systemantics*. New York: Quadrangle/The New York Times Book Co., 1977.

Over the years, students and photographers alike seem to believe that the emphasis is not so much the translation of perception (as evidenced by the photographic print) but rather the ability and technique needed to realize the end result. The means have become an end unto themselves!

After a typical semester, there are any number of students who go forth, not to photograph, but to further refine and perfect their calibrations, using more films and developers ad nauseam. These students can produce a tone scale second to none, but have not produced, or are incapable of producing, a photograph that embodies perception, feeling, or, at its most fundamental level, a literal photographic translation of what they have seen. These aspiring photographers begin the course with a vague disquiet that is somehow mollified by the systems approach inherent in the design of the methodology. However, the appeasement solves little, and instead leads to a depression after the futility of more testing is acknowledged as being superficial at any level.

Unfortunately, the general approach leads to a cult feeling among those who have acquired a knowledge of the procedure. In effect, the language of the Zone System has become an instrument of intimidation by those versed in its semantics against those who seriously want to pursue their photographic education but are unable to dismiss the pretension and atmosphere that surround the discipline.

These problems are certainly not unique to the Zone System, but affect all systems to a greater or lesser degree. Perhaps a cautionary note should be placed on all literature pertaining to the Zone System, thus: "This is a body of knowledge, nothing more/ nothing less. Use what you need to reach that point at which you are free of the burden of the system and can create unencumbered."

RULES OF ETHICAL CONDUCT FOR PHOTOGRAPHERS*

It is not right for a photographer to insist on saving a badly seen or executed negative by solarizing, theorizing, or posturizing his guilt away. He should be arrested by the Bureau of Fraud and Deceit.

It is not right for the photographer to allow the manufacturers of photographic equipment to give him a "new means of expression." Photographers whose vision is not complete without the latest fish-eyed, wide-eyed, zoom-eyed, and hackney-eyed lenses should be confined to a torture chamber and made to photograph lens resolution charts.

It is not right for the photographer to insist that his vision is so pure that technique would only confuse, interfere with, and cloud his gift of revelation. He should be promptly booked for suspicion.

It is not right for the photographer to think that a higher artistic level is achieved by images that shock and terrorize the viewer. He should be denied a license to photograph by the Bureau of Import and Exploitation.

It is not right for the photographer to utilize the other arts to camouflage the artistic shortcomings of his own work. Artists who employ or consort with poets should be accused of contributing to the delinquency of Minor arts.

It is not right for the photographer to artificially limit the sale of his prints by destroying his negative so the prints will have a higher commercial value. An immediate investigation by the Securities and Exchange Commission should be instigated to determine whether a commercial/artistic fraud has been perpetrated.

*With an appreciative nod to Ad Reinhardt.

It is not right for the photographer to denigrate his art as being less than that of the other visual arts due to the "mechanical aspects of the camera and the related chemical procedures." The Department of the Inferior should issue him a musical instrument, or pen and pencil (typewriter), or a paint by the numbers kit.

It is not right for the photographer to be permitted to publicly exhibit his photographs until he reaches the age of thirty-five. If convicted, he should be imprisoned for premature exposure.

It is not right for the photographer who "snaps a picture" to claim that his art is on a higher plane than those who labor to create a photograph. Photographers who photograph without forethought or foresight should be given a life sentence devoted to photographing an infinite number of decisive moments with one roll of film.

It is not right for the photographer to imply that he is setting out on an unchartered course, discovering himself through his art, etc., etc., ad nauseam. The Bureau of Missing Persons should locate him at once, before he causes harm to himself as well as to others.

It is not right for the portrait photographer to insist that a "higher truth" is obtained by photographing his subject in the most awkward, unnatural, and unphotogenic position and pose. He should serve penal servitude in a passport photo studio.

It is not right for the photographer to explain and extol the virtues and concepts of his own work. He should be sentenced to having his work explained for him by photographic critics and the photographic press.

It is not right for the photographer to preach to others as if he were without original sin. He should be forced to atone for his wrongdoings by writing a book on photographic technique.

It is not right for the photographer to denigrate his art as being less than that of the other visual arts due to the "mechanical aspects of the camera and the related chemical procedures." The Department of the Inferior should issue him a musical instrument, or pen and pencil (typewriter), or a paint by the numbers kit.

It is not right for the photographer to be permitted to publicly exhibit his photographs until he reaches the age of thirty-five. If convicted, he should be imprisoned for premature exposure.

It is not right for the photographer who "snaps a picture" to claim that his art is on a higher plane than those who labor to create a photograph. Photographers who photograph without forethought or foresight should be given a life sentence devoted to photographing an infinite number of decisive moments with one roll of film.

It is not right for the photographer to imply that he is setting out on an unchartered course, discovering himself through his art, etc., etc., ad nauseam. The Bureau of Missing Persons should locate him at once, before he causes harm to himself as well as to others.

It is not right for the portrait photographer to insist that a "higher truth" is obtained by photographing his subject in the most awkward, unnatural, and unphotogenic position and pose. He should serve penal servitude in a passport photo studio.

It is not right for the photographer to explain and extol the virtues and concepts of his own work. He should be sentenced to having his work explained for him by photographic critics and the photographic press.

It is not right for the photographer to preach to others as if he were without original sin. He should be forced to atone for his wrongdoings by writing a book on photographic technique.

It is not right for the photographer to denigrate his art as being less than that of the other visual arts due to the "mechanical aspects of the camera and the related chemical procedures." The Department of the Inferior should issue him a musical instrument, or pen and pencil (typewriter), or a paint by the numbers kit.

It is not right for the photographer to be permitted to publicly exhibit his photographs until he reaches the age of thirty-five. If convicted, he should be imprisoned for premature exposure.

It is not right for the photographer who "snaps a picture" to claim that his art is on a higher plane than those who labor to create a photograph. Photographers who photograph without forethought or foresight should be given a life sentence devoted to photographing an infinite number of decisive moments with one roll of film.

It is not right for the photographer to imply that he is setting out on an unchartered course, discovering himself through his art, etc., etc., ad nauseam. The Bureau of Missing Persons should locate him at once, before he causes harm to himself as well as to others.

It is not right for the portrait photographer to insist that a "higher truth" is obtained by photographing his subject in the most awkward, unnatural, and unphotogenic position and pose. He should serve penal servitude in a passport photo studio.

It is not right for the photographer to explain and extol the virtues and concepts of his own work. He should be sentenced to having his work explained for him by photographic critics and the photographic press.

It is not right for the photographer to preach to others as if he were without original sin. He should be forced to atone for his wrongdoings by writing a book on photographic technique.

Bibliography

MAIN REFERENCES

Adams, Ansel. *Camera and Lens.* Hastings-on-Hudson, N.Y.: Morgan and
 Morgan, 1970.
———. *The Negative.* New York: Morgan and Morgan, 1967.
———. *Polaroid Manual.* New York: Morgan and Morgan, 1963.
———. *The Print.* Hastings-on-Hudson, N.Y.: Morgan and Morgan, 1967.
Birren, Faber. *Color Perception in Art.* New York: Van Nostrand Reinhold
 Company, 1976.
Carroll, John S. *Photographic Lab Handbook.* Garden City, N.Y.: Amphoto,
 1976.
Eastman Kodak Company. *Kodak Master Darkroom Dataguide* (Publication
 No. R-20). Rochester, N.Y.: Eastman Kodak Company, 1967.
———. *Kodak Professional Black-and-White Films* (Publication No. F-5).
 Rochester, N.Y.: Eastman Kodak Company, 1976.
———. *Photographic Chemistry, Parts 1 and 2.* Rochester, N.Y.: Eastman
 Kodak Company, 1971.
———. *Photographic Sensitometry* (Publication No. Z-22-ED). 2nd ed.
 Rochester, N.Y.: Eastman Kodak Company, 1961.
Eaton, George T. *Photographic Chemistry.* 2nd ed. Hastings-on-Hudson, N.Y.:
 Morgan and Morgan, 1965.
Gregory, R.L. *Eye and Brain.* 2nd ed. New York: World History Library, McGraw-
 Hill Book Company, 1972.
Jacobson, C.I. *Developing.* London and New York: Focal Press, 1970.
Marx, Ellen. *The Contrast of Colors.* New York: Van Nostrand Reinhold
 Company, 1973.
Mees, C.E. Kenneth, and T.H. James. *The Theory of the Photographic
 Process.* New York: Macmillan and Company, 1966.

Neblette, C.B. *Photography, Its Materials and Processes.* 6th ed. New York: Van Nostrand Reinhold Company, 1962.

Readings from Scientific American: Perception: Mechanisms and Models, 1950-1972. San Francisco: W. H. Freeman and Company, 1972.

Readings from Scientific American: Recent Progress in Perception, 1964-1976. San Francisco: W. H. Freeman and Company, 1976.

Todd, Hollis N., and Richard D. Zakia. *Color Primer, I and II.* Dobbs Ferry, N.Y.: Morgan and Morgan, 1974.

———. *Photographic Sensitometry.* Hastings-on-Hudson, N.Y.: Morgan and Morgan, 1969.

Wilhelm, Henry. *Preservation of Contemporary Photographic Materials.* Grinnell, Iowa: East Street Gallery, 1978.

SUGGESTED READINGS

Danziger, James, and Barnaby Conrad, III. *Interviews with Master Photographers.* New York: Paddington Press, 1972.

Lyons, Nathan. *Photographers on Photography.* Englewood, N.J.: Prentice Hall, 1966.

Rose, Barbara. *Art as Art: The Selected Readings of Ad Reinhart.* New York: Viking Press, 1975.

Rosenberg, Harold. *Art on the Edge.* New York: Macmillan, 1975.

———. *The De-Definition* of Art. New York: Macmillan, 1972.

Sontag, Susan. *On Photography.* New York: Farrar, Strauss and Giroux, 1977.

Szarkowski, John. *Looking at Photographs.* New York: The Museum of Modern Art, 1973.

Weston, Edward. *The Daybooks of Edward Weston. Vol. I:* Rochester, N.Y.: George Eastman House, 1961; *Vol. II:* New York: Horizon Press, 1966.

PHOTOGRAPHIC BOOKS

Adams, Ansel. *Ansel Adams.* Hastings-on-Hudson, N.Y.: Morgan and Morgan, 1972.

———. *Singular Images.* Dobbs Ferry, N.Y.: Morgan and Morgan, 1974.

———, and Nancy Newhall. *This is the American Earth.* San Francisco: Sierra Club, 1960.

Bibliography

MAIN REFERENCES

Adams, Ansel. *Camera and Lens.* Hastings-on-Hudson, N.Y.: Morgan and Morgan, 1970.

————. *The Negative.* New York: Morgan and Morgan, 1967.

————. *Polaroid Manual.* New York: Morgan and Morgan, 1963.

————. *The Print.* Hastings-on-Hudson, N.Y.: Morgan and Morgan, 1967.

Birren, Faber. *Color Perception in Art.* New York: Van Nostrand Reinhold Company, 1976.

Carroll, John S. *Photographic Lab Handbook.* Garden City, N.Y.: Amphoto, 1976.

Eastman Kodak Company. *Kodak Master Darkroom Dataguide* (Publication No. R-20). Rochester, N.Y.: Eastman Kodak Company, 1967.

————. *Kodak Professional Black-and-White Films* (Publication No. F-5). Rochester, N.Y.: Eastman Kodak Company, 1976.

————. *Photographic Chemistry, Parts 1 and 2.* Rochester, N.Y.: Eastman Kodak Company, 1971.

————. *Photographic Sensitometry* (Publication No. Z-22-ED). 2nd ed. Rochester, N.Y.: Eastman Kodak Company, 1961.

Eaton, George T. *Photographic Chemistry.* 2nd ed. Hastings-on-Hudson, N.Y.: Morgan and Morgan, 1965.

Gregory, R.L. *Eye and Brain.* 2nd ed. New York: World History Library, McGraw-Hill Book Company, 1972.

Jacobson, C.I. *Developing.* London and New York: Focal Press, 1970.

Marx, Ellen. *The Contrast of Colors.* New York: Van Nostrand Reinhold Company, 1973.

Mees, C.E. Kenneth, and T.H. James. *The Theory of the Photographic Process.* New York: Macmillan and Company, 1966.

Neblette, C.B. *Photography, Its Materials and Processes.* 6th ed. New York: Van Nostrand Reinhold Company, 1962.

Readings from Scientific American: Perception: Mechanisms and Models, 1950-1972. San Francisco: W. H. Freeman and Company, 1972.

Readings from Scientific American: Recent Progress in Perception, 1964-1976. San Francisco: W. H. Freeman and Company, 1976.

Todd, Hollis N., and Richard D. Zakia. *Color Primer, I and II.* Dobbs Ferry, N.Y.: Morgan and Morgan, 1974.

————. *Photographic Sensitometry.* Hastings-on-Hudson, N.Y.: Morgan and Morgan, 1969.

Wilhelm, Henry. *Preservation of Contemporary Photographic Materials.* Grinnell, Iowa: East Street Gallery, 1978.

SUGGESTED READINGS

Danziger, James, and Barnaby Conrad, III. *Interviews with Master Photographers.* New York: Paddington Press, 1972.

Lyons, Nathan. *Photographers on Photography.* Englewood, N.J.: Prentice Hall, 1966.

Rose, Barbara. *Art as Art: The Selected Readings of Ad Reinhart.* New York: Viking Press, 1975.

Rosenberg, Harold. *Art on the Edge.* New York: Macmillan, 1975.

————. *The De-Definition* of Art. New York: Macmillan, 1972.

Sontag, Susan. *On Photography.* New York: Farrar, Strauss and Giroux, 1977.

Szarkowski, John. *Looking at Photographs.* New York: The Museum of Modern Art, 1973.

Weston, Edward. *The Daybooks of Edward Weston. Vol. I:* Rochester, N.Y.: George Eastman House, 1961; *Vol. II:* New York: Horizon Press, 1966.

PHOTOGRAPHIC BOOKS

Adams, Ansel. *Ansel Adams.* Hastings-on-Hudson, N.Y.: Morgan and Morgan, 1972.

————. *Singular Images.* Dobbs Ferry, N.Y.: Morgan and Morgan, 1974.

————, and Nancy Newhall. *This is the American Earth.* San Francisco: Sierra Club, 1960.

Bullock, Wynn. *Wynn Bullock Photography: A Way of Life.* Dobbs Ferry, N.Y.: Morgan and Morgan, 1973.

Callahan, Harry. *Callahan.* New York: The Museum of Modern Art/Aperture, 1976.

Caponigro, Paul. *Paul Caponigro.* Millerton, N.Y.: Aperture, 1972.

———. *Landscape.* New York: McGraw Hill, 1975.

———. *Sunflower.* New York: Filmhaus, Inc., 1974.

Davidson, Bruce. *East 100th Street.* Cambridge, Mass.: Harvard University Press, 1970.

Michals, Duane. *Real Dreams.* Danbury, N.H.: Addison House, 1976.

Newhall, Beaumont. *Fredrick H. Evans.* Millerton, N.Y.: Aperture, 1973.

Newman, Arnold. *One Mind's Eye.* Boston, Mass.: Godine, 1974.

Siskind, Aaron. *Places.* New York: Light Gallery/Farrar, Straus and Giroux, 1976.

Strand, Paul. *Paul Strand.* Millerton, N.Y.: Aperture, 1971.

Weston, Edward. *Edward Weston.* Millerton, N.Y.: Aperture, 1973.

White, Minor. *Light[7].* Millerton, N.Y.: Aperture, 1968.

———. *Mirrors Messages Manifestations.* Millerton, N.Y.: Aperture, 1969.

Author's note: Below is a chapter-by-chapter listing of works used as reference materials for this book. The reader is referred to the Bibliography for full publication information.

Chapter 1 Visual Perception/Tone Reproduction
Faber Birren, *Color Perception in Art.*
R.L. Gregory, *Eye and Brain.*
*Readings from Scientific American: Perception: Mechanisms and
 Models, 1950–1972.*
*Readings from Scientific American: Recent Progress in Perception,
 1964–1976.*

Chapter 2 Tone Reproduction/Exposure
Ansel Adams, *The Negative.*
Hollis N. Todd and Richard D. Zakia, *Photographic Sensitometry.*

Chapter 3 Development
Ansel Adams, *The Negative.*
C.B. Neblette, *Photography, Its Materials and Processes.*

Chapter 4 Sensitometry/The Language of Photography
Eastman Kodak Company, *Photographic Sensitometry.*
Hollis N. Todd and Richard D. Zakia, *Photographic Sensitometry.*

Chapter 5 Film
John S. Carroll, *Photographic Lab Handbook.*
Eastman Kodak Company, *Kodak Professional Black-and-White Films.*
C.B. Neblette, *Photography, Its Materials and Processes.*

Chapter 6 Development Chemistry/Procedures
Ansel Adams, *The Negative.*
John S. Carroll, *Photographic Lab Handbook.*
George T. Eaton, *Photographic Chemistry.*
C. I. Jacobson, *Developing.*
Eastman Kodak Company, *Photographic Chemistry, Parts I and II.*
C.E. Kenneth Mees and T.H. James, *The Theory of the Photographic
 Process.*

Chapter 7 The Darkroom
Ansel Adams, *Camera and Lens.*

Chapter 8 The Print
Ansel Adams, *The Print.*
Eastman Kodak Company, *Kodak Master Darkroom Dataguide.*

Chapter 9 Notations in Passing
Ansel Adams, *Polaroid Manual.*
Ellen Marx, *The Contrast of Colors.*
Hollis N. Todd and Richard D. Zakia, *Photographic Sensitometry.*
————, *Color Primer.*
Henry Wilhelm, *Preservation of Contemporary Photographic Materials.*

Index